Hometown Texas

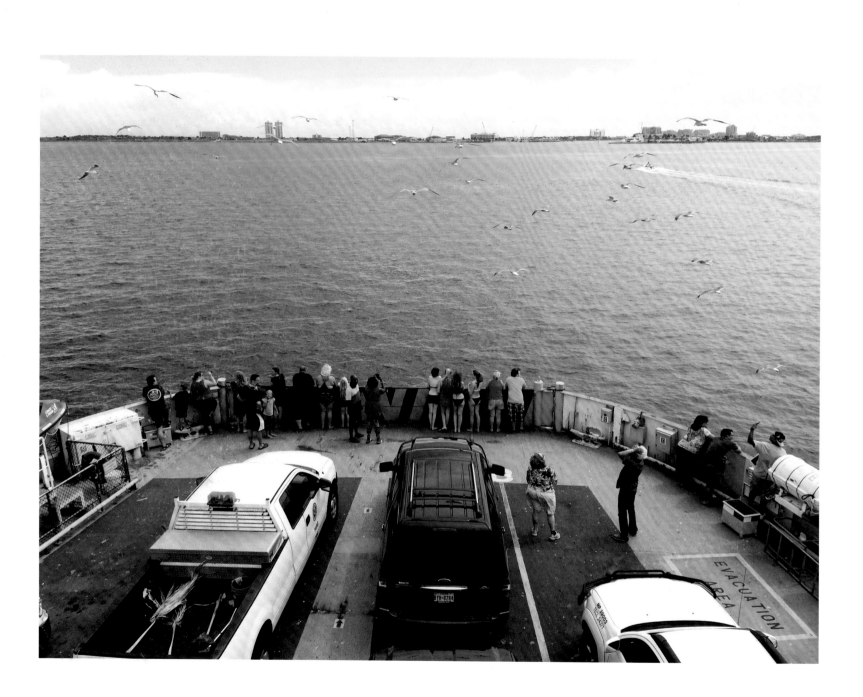

HOMETOWN TEXAS

Photographs by Peter Brown | Stories by Joe Holley

MAVERICK BOOKS · TRINITY UNIVERSITY PRESS

San Antonio, Texas

For Jill and Caitlin
PETER BROWN

For Laura
JOE HOLLEY

Hometown Texas

Introduction ★ Peter Brown

The astonishing thing to me about photography and the mind is an instantaneous recognition of what may be a good photograph. And in this split second myriad factors converge. They involve memory, aesthetics, cultural history (in this case Texas history), the history of photography, the natural world, time and timing—luck. And all these things function together. Only after the fact do I begin to know what's caught my attention. And then, in a comparatively slow way, I can reexamine first the memory of taking the picture, then the view at the back of the camera, and ultimately the print or projection to discover why it seemed a moment worth saving. And then—and this is what makes the medium so exciting and perpetually resonant for me—if it's a successful photograph, there is an X factor that seems inexplicable. A magic that opens into another realm.

Many photographers will agree that one can enter a state in which senses are attuned and consciousness is both closely focused and paradoxically open at the same time. And out of that, a transcendence of sorts may occur. And if this is handled carefully, an image that speaks in a variety of ways can be created and passed on.

Hometown Texas involves the whole of Texas, but no photographer can sum up the state in a documentary way in a hundred pictures. And I have not tried to do so. The great Walker Evans, at the end of his life, wrote of a "lyric documentary" style. A way of photographing that is both descriptive and personal, more fictional or poetic than photojournalistic—a style that uses a narrative. And this is the model I've used in my work for many years. And this is the model I use here.

Joe and I have broken the state into its generally agreed-upon regions, and for each (West, North, Central, South and East) I have linked together an impressionistic group of pictures.

What you will see, then, is my reaction to the various parts of the state. The sequences set the scene visually and metaphorically for Joe's columns. They create

context for the stories. And while there are few one-to-one connections with the writing, the spirit of Joe's words and my photographs, I think, remains the same throughout.

In these photos, I've tried to get at the ethos of each region—the things that have stayed with me after many visits: the ineffable feel, the particular look, the signs, the symbols, the varying landscape, the architecture. All that differentiates one region from the next.

Yet in my travels it's also become clear to me that there are things that remain the same throughout the state. A few of these: flags . . . American, Texas, UT, Aggies . . . occasionally a Confederate; a Main Street, always; movie theaters in various states of disrepair; churches; exuberant displays of religion; Dairy Queens; new entrances to towns that are filled with motel chains and fast food restaurants; expanding space (even in the Piney Woods of East Texas); good Farm to Market roads; quiet neighborhoods; railroads and the territory they establish; an unusually energetic life force in the people; a visible sense of humor; an openness and curiosity in regard to strangers; lingering signs of racism, sexism and homophobia; football; unapologetic individualism; cattle, sheep, goats or horses; oil; a wide sky; spectacular weather; wildflowers; dogs; cute kids—clichés all, but they ring true. And trying to make interesting photographs out of them is a challenge that I've embraced. Being at large, out on the roads of Texas, is always good.

As far as technique goes, the genesis of these images ranges widely, from iPhones to my beloved view camera—and to digital cameras in between.

A few words on my ties, photographic and otherwise to Texas: When I came to Houston to teach photography at Rice University at thirty, a student of mine had a difficult time understanding who I was geographically. I told her about the various places that I had lived over the years, and after a bit of mulling this over she said, "Why, you're nothing but a Yankee gone out west and come down south." And that neatly sums it up.

Now, many years later, I find that I've lived in Texas longer than anywhere else, and although my wife, Jill, born in Sweetwater and a fourth-generation Texan, will not quite accept me as "a Texan," I think that my claim is good. Thirty-five years should be enough.

I've been fascinated by Texas and the West for my entire life. I've photographed the state for as long as I've lived here. Yet I've never been involved in a book that could photographically describe my feelings about Texas. And I've wanted to do that for a long time.

Joe's writing mirrors, remarkably, the small-town / rural life that I've been involved with in my work. And our collaboration describes the way we feel: That there is much to be seen, heard and appreciated in these little towns. That there are creative and energetic people working with good ideas that they apply locally, and that their stories are worth passing on and celebrating.

This is true of the physical world as well: those towns, those Main Streets, the buildings, the signs, the symbols, the people, the cultural landmarks—and the rich land that surrounds all this—can say so much. Visual history exists everywhere, and when it becomes layered with the present, the combination can spin off a wonderful mix of contemporary narrative and historical fact.

Introduction ⭐ Joe Holley

The Texas that most Americans know from the head-
lines, the magazine stories and the movies is not neces-
sarily the Lone Star State that Peter Brown and I know.
As a photographer and a writer, we each find our Texas
more appealing, in part because it's fast passing, in part
because we find it beautiful in an unaffected way.

The Texas we know is off the busy interstates, beyond
the metropolitan regions spreading amoeba-like into
the surrounding countryside. It's rural, small-town and
slower-paced. Even today, it's much more connected to
the land, to the pine forests and pasture, the rich river
bottoms and the vast stretches of rangeland that drew
early settlers to Texas in the first place. The Texas we
know and appreciate also is more intimately connected
to the state's frontier heritage.

That's the Texas I encounter in my "Native Texan"
columns in the *Houston Chronicle,* where these writings
appeared originally. Even as the land empties out and
the once-vital small towns collapse in on themselves,
even in their dying, I find a certain rough beauty.

It's also a Texas much more familiar to most Texans—
urban and otherwise—than you would guess. A great
many Houstonians, Dallasites and Austinites grew up in
small-town Texas. Many are only a couple of generations
off the land. Even if they didn't live it themselves, they've
heard stories about small-town and rural childhoods,
the appeal of growing up in a place where everyone
knows your name.

One morning a few years ago, I flew to Amarillo,
rented a car and drove to Lipscomb, Texas (pop. 44),
to interview the county judge. As we shook hands, he
told me I had just missed a deer that had wandered in
through the front door of the Lipscomb County court-
house and strolled out through the back. What I didn't
miss as I hung around Lipscomb for a couple of days was
the flock of wild turkeys that for decades has ambled

around town, the easygoing gobblers always sticking together, minding their own turkey business, with never a worry about being bothered by the locals.

Most Texans have never heard of Lipscomb. Among the northernmost tier of Panhandle counties, Lipscomb is closer to Liberal, Kansas, than to any good-sized town in Texas. The first time I happened upon the green and leafy little place, I was writing a piece for *Texas Monthly* about the Panhandle invasion of corporate hog farms. I've been back several times to investigate and appreciate the tiny community.

Founded a bit more than a century ago by German and Russian wheat farmers, the farming and ranching community was dying—had died except for the courthouse. Two lesbian women revived it.

Drawn to the abandoned western-style storefronts on the courthouse square, Debbie and Jan rented a house, set up pottery and painting studios and a gift shop in a couple of the ramshackle old buildings and, despite some initial suspicion on the part of a few Lipscombites, made themselves part of the community. Not long after they moved in, the two women built an open-air dance platform and invited Bob Wills–style western swing bands from throughout the Panhandle and West Texas to play on Saturday nights. Every weekend, an hour or so before the fiddler struck up the opening Texas two-step tune, they put on country suppers, with farm and ranch women from miles around contributing their home-made specialties.

A few years later, two B&Bs opened up—in Lipscomb, Texas, of all places. Folks from Amarillo, ninety miles away, restored some of the old houses as second homes. More artists moved in. Lipscomb had come alive.

I take the time to tell the Lipscomb story because it contains the three elements that draw me to an older, more rooted Texas: intriguing people, the pervasive influence of place and the enduring significance of the past on present-day lives. These three elements are the focal points for *Hometown Texas*.

What intrigues me as writer is how men and women take the hand they've been dealt—fate, family, circumstance, luck—and craft a life for themselves, not unlike a poet acknowledges the rules and limitations of a particular type of poem and constructs a work of art. We all do the same thing with our own lives. The challenge for the writer is to work to understand a person's life, to get a feel for it and then to re-create that life in a compelling way.

When I was a boy growing up in a working-class suburb of Waco, my dad had a potato chip route. Several days a week each summer from about age four until I was a teenager, I was his Creamer's "Clover Fresh" Potato Chips helper, as we called on grocery stores and beer joints and hamburger stands in small towns within about a fifty-mile radius of Waco. I came to appreciate the particularities—indeed, the peculiarities—of place.

Pulling into Marlin on Friday mornings in our yellow step-in van—Marlin, where the New York Giants trained in the 1920s because of the town's restorative hot sulfur springs—I would try to sense how the little town was different from, say, Belton or Rosebud or Copperas Cove. As a kid, I gradually came to realize that towns, like people, are intelligible. They have distinctive personalities.

"The puzzle of Texas is that it is simultaneously diverse and unified," Stephen Brook writes in his book *Honkytonk Gelato*. "Climactically, topographically, eco-

nomically, the east has no connection with the west, yet the Texans' sense of themselves, their cultural identity links the rancher from San Angelo with the timber merchant from Nacogdoches like mountaineers at different heights yet on the same rope."

Anyone who's driven across Texas is well aware that it's a large and remarkably diverse state, one so large and so diverse that some have suggested carving five states out of the one. When Texas was admitted to the Union, in fact, Congress authorized it to form "new States of convenient size, not exceeding four in number and in addition to the said State of Texas."

Former Vice President John "Cactus Jack" Garner of Uvalde, Texas—best known for comparing the vice presidency to "a pitcher of warm spit"—maintained in the 1920s that slicing Texas into five states the size of Arkansas would "transfer the balance of political power to the South and secure for the Southern States prestige and recognition."

Garner envisioned an East Texas, West Texas, North Texas and South Texas, with just plain Texas in the middle. The idea went nowhere, largely because most Americans believed that one Texas was more than enough.

Although Texans these days have too much invested in bigness to ever voluntarily dismember their Lone Star State, they are very much aware of the distinctions; they still consider themselves East Texans, South Texans and so forth. As A. C. Greene, a West Texan, wrote in *A Personal Country*, "The Texan is fiercely proud of his locality, and if he cannot find anything good in it to brag about, he will brag about how bad it is."

You see that appreciation for locality in names of businesses and institutions—West Texas Utilities, South Texas College of Law, Central Texas Iron Works—and in everyday references ("Bob had to drive over to East Texas today"). Those distinctions—cultural, topographical and geographic—are useful to Peter and me, even though the borders can be hazy, there are no fixed boundaries and some of the "five states" overlap. *Hometown Texas* is divided into the five sections Cactus Jack suggested, sections that make sense to most Texans.

WEST TEXAS

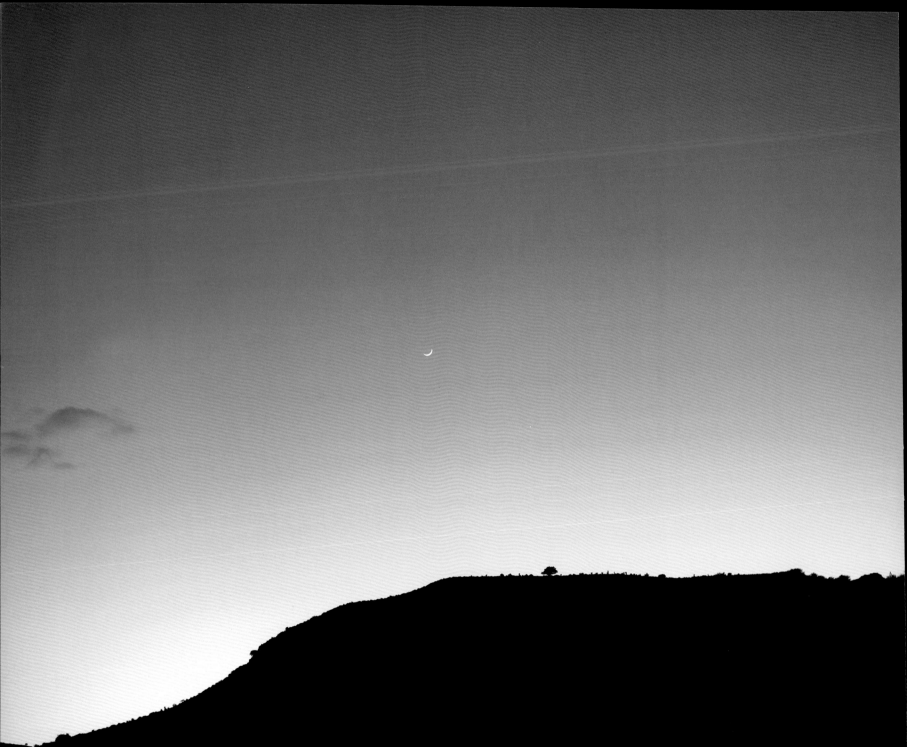

⭐ Sam Houston's son lived brightly in father's shadow ⭐

MOBEETIE—It was the face that drew me in: clean-shaven; strong chin; eyes and mouth suggesting mischief, if not malice; handsome features framed by short, curly hair, no sideburns. If not for the tie and high collar, I would have guessed I'd seen the young man in a yearbook fraternity photo or maybe having a drink in a bar on Sixth Street in Austin.

The photo, taken in the early 1880s, is that of Temple Lea Houston, son of Sam Houston, whose life in the shadow of his famous father was remarkable in and of itself. An attorney and Texas state senator, the younger Houston was known for a "tongue touched with fire" in the courtroom (to borrow biographer Glenn Shirley's phrase), for his brilliance and for a few eccentricities that he must have inherited from the Old Raven himself.

"He loved clothes," his wife, Laura, wrote. "He would dress up in a yellow-beaded vest, Spanish caballero-style trousers and sombrero with a great silver eagle on it, and go to Kansas City on railroad business. Of course,

he attracted a lot of attention. When people asked why I let him dress that way, I would say, 'That's why I married him—because he was different.'"

He was the first child born in the Texas governor's mansion, on August 12, 1860, although Texans rabid for secession forced his famous father out of office the year after Temple's birth. He was three when his father died, seven when his mother succumbed to a yellow fever epidemic. He lived with an older sister in Georgetown until he was twelve and then rode his horse to West Texas to become a cowboy. After making a trail drive to the Dakota Territory, he got back home by hiring on as a clerk on a Mississippi River steamboat.

He served as a page in the U.S. Senate for four years before enrolling at sixteen in a newly established Texas school, the Agricultural and Mechanical College at Bryan. He was an Aggie for a year before transferring to Baylor, where he majored in law and philosophy. Completing a four-year course of study in nine months,

New moon and silhouetted hillside, Davis Mountains State Park, 2013

he graduated at nineteen and applied to the Texas bar, even though the age requirement was twenty-one. An exception was made for the brilliant young man with the sterling Texas pedigree.

Houston established a criminal-law practice in Brazoria, was elected county attorney at twenty and met young Laura Cross at a dance. He was twenty-one, she seventeen, when they married.

Gov. Oran Roberts—the man who, as associate justice of the Texas Supreme Court, drew up the plan to force Sam Houston out of office—asked Temple Houston to help him tame lawless northwest Texas by serving as district attorney of the twenty-seven Panhandle counties. Even though the young attorney was advised that to venture into a Panhandle courtroom unarmed was to risk his life, he said yes (maybe for that reason). He rode the train from Galveston to Fort Worth and then to the end of the line at Henrietta, where he took a stagecoach the rest of the way. He passed the time by shooting through the open window at jackrabbits, prairie dogs and rattlesnakes. A trail strewn with whiskey bottles signaled the coach was nearing Mobeetie, county seat in those days.

"He was a volatile type of guy," his grandson, Sam Houston IV, told me earlier this week. Houston, eighty-four, mentioned his grandfather's famous defense of a friendless cowboy accused of stealing a horse and killing the animal's owner, an Oklahoma rancher. The rancher had the reputation of being a quick-triggered gunman. The cowboy's plea was self-defense, but witnesses testified he had shot and killed his victim without giving him an opportunity to draw.

Houston, tall and handsome at thirty-three, strolled over to the jury box and leaned over the pine railing. He asked the jurors to consider what they would have done in a similar situation. "This malefactor was so adept with a six-shooter," he told them, "that he could place a gun in the hands of an inexperienced man, then draw and fire his own weapon before his victim could pull the trigger. Like this!"

From under his frock coat, he whipped out a white-handled, nickel-plated Colt revolver and fired six times at the jurors. The judge ducked beneath the bench, the defendant dived under the table, spectators ran for the doors and windows and the jurors "scattered like winter's withered leaves." (Houston was firing blanks, but given his reputation, no one was taking any chances.)

Once the jurors reassembled, they found Houston's client guilty, but the young attorney filed a motion for a new trial on grounds that the jury had "separated during the hearing and mingled with the crowd." The judge reluctantly granted the request, and several months later a new jury acquitted the cowboy.

Houston was elected state senator in 1884 and served two terms. He was often mentioned as a candidate for governor, but, as his grandson noted, it rankled him when he was introduced as "Old Sam's youngest boy," even though he revered his famous father. "Every tub must stand on its own bottom," he said. "If my own record isn't good enough, then I'll seek other fields in which to carve my fortune."

In 1893 he moved his family and his practice to Woodward, Oklahoma, in the newly opened Cherokee Strip. He decided, it seems, that Texas would never be big enough for two larger-than-life Houstons.

A Woodward courtroom was the scene of Houston's

most memorable performance. Representing pro bono a prostitute named Minnie Stacey—he had only ten minutes to prepare—he reminded jurors that "one of our sex was the author of her ruin, more to blame than she."

A close student of the Bible, he recalled Jesus's encounters with fallen women. "The Master, while on earth, while He spake in wrath and rebuke to the kings and rulers, never reproached one of these," he said. "One he forgave, another he acquitted. . . . If the prosecutors of this woman whom you are trying had brought her before the Savior, they would have accepted his challenge and each one gathered a rock and stoned her in the twinkling of an eye. No, gentlemen, do as your Master did twice under the very circumstances that surround you. Tell her to go in peace."

The gentlemen of the jury did just that.

Temple Lea Houston died of a brain hemorrhage in 1905. He was only forty-five. His son, Sam III, became a polo coach at Oklahoma Military Academy in Claremore and in 1931 celebrated the birth of his own son by going on a drinking spree with his close friend Will Rogers. Sam IV, who is retired from U.S. Steel, lives in Katy. Both Houstons were successful in their chosen fields, although, as Sam IV acknowledges, the wildness of the Raven died with his flamboyant granddad, the lawyer with a gun.

September 19, 2015

★ A wrangling of words and rhyme at Cowboy Poetry Gathering ★

The city boy felt out of place,
Sitting in that cowboy space.
His jeans weren't Wranglers, not even Lee,
He spied the door and thought to flee.
But then, like Homer, the sightless Greek,
The poets started in to speak.
The tales they told in easy rhyme,
Took him back to a simpler time—

ALPINE—Oh, sorry, I got carried away after spending last Saturday at the twenty-ninth annual Texas Cowboy Poetry Gathering on the campus of Sul Ross State University. The gathering—not a festival but a gathering, poet and musician Don Cadden of Alpine told me—was my first, although I got the impression that many attendees and participants return year after year.

I read once that old-time cowboys, stuck out by themselves in a line shack through a long, lonely winter, a trusty steed their only company, would memorize labels on cans of peaches and tomatoes to stave off cabin fever, or worse. It was an act of desperation, I suppose, and yet that information occasionally turned out to be useful—in the spring, say, when the young cowpoke, hat in hand, would be courting a girl. The two of them would be sitting in her parlor, the conversation lags and the cowboy reverts to the tried and true: "There's water, corn syrup, sugar . . ."

There was no loss for words that weekend, with cowboys—and girls—either singing songs or reciting long strings of rhyming couplets to overflow audiences. The cowboy poets covered the range, with recitations about stove-up old wranglers and melancholy ramblers, good horses and balky cows, the country hardships of a cowboy's wife, the sun setting on a treasured way of life. (Can't stop that rhyming!)

Why cowboys and why poetry, I asked Apache Adams, a cowboy storyteller in his late seventies from Bronte, near San Angelo. He laughed. "'Cause there's not much else to do on horseback," he said.

Cadden, this year's president of the steering committee, gave me a similar, slightly more detailed answer. After the Civil War, he said, when Texas ranchers realized there was money to be made rounding up unbranded longhorns and heading them north to market, they needed cowboys to get the half-wild creatures from here to there.

A lot of their hands were young guys just off the boat, many from Ireland or Scotland, many of them illiterate albeit heirs to a rich oral tradition. Whether they were moseying along with the herd day after day or sprawled around a campfire at night, they passed the time by telling tales, reciting original verse and singing old songs.

"The trail drives are what we consider to be the beginning of cowboy poetry," Cadden said. "I think the basis of a lot of original cowboy poetry is, something would happen—maybe somebody'd get bucked off or somebody'd get killed, whatever—and in order to retell that story they'd put it in a rhyming form. That way, it's much easier to remember."

Listening to Cadden, I was thinking of a cowboy poet I had heard earlier in the day. Eighty-three-year-old Ray Fitzgerald, a retired Border Patrol agent from Van Horn, ambled up to the microphone, cocked his head and stared at the back wall as if he were out on the lonesome prairie, before launching into a long, lyrical recitation about the hardships of the cowboy life or about cowboy love (usually unrequited). I heard him recite four of his own poems and another written by someone else with nary a pause or stumble. His most ambitious poem, he told me later, is "fifty-some-odd verses long."

Tall and lean, with a sonorous, rocking chair–slow voice, Fitzgerald grew up on a ranch in Oregon, worked for the Border Patrol in Arizona and Texas and then hired on as a cowboy for the Kokernot family's vast 06 Ranch between Alpine and Fort Davis. He worked on the 06, spring and fall, for thirty years. He had never thought about poetry, either reading or writing it.

"I'm not an educated man," he told me, "but I've had a lot of education in the real world." A cowboy friend of his, Joel Nelson, helped organize the inaugural gathering in 1987 and urged him to enter the second year. He did and found out he had a knack.

Fitzgerald lives alone in Van Horn after losing his wife in a car accident a couple of years ago. "I finally had to quit cowboying last fall," he told me. "I got so crippled up I couldn't saddle a horse or get on one." He's still writing, though, still reciting. He has thirty or forty poems committed to memory, he said, with more coming whenever the muse pays a visit.

Doris Daley doesn't wait for inspiration; she writes every day. From a fifth-generation Alberta, Canada, ranching family, she's been one of the cowgirl stars on the circuit since the early 1990s. One of the poems she

recited in Alpine is called "Bones," written, she said, after sitting around the kitchen table listening to three cowboys moan about how dangerous and unhealthy it was to venture into the city. It starts like this:

Three cowboys sit on a split rail fence,
Long on bruises, short on sense.
Put 'em together and what do you get—
Besides three pairs of jeans and a pile of debt?

Daley enumerates their collection of missing fingers, bum knees, aching backs and bad hearts, all the result of the cowboy life, before concluding:

They'll never be famous, they'll never be wealthy
But they love the life—because it's so darn healthy!

Alpine is one of maybe two hundred cowboy poetry gatherings throughout the West, the biggest and most famous being the Elko Festival. The tiny town in the middle of nowhere Nevada attracts big-name perform-ers and some fifteen thousand attendees over a ten-day period in the middle of January. The Texas gathering, with about a thousand in attendance and fifty or so performers, sticks to its neighborly roots. That's why it's a gathering, Cadden said, not a festival. "There's no commercialism. We want it to be intimate."

"We try our best to stick with the guys who are mak-ing their living in the livestock business," said Nelson, an Alpine-area rancher who considers himself, not a cowboy poet, but rather a poet who happens to write about the cowboy life he knows and loves. "The ones who are not heavily invested in the lifestyle quickly reveal themselves in their words," he added.

The audience continues to grow, Nelson said, but unfortunately the stock of poets isn't. Young cowboys are still roping and riding, but they aren't writing and reciting. It's a topic that will prompt a poem, I'm guess-ing—something like:

I see by your notebook that you are a cowboy
a wrangler of words that tell a sad tale . . .
<div align="right">

March 7, 2015
</div>

★ Two nations together again at Boquillas ★

BOQUILLAS CROSSING—On a cold, gray afternoon in Big Bend National Park, the rugged peaks and buttes wreathed by graceful low-hanging clouds, thirty or so American tourists are slouched against walls or sitting cross-legged on the hard floor of a small building manned by the National Park Service. We've all spent a portion of our day in the dusty little village across the Rio Grande—kids among us have brought back antenna-wire scorpions as souvenirs—but now balky technology connecting the park building to U.S. Customs and Border Protection three hundred miles away in El Paso is preventing us from reentering the United States. We're supposed to scan our passports at a kiosk and talk by phone to an agent, but the park ranger informs us that the cold weather is messing with the machine. "Don't forget to tell everybody it's Homeland Security, not the National Park Service," she says, smiling.

Everyone's good-natured about the holdup, even though some of us have waited more than an hour and we're all worried about possible ice on the roads. It suddenly hits me as I sit on the floor: what's an hour compared to nearly a dozen years? That's how long the people of Boquillas had to wait for their fickle neighbors to the north to get over their fears.

The two hundred or so people who live in the old mining community are five hours and 160 miles—half that distance unpaved—from the nearest town of any size, Musquiz. They're five minutes from the national park across the river. In addition to hard cash from the American tourist trade, they always got their food, gasoline and mail from the other side and had friends and relatives just across the river. The hundred-yard span of water was less an international border than a minor inconvenience.

All that changed in the wake of 9/11, when, in May 2002, the United States closed all unofficial border crossings along the Rio Grande. Deprived of tourism dollars and prevented from buying groceries or visiting doctors across the river, families had little choice but to move away.

Boquillas (Spanish for "nozzles") became a ghost town. Winter and summer for the past several years, the wind has scoured the walls of abandoned adobe huts and whipped up dust along the village's unpaved main street. About the only other sound was the wail of coyotes echoing at night off the majestic cliffs of the Sierra del Carmen.

Lilia Falcon and her family were among those who had to leave. Her parents, José and Ofelia Falcon, ran the popular Falcon's Restaurant and Bar. Even though a pickup accident left her father using a wheelchair, "he loved to greet the customers, show them the curio shop and tell them about Boquillas and the area," she recalls. "He was a man with a big heart, respected and loved by many people on both sides of the Rio Grande."

For years, American tourists crossed the river in a

rowboat, then rode a donkey or hired a pickup to take them up the hill to town. Many of us topped off our little Boquillas adventure with a plate of Ofelia Falcon's bean tacos or burritos and a cold cerveza. Robert Earl Keen got it right after a Boquillas visit: "For a while we knew that life was good / and it was ours to take back home" (from "Gringo Honeymoon").

Lilia Falcon, forty-three, basically grew up in her parents' restaurant and expected to carry on the family tradition—her father died in 2000—but with no tourists coming across, she had to close. She has dual citizenship, so she and her husband, Bernardo Rogel, settled in Atlanta, where they ran their own construction company.

With their three daughters, they thrived in the United States, and yet they missed dusty little Boquillas. She hated the idea of the empty restaurant, her parents' pride and joy, caving in on itself as the years went by.

The Falcons got their chance to return in April 2013, when the border reopened after years of negotiation between officials from both countries. The reopening coincided with construction of a $3.2 million port of entry, the handsome building where we had to wait for the weather-sensitive kiosk. According to a plaque outside, the building symbolizes "a reunification of the regions and a return to a time when the crossing was seamless."

Except for the little computer snafu at the end, our crossing was indeed seamless, pretty much the way I remembered it years ago. After a park ranger explained the rules and reminded us that we needed a passport, we walked along a path shaded by mesquite trees and willows down to the shallow, swiftly flowing river. An oarsman plying his small metal boat against the current took us across for five dollars.

Victor Valdez, a retired boatman huddling with buddies around a charcoal fire, hopped up to greet us with a Mexican folk song and to explain our options for getting into town, less than a mile up the hill. We opted for the pickup, not the donkey; our driver, eighteen-year-old Arturo, also charged five dollars. A Mexican customs agent in a portable trailer took care of our documents quickly and courteously. Most days, he said, Boquillas gets about thirty border-crossers, but on this, the last day of the year, he had processed more than a hundred.

To be honest, there's not a whole lot to do in Boquillas other than stroll around and appreciate the dramatic mountain views, visit a couple of curio shops, drink at the Park Bar or eat at either Lilia Falcon's brightly painted restaurant—her mother still cooks—or at a brightly painted Falcon's restaurant across the street, run by a cousin. (I sensed a bit of family tension.)

The border crossing is closed on Mondays and Tuesdays, so Falcon and her husband drive to Musquiz on Sunday evening, buy supplies for the restaurant and curio shop on Monday and get ready on Tuesday to open for the week. "We never know when we'll get a lot of people, but we try to be ready," she said.

The Mexican government, particularly the governor of the state of Coahuila, has worked to revive Boquillas. Homes are being remodeled and freshly painted, a new kindergarten and a clinic have opened and the government has installed a solar farm for the community's energy needs.

"We're blessed to have a governor who's interested in Boquillas," Falcon told me as she sat behind the counter

and tended to a steady stream of restaurant and curio customers.

Back on the U.S. side, I noticed a plaque lined up with the majestic cliffs across the river. The inscription described efforts beginning in the 1930s to create an international park that would welcome visitors to preserved lands on both sides of the river. Nothing has ever come of the idea, a Big Bend spokesman told me this week, and yet peaceful little Boquillas, where people on both sides of the border again come and go with mutual respect and minimal difficulty, is something of an international park in action every day. Except Mondays and Tuesdays, that is.

January 10, 2015

★ The saga of Blas Payne, Big Bend cowboy ★

MARATHON—Let's say you're at Marathon's venerable hotel, the Gage, and you decide to explore the immediate area before heading down to Big Bend National Park. Crossing the railroad tracks that parallel Highway 90, you might head south out of town on what the locals call the Post Road, named for an old army post at road's end called Camp Peña Colorado.

After about four miles, just before you get to an inviting spring-fed pool that's now a Brewster County park, you'll see on the left a rugged hill, fairly steep. If you look closely about three-quarters of the way up, you'll notice a small chain-link enclosure. Inside that enclosure is a tombstone marking the last resting place of a man named Blas Payne, a true Big Bend character whose full life and rich family history are as intriguing as the Big Bend itself.

Payne, who died in 1990 at age eighty-eight, was a cowboy—"the best cowboy I ever saw," said the late Joe Graham, a ranch-life anthropologist at Texas A&M at Kingsville and a Big Bend native.

State Comptroller Susan Combs knew him from when she was a little girl growing up on her family's Brewster County ranch. Payne worked for the Combs family for seventy years. "He was super-good with horses, super-good with cattle. He prided himself on the weight his calves got," Combs told me not long ago. She and her husband named their middle son, Blaise Nicholas Duran, after the old wrangler.

The Paynes, several of whom still live in the Big Bend, are Black Seminoles. Their eighteenth-century ancestors were African American slaves who fled plantations in South Carolina and found refuge among the Seminoles, who had lived for centuries pretty much unprovoked in the Everglades of Spanish Florida.

When the United States acquired Florida and forced the Seminoles to resettle in Indian Territory (Oklahoma), the Black Seminoles, by then an integral part of the tribe, moved with them. In the 1840s a group of them, fearful of being kidnapped by slave traders, made their way across Texas and into northern Mexico.

The Mexican government gave them a land grant near Musquiz, a village a few miles southwest of Eagle Pass / Piedras Negras, in exchange for protecting settlers against Apache and Comanche raids.

When the Civil War ended, the U.S. Army made a similar offer, and a number of Black Seminoles crossed the Rio Grande. Although the army reneged on the land offer, two generations of Black Seminoles served with distinction as scouts for the buffalo soldiers of the Tenth Cavalry. They knew the land, they knew horses and they were expert trackers.

Although the Black Seminoles never received the land they'd been promised, the army allowed them to settle with their families on Fort Clark near Brackettville—until, that is, their unit was dissolved in 1914. Expelled from the fort, their homes razed, they scattered across West Texas, where a number of them caught on as cowboys. (Anybody who's seen movie director John Sayles's *Lone Star* has a passing acquaintance with the Black Seminoles in Texas.)

Among those who settled in the Big Bend was Blas Payne's father, John Payne, who arrived in 1914 after being involved in the Mexican Revolution for a couple of years. He worked for several Brewster County ranches before becoming foreman of the Combs Ranch, a job he held until he died in 1941.

Blas was born in 1901 and, like his father, was a cowboy his whole life. Ike Roberts, a retired third-generation foreman on the legendary Catto-Gage Ranch, told me about Blas's most famous exploit, when he was fifteen years old. The teenager was building dirt tanks for the Combs Cattle Company in the spring of 1916 when he got word that Mexican revolutionaries had crossed the river and attacked the villages of Boquillas and Glenn Springs.

In Glenn Springs the raiders burned several buildings and fought a three-hour battle with a small force of American soldiers stationed in the area. A second band robbed a general store, made off with the company payroll at a Boquillas silver mine and took two men hostage. Four Americans were killed in the skirmish.

As Roberts tells the story, young Payne was worried that the Mexicans were headed toward Marathon, some twenty-five miles away. On his own, he managed to round up a remuda of two hundred horses near the river, evade the Mexican rebels and ride all night with the horses through rough country to warn the settlers. "Those Seminoles were all good horsemen," Roberts said.

It seems that everybody who knew Payne has a story about him, usually told with a smile. "He was hilarious," Combs told me.

"He was just as witty as he could be," Roberts said. I asked Roberts for an example of Payne's humor, and he recalled a day when both of them were working with a heifer that was trying to calve. A vet, Charlie Edwards, was on hand to vaccinate the cow against blackleg disease.

"Blas told Charlie he tried the vaccine on himself, and he didn't think it worked," Roberts recalled. "Then he pulled up his britches leg to show him." (Maybe you had to have been there.)

Payne was of mixed racial descent—Indian, Hispanic, African American—but in the Big Bend he was black. Combs recalled going in a drugstore with him for lunch on occasion when she was young, but he would never sit

at the table with her, even though she urged him to. "He went through the era when he had to come through the back door," Roberts said. "But everybody respected him. He was as good a friend as anyone could want."

Lonn Taylor, a retired Smithsonian historian who lives in Fort Davis, told me about an African American writer from Washington, D.C., who was sure that Payne was buried on that mountain because the local cemetery wouldn't have him. In a two-hour conversation at the Gage Hotel with Roberts, she learned otherwise—and seemed pleased, Taylor said, that she had been misinformed.

"That's where Blas wanted to be," Roberts told me. "He talked to David Combs, Susan's dad, years ago, and Susan gave him permission. He wanted to be buried on the east side of that hill, so he could see the sun come up."

July 5, 2014

☆ Big Bend lifestyle can cast a spell ☆

MARATHON—Nancy Lee and I were sitting at the communal table at Nancy's Coffee Shop in Marathon on a recent weekday morning, and she was telling me about the previous owner, a woman who not only ran off all the help but also saw most of her customers tumbleweed out the door. "She wanted to sit up in Austin and run her business," Nancy was saying over coffee. "In a small town you can't do that."

Lee, who's seventy, grew up in Marathon, the dusty little ranching town on state Highway 90 that considers itself the gateway to the rugged Big Bend wilderness. Since she took over the coffee shop four years ago (for the second time), it's once again become the community gathering place.

"I wanted a place where cowboys are comfortable coming into," she said. "If we have a place where the local people are comfortable, we can at least keep the doors open."

You know the kind of place she's talking about, whether it's Hemingway's "Clean, Well-Lighted Place" or "Cheers" ("where everybody knows your name") or a Big Bend coffee shop where the cowboys drop by for their morning cup, along with scrambled eggs and bacon or breakfast enchiladas (all seasoned with the latest gossip). This isolated region welcomes newcomers, to be sure, but any big-city Texan planning to become a Big Bend Texan needs to appreciate the lives of those who show up at Nancy's, those who've been rooted in the rocky terrain for a while.

Early one morning at the coffee shop, I asked Big Bend native Lyn Shackelford about newcomers. The forty-seven-year-old owner of the Dead Horse Mountain Ranch grinned and got to telling me about the woman who a few years ago bought the place next door to his house in Marathon. "She moved here from Houston," he said, "fixed her house up, and then she started working on mine."

12

Or tried to. Every few weeks she would ask him when he was going to clear out the junk around his place. "She was nice about it," he said, "but now she's gone. And the junk's still there."

His friend Toby Caveness was also at the table. Like Shackelford, Caveness grew up in Marathon; now he owns Cowboy Grill in Alpine. "They move here because they like what we have out here," he observed, "but then they try to change it to what they had back there."

I like what they have out there too. I liked stopping in at Nancy's place every morning, liked talking and listening to the locals over breakfast.

I started out my Big Bend week in my "ace reporter" mode, camera in one jeans pocket, iPhone audio recorder in the other. From Sanderson to Marathon, down to Alpine and Marfa, over to Terlingua and Lajitas, I spent my days asking intrusive questions and madly scribbling in my reporter's notebook.

My Friday plan was to get back in the SUV and drive the fifty miles from Marathon to Marfa. I thought I would track down a few people I had missed earlier in the week. But when I woke up and walked outside—the morning air crisp and clean, the cloudless sky a porcelain blue—I didn't want to drive. All I wanted to do was amble across the road from the old adobe house where I was staying and sit on a low stone wall. That's what I did.

I sat there in the sun for a while, eating an orange. Glancing down at my dusty hiking boots and then up at the Del Norte Mountains in the distance, I wondered if a lifelong city/suburb guy could slow down and settle in Marathon or Marfa or Fort Davis. Could he make a life?

I thought about what Paige Phelps had told me earlier in the week. She's thirty-eight, describes herself as "a recovering reporter" and works behind the desk at Marfa's historic Hotel Paisano. She was drawn to the Big Bend three years ago, she told me, because of the light, the land and the landscape.

"Marfa," she said, "is where people come to put their lives back together again. Either they put them back together and leave, or they don't—and leave."

You could probably say the same for the Big Bend in general, and yet not everybody leaves. My friend Russ Tidwell came to stay. A state representative in the 1980s, Russ grew up in Del Rio but lived for decades in Austin, where he was the longtime political director for the Texas Trial Lawyers Association.

He fell under the spell of the Big Bend years ago and in 1993 started making the 400-mile drive to Marathon at least every other weekend. He bought the two-story home of the town's founder and turned it into a B&B and also restored five crumbling adobe houses, transforming them into guest cottages. These days he's finishing up a new house for himself and has reversed the routine; he now spends three weeks or so each month in Marathon and only a few days in Austin. The peace and tranquility he's found in the Big Bend is what I got a taste of sitting on that stone wall eating an orange.

Tiffany Harelik (rhymes with garlic) wakes up every morning in a rented house on the outskirts of Marathon to a view of the Glass Mountains, an ancient reef structure that formed two hundred million years ago. The thirty-three-year-old University of Texas at Austin grad describes herself as a country girl even though she's a fourth-generation Austinite. (She's also proud to tell you she was the 1997 Sweetwater Rattlesnake Roundup Queen.) She "made the leap" to Marathon on New Year's Eve.

13

"There's a lot of wonderful, beautiful things about Austin that I miss," she told me, "but I am so happy out here with the wide-open spaces. I wake up here, and I hear the owl, and deer will go by and javelina. Out here, you can think. In Austin, what you hear is traffic."

Not unlike a lot of young people who are drawn to an area where jobs can be scarce, she's cobbling together a Big Bend life. The author of four Texas food-trailer cookbooks, she's researching a Big Bend cookbook, managing Marathon's El Burro Bar and working on food-truck events back in Austin. "I don't have plans on leaving anytime soon," she said, "but I'm kind of a leaf on a stream."

Leaves leave, of course, and maybe Harelik will, too, one of these days, like Nancy Lee's predecessor at the coffee shop. She gave up trying to be an absentee owner and got into something closer to her Austin home. Now she's making more money selling bull semen than she ever did in the Big Bend café business.

April 27, 2014

★ An Italian renaissance in the Panhandle ★

UMBARGER—Let's say you're driving southwest on U.S. Highway 60 out of Canyon toward Hereford, the Panhandle plains around you flat and treeless, the road straight and true. There's a good chance that the scattering of houses, an abandoned grain elevator and a few commercial buildings known as Umbarger might not register, particularly if you blink. Founded by German and Swiss immigrant farmers from Nebraska a little more than a century ago, Umbarger is down to about a hundred hardy souls these days.

You also might miss Saint Mary's Catholic Church, an unremarkable tan-brick building with belfry just off the highway. And that's too bad, because inside those church doors is not only an astonishing sight but also an intriguing World War II–era story that Umbarger residents are proud to tell.

Hereford, twenty miles to the west, was home to an 800-acre prisoner-of-war camp that housed some three thousand Italian prisoners of war, most of whom were captured in North Africa. In the fall of 1945, with the end of the war in Europe and in the wake of unspeakable concentration camp atrocities, American attitudes hardened toward German and Italian POWs being held in camps around the United States. Aware of the shocking photos of bodies and skeletal concentration camp survivors, the army colonel in charge at Hereford took it upon himself to drastically reduce both privileges and rations. The POWs began to lose weight and to get sick. Some were reduced to eating grasshoppers and rattlesnakes, maybe even stray dogs and cats.

Conditions eased a bit after the bishop of Amarillo, Father Laurence J. FitzSimon, wrote a letter to his congressman detailing the harsh conditions. He reminded the congressman that the Italian POWs had not committed war crimes, were not criminal Fascists and deserved to be treated humanely.

For a select few, conditions eased dramatically when the Rev. John H. Krukkert, the newly appointed Saint Mary's pastor, discovered that gifted artisans and artists were among the prison population. Krukkert had just moved to the Panhandle from Southern California, where he owned a white stucco beach house with a landscaped yard, brilliant flowers and a tiled cliff's edge patio looking out over the Pacific. In Umbarger he peered out his parsonage window at—well, not the blue Pacific, to be sure.

Saint Mary's church, built in 1929 on the cusp of the Depression, was about as drab as the surrounding landscape, so this lover of art and architecture hit upon the idea of enlisting the nearby POWs to decorate the sanctuary. They refused initially, until Krukkert told them: "I can't pay you, but I can feed you."

Five days a week for the next six weeks, eleven POWs—nine artists and artisans and two helpers—climbed into the back of a truck and rode the twenty miles to Umbarger. Their "guard" and driver was an army sergeant from Pennsylvania named John Coyle.

In addition to becoming their friend, Coyle helped the POWs increase their protein intake. Bouncing across tall-grass pastures at night on the hood of a Model T driven by local farmer Meinrad Hollenstein, the sergeant would fire at jackrabbits with a twelve-gauge shotgun borrowed from Krukkert. With an estimated four hundred rabbits per square mile, it didn't take long before he had dozens of the long-eared creatures, considered pests by Panhandle farmers. Back home, Hollenstein would skin and gut the animals for the Italians. To get past the prison guards, they would tie the carcasses to their belt loops and let them hang down inside their loose-fitting pants.

"If Coyle had ever been caught, he would have lost all his stripes, but they never got caught," recalled Jerri Skarke Gerber, who was a teenager at the time. "Next time they were going to do that, Franco Di Bello, who spoke perfect English, he come up to Mr. Hollenstein and said, 'Would you please just leave the fur on? That sure is cold and sticky when you stick it down in your trousers.'"

Gerber, a lifelong church member who has spent all of her eighty-seven years in and around Umbarger, was a pretty and personable eighteen-year-old when the POWs came to Saint Mary's. A sight for sore Italian eyes, she helped her mother and the other church women prepare and serve meals. (She also confesses to kissing the dashing Di Bello, an Italian officer and gifted painter.)

Gerber remembers lunch—or dinner, as farm families call the midday meal—at long tables in the church basement. After working all morning, the men sat down to roast sausage, ham, fried chicken, homemade bread, sauerkraut, mashed potatoes. In the afternoon, they took a break from work for cakes, pies, cobblers and cookies. They climbed into the truck in the evening with their pockets stuffed with cookies for their buddies back at camp. Working hard and eating hearty, they began to regain the weight they had lost on their daily ration of one salted herring or a bowl of watery soup.

What they were doing in the sanctuary upstairs was little short of miraculous. They repainted the dingy, white walls a cheery pale yellow, with complementary mauve trim. Reflecting their Italian Renaissance roots,

they carved a magnificently detailed bas relief of Da Vinci's *The Last Supper*, which fronts the white marble altar.

They installed stained-glass windows, painted intricate, historically accurate ornamentation on the walls and large murals of the Annunciation and the Visitation; both murals feature pastoral Panhandle settings (including Gerber's childhood home).

Their pièce de résistance was the Assumption, a painting eight feet high and twelve feet across of Mary and accompanying infant angels. All in six weeks.

When the time came for repatriation, the Italians weren't quite finished. Although it had been years since they had seen their families and their native land, they begged to stay three more days. They weren't allowed to do so, but Di Bello and his prison pals—and later their children and grandchildren—came back to Umbarger in the 1980s and 1990s; Saint Mary's members repaid their visits in Italy.

On the second Sunday of November every year, the Fall German Sausage Festival brings several thousand Panhandle residents to Saint Mary's for sausage, sauerkraut, mashed potatoes and homemade bread. It's a meal the POWs enjoyed, and Father Daniel Dreher, Saint Mary's thirty-two-year-old pastor, sees a symbolic connection. During the war, he points out, the church fed and nourished people so they could do what needed to be done. He's proud of the fact that his tiny congregation is still cooking, still feeding, still nourishing.

March 23, 2014

☆ Amarillo "teenager" still tends to Route 66 ☆

AMARILLO—Bob "Crocodile" Lile and I were sitting on comfortable couches near the front door of his Amarillo art gallery on a slow Sunday afternoon recently. Lile, a Booker native and former Ford dealer who describes himself as Amarillo's only seventy-three-year-old Harley-riding teenager, was telling me that foreigners have a fonder appreciation for American history than Americans themselves do. That included old Route 66, the iconic roadway just outside the open doors of the gallery.

As if on cue, a young couple walked in off the sidewalk and the woman, glancing around at the paintings, the posters and the Route 66 souvenirs, exclaimed in the cheery, lilting accent of a Brit, "This is so cool!"

Her name was Terri O'Sullivan, from Warwickshire. She and her friend, Bradley Monton, a philosophy professor at the University of Colorado, were driving Route 66 from Illinois to California. Another American icon sparked her interest in America in general and Route 66 in particular, she said. His name was Forrest Gump.

"For me, this is the most exciting part of America," the thirty-four-year-old psychology graduate student told Lile. "It's what America was in the '30s, '40s and '50s."

The silver-haired gallery owner, a ruby-red stud gleaming in his left ear, glanced at me and grinned. He gestured toward Sixth Avenue, the Route 66 remnant that runs for a few blocks just west of downtown.

"Aussies, Chinese, Mexicans, it's what they want to see," he said. "A hundred thousand Europeans come through every year."

What they come to see are artifacts of a two-lane highway that for nearly six decades covered 2,448 miles from Chicago to Los Angeles, ending at the Pacific just a few blocks south of the Santa Monica Pier.

America's fabled "Mother Road" was more than just a highway. Much more. It was a path to salvation for desperate "Okies" fleeing the Dust Bowl in the 1930s. It was the road that lured the writer Jack Kerouac and other nomads westward. It was a '60s-era TV show, and, biggest of all, it was Bobby Troup's timeless song, recorded most famously by Nat King Cole but also by the Rolling Stones and others. ("Won't you get hip to this timely tip / When you make that California trip / Get your kicks on Route 66.")

It had its origins in the 1920s, when growing car ownership prompted federal highway officials to institute a numbered road system to replace the frustratingly disjointed trails that passed for roadways in those days. Route 66, sometimes called "Will Rogers Highway," got its name on April 30, 1926.

Its golden era was the twenty years or so after World War II, when Americans began buying cars again and hitting the road. That's when motels, gas stations and diners—not to mention tourist traps—began cropping up along Route 66 to accommodate their needs. (McDonald's, for example, originated on Route 66, in Monrovia, California.)

The highway's fate was sealed in 1956 when President Eisenhower enacted the Federal Aid Highway Act. He had seen the German autobahn during World War II and decided that the United States needed a nationwide system of safe, efficient four-lane highways. By the 1970s, Route 66 had been largely replaced by five different interstates. Interstate 40, serving Amarillo and most of the Southwest, replaced the longest portion; the entire route was decommissioned in 1985.

What's left, in addition to fond memories, are bits and pieces of the road: the U-Drop Inn in Shamrock, featured in the 2006 animated Disney film *Cars*; the Blue Swallow Motel in Tucumcari, New Mexico (and all the road signs touting Tucumcari motels); the El Vado Motel in Albuquerque, among many other places to stay and things to gawk at all along the way.

In addition to its Sixth Avenue portion, Amarillo is home to a stretch of Route 66 restaurants, tourist courts and motels along Amarillo Boulevard east of downtown. If you squint hard enough, they evoke summer vacations, families in station wagons headed west, kids cannonballing into motel pools at the end of the day. What you see with eyes wide open, though, is Route 66 flotsam—faded neon signs, empty pools outside tattered 1950s-era buildings, broken-down cars and broken-down people drifting into town on the Panhandle wind.

What's left of Route 66 on the other side of downtown—Croc Lile's side—is a lot cheerier. Single-story brick buildings that once housed mom-and-pop grocery stores, hardware stores and cafés are now antique shops, art galleries, bars and restaurants, most featuring Route 66 themes.

Across the street from Lile's gallery is the Golden Light Café, feeding locals and travelers since 1946. Known for its green-chili cheeseburgers and its Frito pie (here

called Flagstaff pie), it's the oldest eatery in Amarillo and may be the oldest continuously operating café along Route 66.

The Golden Light's fifth owner, Angela Corpening, is a thirty-two-year-old MBA graduate from West Texas A&M University whose grandfather introduced her to the place and who worked as a Golden Light waitress during college. Corpening bought the place in 2006, intending, as she told her banker, to change nothing.

Her regulars include a gaggle of old men who gather at the bar at two every afternoon for beer and burgers as well as a mix of tourists from all over.

"The Germans love Route 66," she said. "We get a lot of Germans."

"These foreigners from Europe, they understand," Lile said. "The Americans just haven't quite got it yet."

December 1, 2013

★ Flipper: From slave to success on the Texas frontier ★

FORT DAVIS—Usually the delicate scent of magnolia clung to the doctor's wife, even after months in dusty little Fort Davis, hundreds of miles west of her beloved Mississippi. But after two days and nights in the forbidding mountains of northern Mexico jouncing astride the bony back of a Mexican mule, the prevailing odor was not magnolia but sweat and leather and hot human beings.

The tortuous mountain trail and forbidding lunar landscape were an ordeal, and their destination wasn't all that appealing either. Somewhere in these mountains, the guerrilla bandito Pancho Villa waited for them; his men needed a doctor.

Near the end of the second day, the little party crested a steep rise and saw in the valley below a rock-and-log house. There were roses blooming, a well-tended garden. The doctor's wife feared a mirage.

They were greeted at the door by a *mozo*, who explained that his master was away but that he would want them made welcome. The doctor helped his wife from the saddle, and as they stepped into the front room her eyes opened wide. Around the walls were shelves filled with books, Indian pottery and artifacts. Mexican and Indian rugs covered the wide pine boards of the floor, and in front of the fireplace was a bearskin rug. A mahogany piano graced a corner of the room.

The doctor and his wife stayed the night, enjoying leisurely baths, dinner and a restful sleep. After a hearty breakfast the next morning, their host arrived. Pleased at the presence of guests, he approached with outstretched hand. The doctor's wife stood rooted to the floor. Her host was a black man.

That was Catherine Louise Cyalthea Dunn's introduction to Henry Ossian Flipper—whose hand she did at last shake. It also was my introduction a few years ago to this remarkable man, as discovered in a collection of oral histories about Pancho Villa.

Flipper "demonstrated the trials, tribulations and patriotism that was part of the African American struggle. He stood up for America when America didn't always stand up for him," former army captain Paul J. Matthews told me. Matthews, an African American mili-

tary historian and a Vietnam veteran, is the founder and chairman of Houston's superb Buffalo Soldiers National Museum. The museum has several Flipper artifacts in its collection.

Born of slave parents in Thomasville, Georgia, in 1856 and raised in Atlanta, Flipper became West Point's first black graduate—despite being shunned the whole four years he was in school. In 1878 he became the only African American among 2,100 officers in the U.S. military. He was dispatched to Fort Sill, Oklahoma, to serve with the "buffalo soldiers," black cavalry troops recruited after the Civil War and sent west to help subdue the Indians.

At Fort Sill, the young lieutenant designed a ditch to drain cesspools, breeding grounds for malaria. Flipper's white superiors ridiculed the design, claiming the ditch ran uphill. Flipper explained it was an optical illusion. The ditch worked, easing the malaria threat.

He was friendly with Capt. Nicholas Nolan, an Irishman, and Nolan's sister-in-law, Mollie Dwyer. Flipper and the young woman became riding companions in the nearby Wichita Mountains. Not surprisingly, their relationship enraged several white officers, and Flipper suffered the consequences.

In 1880 he was dispatched to Fort Davis, where he fought in the campaign against the Apache chieftain Victorio and was "acting commissary of subsistence." Shortly after he arrived, the fort's new commander, Col. William Rufus Shafter, tried to strip Flipper of his duties. Two other white officers were out to get him as well—one because of Mollie Dwyer, the other still nursing a grudge from West Point.

In July 1881 Flipper discovered that commissary funds were missing from his trunk. He knew he'd been set up but was afraid to report the missing funds. Instead, he decided to keep quiet and make up the deficit on his own. Although he repaid the money within two weeks, Shafter pressed forward with a court-martial. On December 8, 1881, the court found the young officer innocent of embezzlement but guilty of "conduct unbecoming an officer and a gentleman." The penalty was a dishonorable discharge.

Flipper, then twenty-six, moved to El Paso, where he embarked on a remarkable career spanning four decades. Finding in the borderlands a place where the conventional bigotries exerted only minimal influence on his abilities, he worked as a mining engineer and resolved several land disputes between Mexico and the United States.

He served as an interpreter and translated Spanish land laws as a U.S. Justice Department agent in northern Mexico, wrote several books and for a time was the editor of a white newspaper, the *Nogales Sunday Herald*.

From 1919 to 1923 he worked in Washington as assistant to the secretary of the interior and then returned to Atlanta, where he lived with his brother until his death in 1940 at age eighty-four. Under "occupation" on his death certificate, his brother wrote: "Retired Army Officer."

On December 13, 1976, the Army Board for the Correction of Military Records concluded that Lt. Henry Flipper's dishonorable discharge had been inappropriate. The board issued an honorable discharge—ninety-five years after the Fort Davis court-martial.

October 13, 2013

Full moon over the Chisos Mountains, Big Bend National Park, 2006

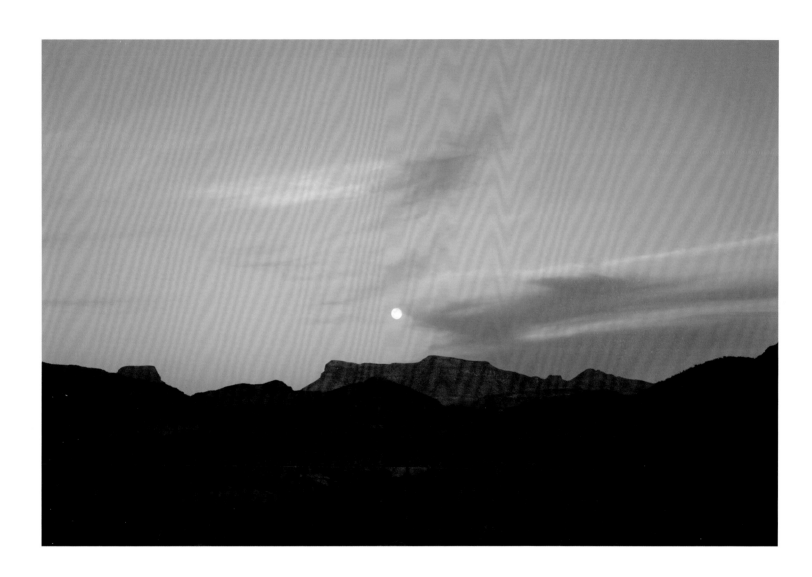

Horse in open country, north of Marathon, 2003

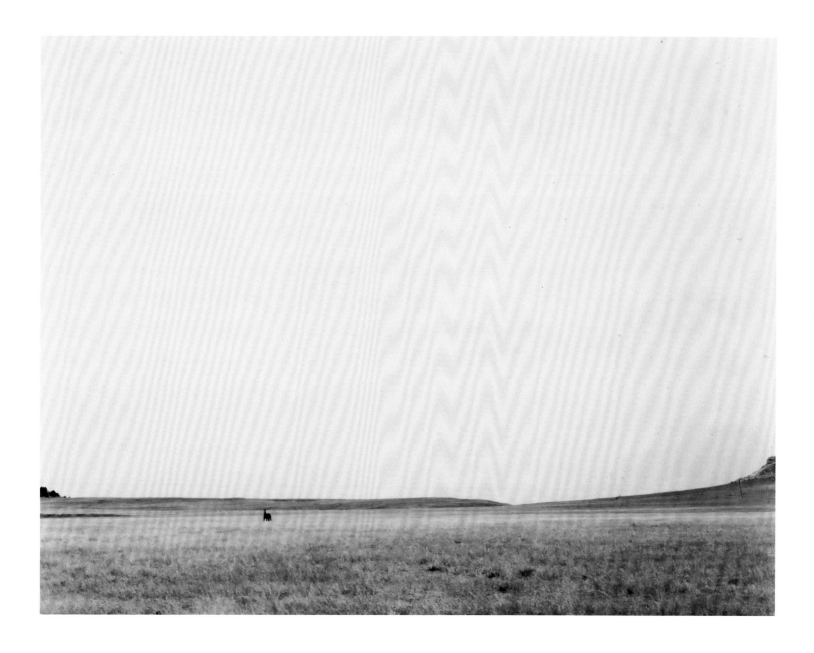

German tourists viewing the Rio Grande, Big Bend National Park, 2013

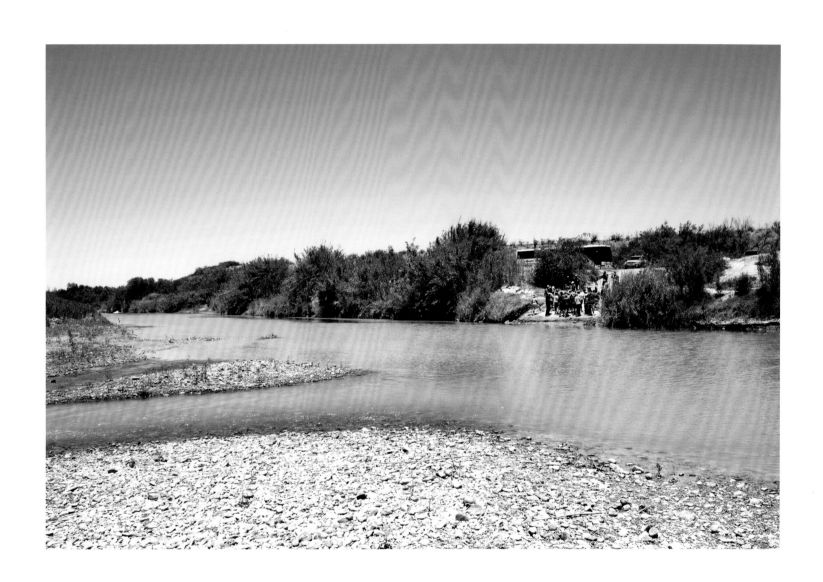

Ocotillo in bloom, Mule Ears Peaks, Big Bend National Park, 2006

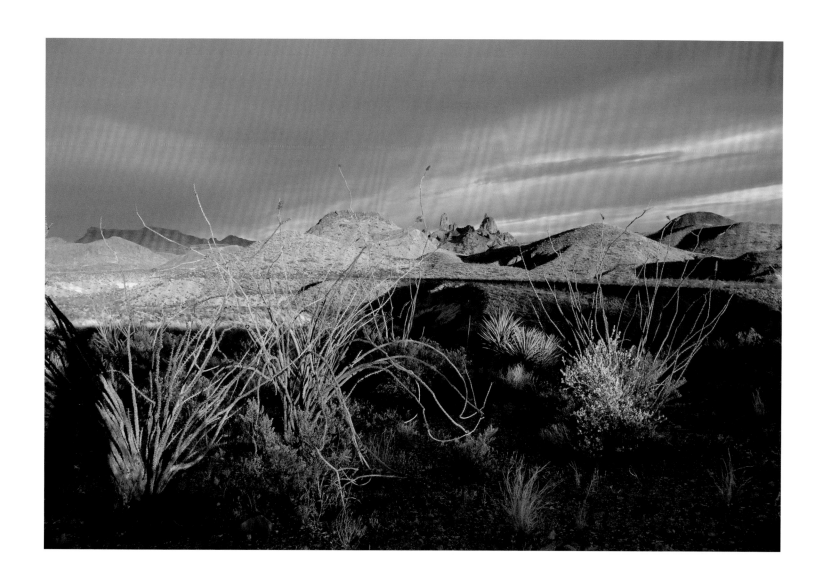

Fort Davis plain from the Davis Mountains, 2012

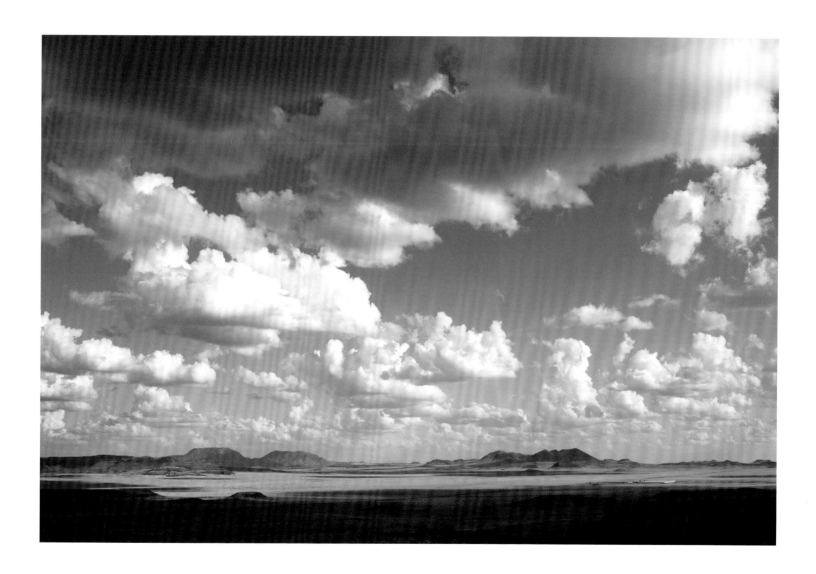

Wind turbines and cedar fence near Pecos, 2014

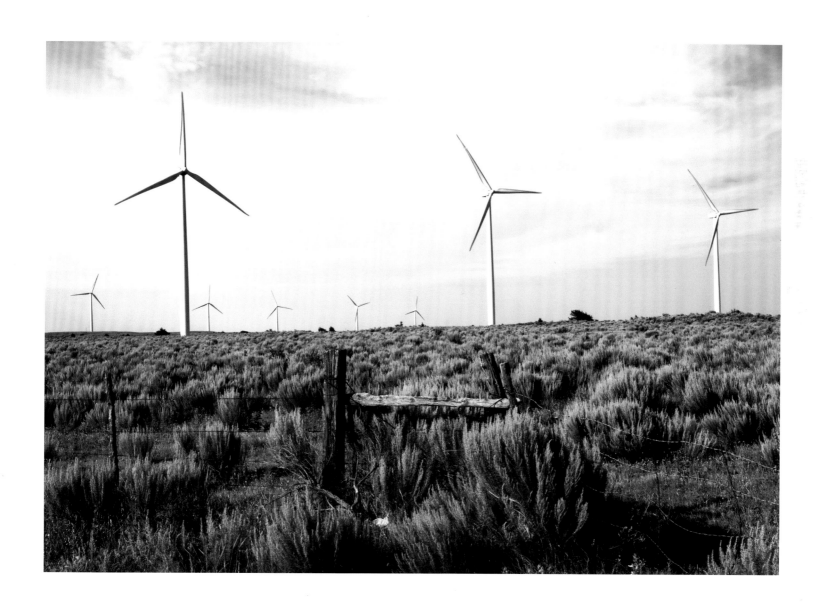

Union Pacific freight cars and clouds, Marathon, 2014

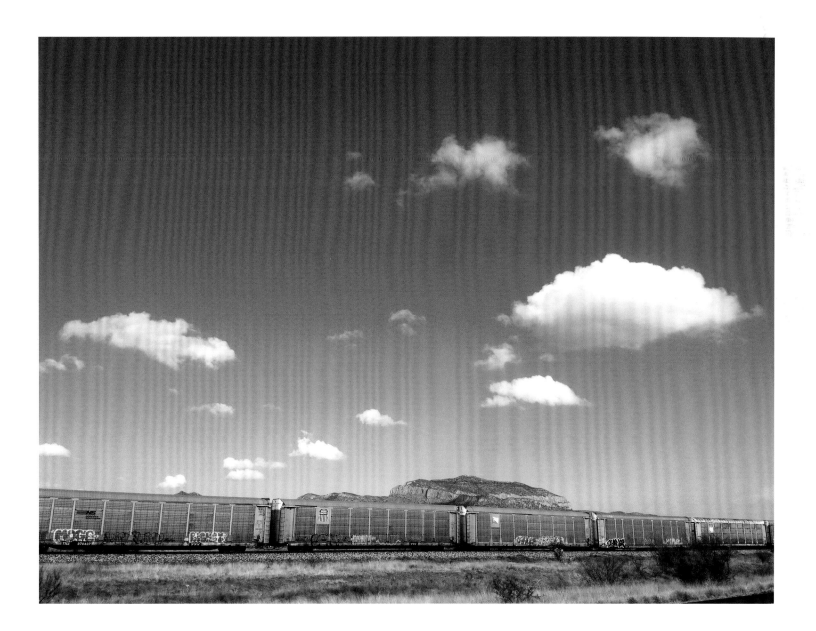

Presidio County Courthouse from the car, Marfa, 2014

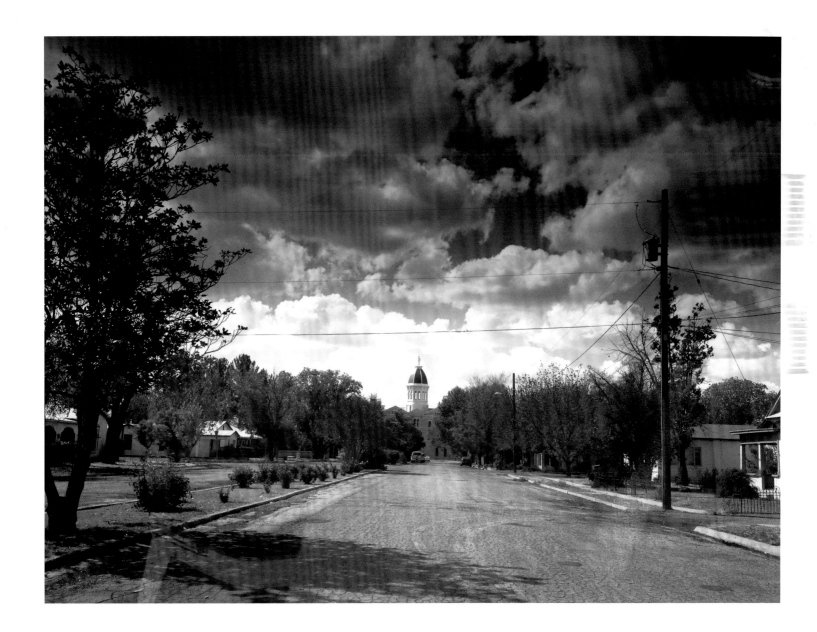

Cowboy and young women, Marfa, 2002

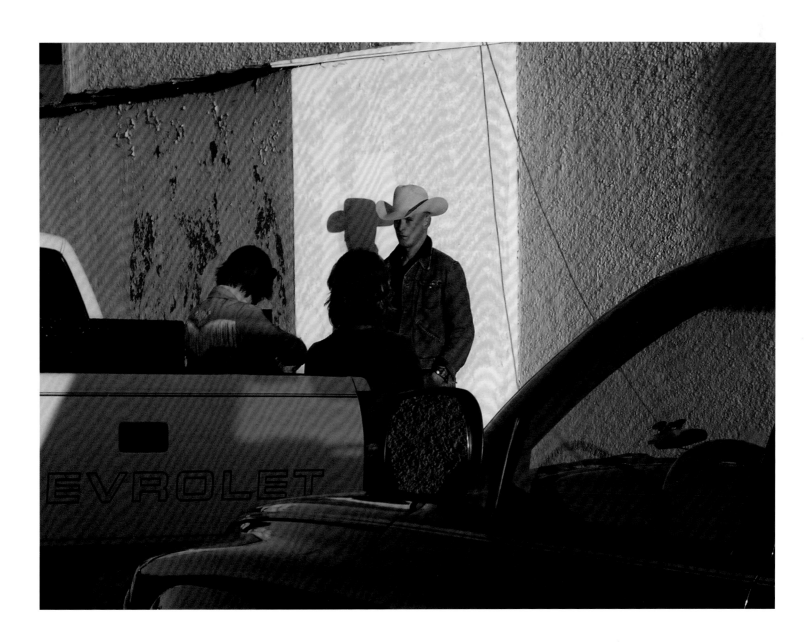

Kasey and Clay Engdahl dancing at their wedding, San Angelo Country Club, 2014

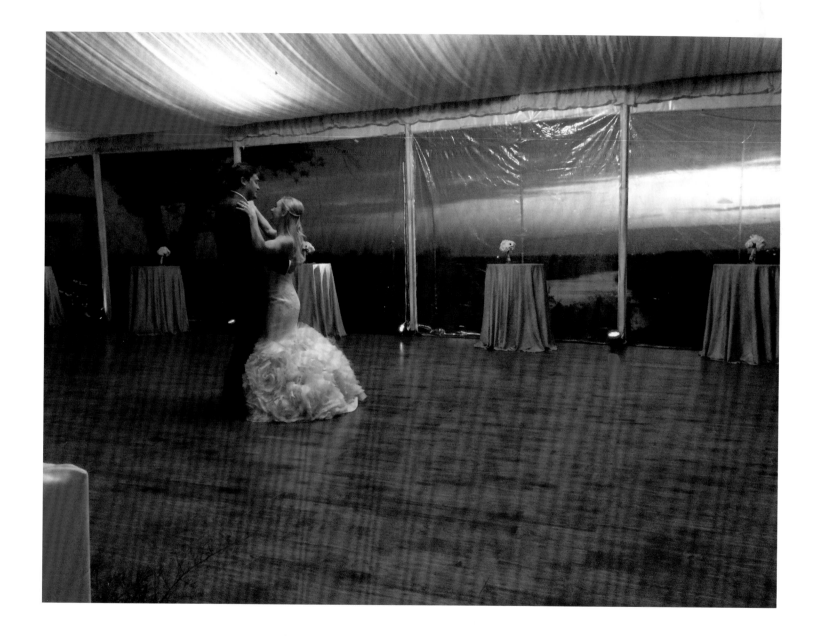

Mural, Badgers football, McCamey, 2014

Attendant, Rattlesnake Museum, Fort Davis, 2014

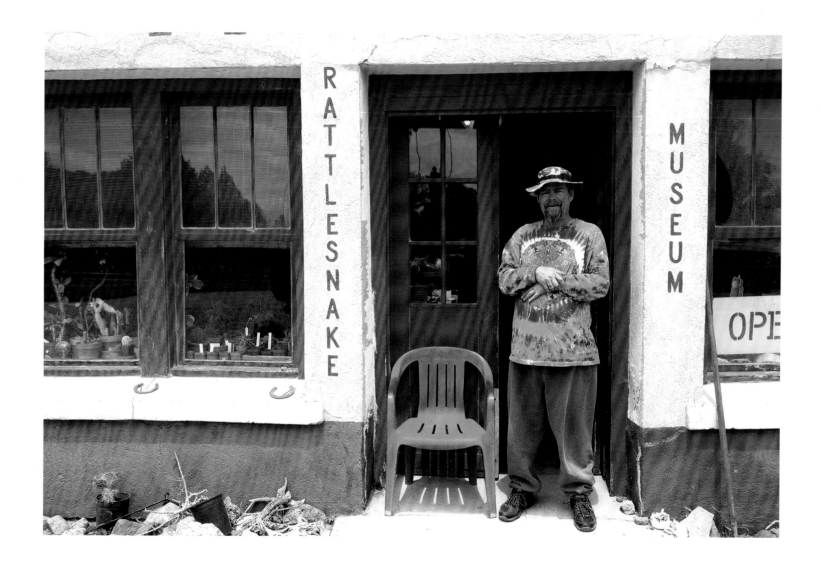

Boatman on the Rio Grande near Boquillas, Mexico, 2013

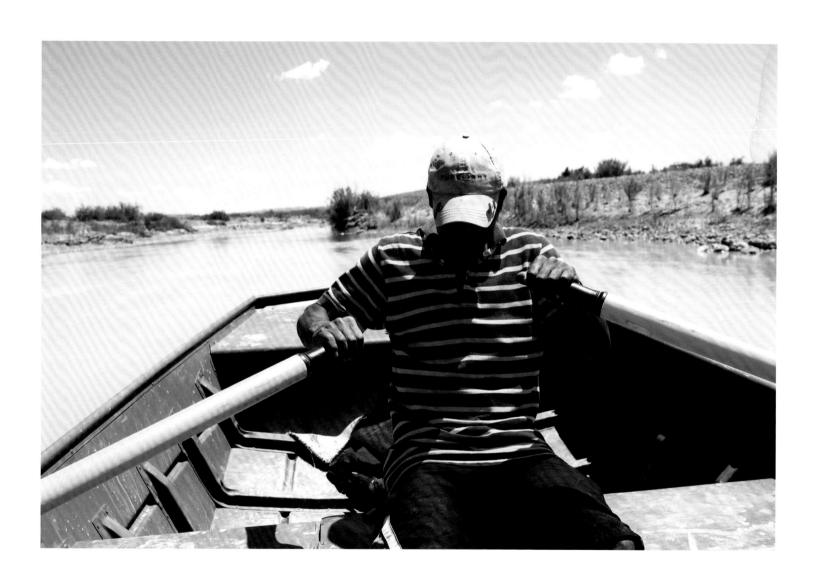

Sunset, the Window, Big Bend National Park, 2013

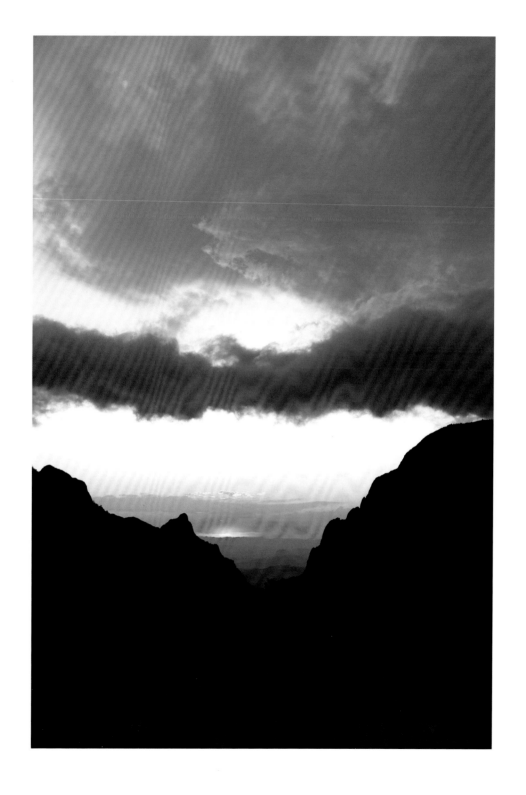

NORTH TEXAS

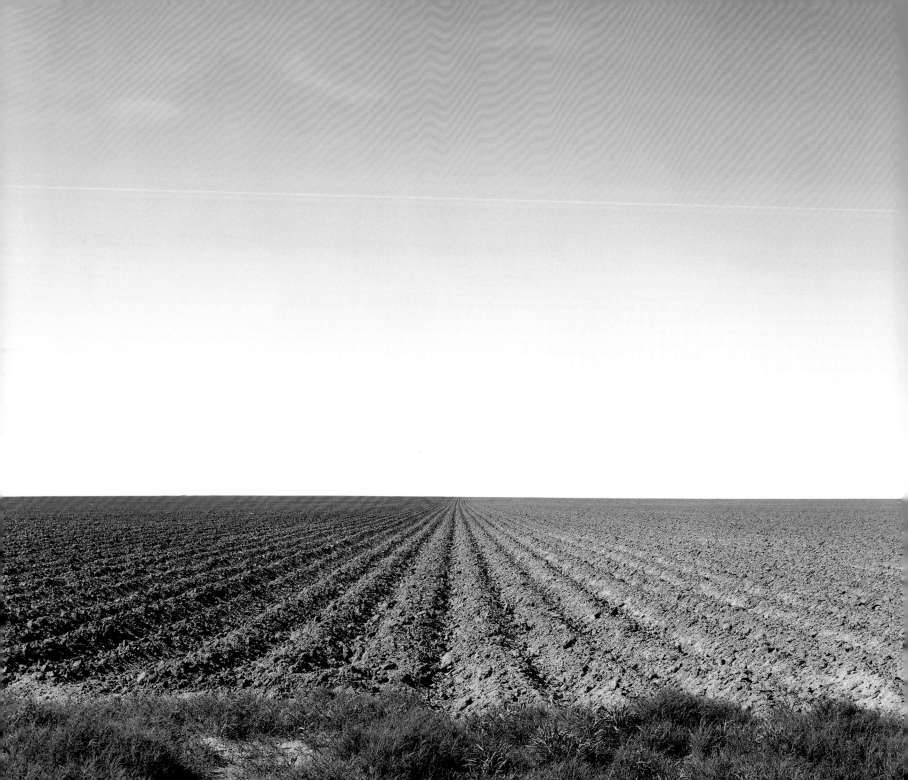

⭐ Waxahachie a perfect place for Chautauqua Assembly ⭐

WAXAHACHIE—With apologies to Rodgers and Hammerstein, I went to Waxahachie on a Friday / By Saturday I learned a thing or two. I heard Apollo 13 astronaut Fred Haise recount the gripping story of his days on the 1970 "Houston, we have a problem" mission. I saw an amazing hawk flying at its falconers' behest through Getzendaner Park. I saw drones in action and listened to a lecture about Leonardo Da Vinci (who anticipated the helicopter, if not drones). I saw Grupo Pakal, dancers in elaborate feathered costumes celebrating the Mayan culture and its veneration of eagles, butterflies and hummingbirds. I saw Waxahachie native and pioneering pilot Bessie Coleman come to life in the person of a young Atlanta actress named Joanna Maddox.

I had to visit Waxahachie for my adventure, a daylong program celebrating flight, because this pleasant North Texas town is the last in the state that participates in the Chautauqua Movement. Its venerable Chautauqua Auditorium, an airy, octagonal building constructed in 1902, hosts a one-day Chautauqua Assembly on the last Saturday in September. With a stage, slatted wooden pews, a sloping floor and ceiling fans (no air-conditioning), the all-wood auditorium seats 2,500 and is the only known original Chautauqua building surviving in the state.

Waxahachie is an appropriate place to venerate America's quintessential informal education venture. With a population of 35,000 and growing, it has its soulless suburban sprawl, but it's also home to arguably the most beautiful courthouse in Texas as well as a downtown of distinguished brick buildings coming back to life and block after block of beautiful, lovingly maintained Victorian homes. For native Waxahachian Steve Chapman, city attorney since 1968, the homes evoke a time when kids played outside till dark and neighbors sat on porches in the cool of the evening, visiting with folks who happened to be strolling by. "I grew up with that," the courtly attorney said. (Chapman, seventy-five,

Plowed field, Patricia, 2002

also collects and restores classic cars and antique electric fans.)

A couple of generations earlier, the Chautauqua Movement would have been part of that neighborliness. In Waxahachie and elsewhere it's an outgrowth of the Chautauqua Institution, a not-for-profit education center beside Chautauqua Lake in southwestern New York. Founded in 1874 as an experiment in out-of-school vacation learning, it continues to attract thousands of people to its classes, lectures and artistic offerings during a nine-week summer season.

"There is no place like it," historian and author David McCullough has said. "It is at once a summer encampment and a small town, a college campus, an arts colony, a music festival, a religious retreat and village square."

Since not everyone could travel to New York more than a century ago, the Chautauqua Movement began to spread across the country. "Daughter Chautauquas" sprang up, and by 1900 there were more than two hundred Chautauqua pavilions in thirty-one states. The first in Texas was in San Marcos, on the site of Texas State University's Old Main building, while others organized in Paris, Georgetown, Mineral Wells, Weatherford, Glen Rose and Dallas.

Waxahachie was considered the biggest and the best. For two weeks every summer, thousands from as far away as Oklahoma set up a tent city in Chautauqua Park (now Getzendaner Park). During the day, they took part in Bible study and other classes and in the evening listened to concerts, poetry readings, lectures and political speeches. Had we been there in the summer of 1900, we could have heard a lecture on Tuesday, July 31, about "the air we breathe" as well as a stereopticon presentation by Professor Stoakes of Trinity University. The professor was on the program on Wednesday evening also, but the *Waxahachie Enterprise* reported that "a severe thunderstorm, coupled with the inattentiveness of the projector operator and equipment problems, spelled disaster."

By the turn of the century, Waxahachie's Chautauqua organizers realized they needed a bigger gathering place. A local builder completed the 2,500-seat auditorium in time for the 1902 summer assembly, but it still wasn't big enough for crowds of 5,000 and more that showed up regularly. With the large, barnlike windows thrown open, spectators could stand outside peering in, while behind them a ring of buggies drawn up around the auditorium provided additional seating.

But then the crowds drifted away. By the early 1930s, interest in Chautauqua in Waxahachie and elsewhere had waned, perhaps because of the Depression, maybe because of radio and the movies. Waxahachie still used its auditorium for graduation ceremonies and other gatherings, but the old wooden structure, ridden with termites, was showing its age. In 1971 the city shuttered its doors and began making plans to tear it down.

As attorney Chapman recalls, the issue was whether to raze it or try to modernize it with air-conditioning and perhaps a brick veneer. "It was never a bitter, bitter fight," he said, "but just differences of opinion."

Chapman was one of the local preservationists who wanted to restore the seventy-five-year-old building, and in August 1971 the Waxahachie City Council voted to do just that. Restoration work began in 1974, the same year the auditorium was added to the National Register of Historic Places. The building was rededicated in a public ceremony the next year.

Since 1986, Kirk Hunter and Maureen Moore have lived in a small Queen Anne cottage four blocks from the auditorium. He's head of the department of chemical technology at Texas State Technical College in Waco, and she worked in Dallas until her recent retirement; Waxahachie puts them between the two cities.

Their evening walks sparked the couple's curiosity about the building, and their subsequent research helped reestablish Waxahachie's connection to Chautauqua. They attend the New York gathering nearly every summer and have been involved with the Waxahachie program almost every year since 2000.

"There's this desire or need to have something real, to have this communal learning experience, a desire for meaningful discussion," Hunter told me earlier this week. He and Moore would like to see an even more ambitious annual gathering.

I would too. As I listened to an astronaut and an actress and watched a fearsome, feather-bedecked Mayan dancer, I realized that the slats on the venerable wooden pews have a little give to them, so it's possible to sit for a spell and learn, just like in the old days. With ceiling fans stirring the air in the high ceilinged structure, even the Texas heat is bearable. The stately Ellis County courthouse a few blocks away enjoys a well-deserved acclaim, but the Chautauqua Auditorium, Waxahachie's hidden gem, deserves a bit of attention too.

October 10, 2015

★ "Brave Bessie" barnstormed as America's first black pilot ★

WAXAHACHIE—On a sunny afternoon in September, a little biplane buzzes back and forth in the bright blue sky above this Ellis County town south of Dallas. Straw-hatted farmers in mule-drawn wagons, women in country bonnets, boys on bicycles, dark-suited businessmen on the courthouse square, a bleacher full of paying customers—all crane their necks skyward as the hardworking Jenny loops, dives and circles like a bee. As the gawkers watch, a hand to the forehead to ward off the sun, they see flowers drifting like plumes of red smoke down to the ground.

The pilot is a Waxahachie native. A young woman. An African American. Those elements alone make her story remarkable, but the fact that it happened ninety years ago, on September 26, 1925, makes it almost unbelievable.

Much about Bessie Coleman's life approaches the unbelievable. Born into grinding poverty, hemmed in at every turn by racial apartheid—not to mention discrimination against women—she became the first black American to receive a pilot's license. She's the forerunner of the Tuskegee Airmen; Col. Guion Bluford Jr., the first black astronaut to go into space; Ron McNair, one of the seven heroes of the *Challenger* disaster; and Dr. Mae Jemison, the first African American female astronaut in space.

Jemison, who lives in Houston, didn't hear of Coleman until after she had become an astronaut.

"I really felt cheated," she said by phone, "because I grew up in Chicago [where Coleman resolved to become a pilot], and here's this incredible young woman with the willpower and audaciousness and daring—all those things we want our children to aspire to. Why didn't I hear about her?"

She was born Elizabeth Coleman on January 26, 1892, in the little East Texas town of Atlanta and grew up in Waxahachie. One of thirteen children, her mother was African American, her father a quarter African American and three-quarters Choctaw. When "Bessie," as she was called, was still a young girl, the father left the family and moved back to a reservation in the Oklahoma Territory.

The Colemans were sharecroppers, picking cotton on the blackland prairie of North Texas in the late-summer heat and struggling to get by whatever the season. Even before the father left, they struggled not only to put food on the table but also to avoid the KKK outrages that were common in the early years of the twentieth century.

When the youngster wasn't helping care for her siblings or hauling a heavy cotton sack down endless rows with other family members, she somehow found time to visit a local lending library and brought home books to read to the younger kids. She walked four miles to a one-room school on the days she could escape her chores. Finishing the eighth grade at the all-black Oak Lawn School, she worked for a year as a laundress, until she had saved enough money to enroll at the Oklahoma Colored Agricultural and Normal University (now Langston University). She ran out of money after a semester.

She still dreamed of a larger life, so she boarded the Katy at Waxahachie's MKT Railroad depot and headed to Chicago, where two of her older brothers lived. She got a job as a manicurist at the White Sox Barbershop on the South Side, where she heard black veterans of the Great War telling amazing tales about their overseas adventures and about flying. She would be a pilot, she decided, but she couldn't find a flying school that accepted blacks. It was a distant dream, to be sure.

This intelligent and beautiful young woman had gotten to know, perhaps at the barbershop, Robert S. Abbott, publisher of the *Chicago Weekly Defender* and one of the nation's first African American millionaires. Abbott advised her to go to France, where she would find the world's aviation leaders as well as people who weren't racist. With money she had saved and with financial assistance from a real estate promoter named Jesse Binga, she set sail for Paris on November 20, 1920. After studying for seven months at the Fédération Aéronautique Internationale, she became the first American—not just the first black American—to receive an international pilot's license.

In France, she learned stunt-flying and parachuting, so when she came back to this country she made her living as a barnstorming civilian aviator, in addition to working with a Chicago flying school. Her first American air show was at Curtiss Field, near Manhattan, on September 3, 1922. She then toured the country before moving to Houston in 1925. Her first Texas performance was in Houston on Juneteenth of that year. By then she was "Brave Bessie," flying Curtiss Jenny planes and army surplus aircraft left over from the war.

"Flight was something totally new, so patterns of segregation had not been established," said John Lienhard, a professor emeritus of engineering at the University of Houston who has written frequently about flight. More women and more African Americans would follow Coleman into the air. "It was an escape, and it's writ so clear in the case of Bessie Coleman," Lienhard said. "It was her back door out of a terrible life."

Determined to open that door wider for African Americans, she gave lectures to schools and churches and dreamed of establishing a flying school. On that September day in Waxahachie, you could buy a ticket for the show, which included a lecture and flying demonstration, but Coleman insisted that blacks and whites use the same entrance to the athletic field where it was held, on the campus of then Trinity University (now Southwestern Assemblies of God University). Once inside, though, they sat in segregated bleachers.

As she soared into the air that afternoon, she was probably focused on the primitive controls, but I wonder if she had time to glance down at the blackland fields where she had picked cotton until her fingers bled or at the stately, pink-hued courthouse where she had to be careful to drink from the "colored" water fountain. I wonder how she felt coming home. (On the ninetieth anniversary of the show, Waxahachie dedicated a plaque honoring Coleman at its regional airport.)

On April 30, 1926, Coleman climbed into a Curtiss Jenny biplane in Jacksonville, Florida, to rehearse for the next day's show. She had bought the used plane in Dallas, and her mechanic and publicity agent, twenty-four-year-old William Wells, had flown it to Jacksonville the day before. For the rehearsal, Wells was in the pilot's seat and Coleman in the open seat behind him. Since she was planning a parachute jump the next day, she unbuckled her seat belt and peered over the side to look for a good landing site. Suddenly the plane nosed into a steep dive and then a tailspin and Coleman tumbled out. She died instantly when she hit the ground. She was thirty-four.

More than six decades later, Jemison buckled herself into a seat aboard the space shuttle *Endeavour* and lifted off the ground to begin an eight-day mission. She carried with her on that history-making flight U.S. postal stamps honoring "Brave Bessie" Coleman.

October 3, 2015

★ Tall tale sprouts tiny skyscraper ★

WICHITA FALLS—Driving into this midsized city on the Wichita River, I was thinking about Norwood, the main character in Charles Portis's gloriously cockeyed novel of the same name. Early in the novel, the proud son of Ralph, Texas, takes a Trailways bus to New York City, hoping to collect on a seventy-dollar debt an old army buddy owes him. In the Big Apple, the young man encounters a midget circus performer who bills himself "the world's smallest perfect man."

Norwood is impressed with the miniature man's proportions. "If you were out somewhere without anything else around, like a desert," he muses, "and I was to start walking towards you I would walk right into you because I would think you were further off than what you were."

Taking the downtown Wichita Falls exit off the interstate, I had similar thoughts. Approaching the "world's littlest skyscraper," would I think it was farther off than it really was? Until I was a block or so away, would I feel like I was driving toward a tall building in downtown Dallas?

The answer to both questions is no. In fact, if you don't know precisely where you're headed, you'll likely miss the ridiculous little landmark on the edge of downtown, corner of Seventh Street and LaSalle.

The famed Robert Ripley of *Ripley's Believe It or Not* is supposed to have given the structure its nickname. Like many things Texan, it was a product of big dreams—or, more precisely, big schemes. The year was 1912, and oil was gushing out of the ground in nearby Burkburnett, which would soon be producing 68 percent of all the nation's oil and gas. Wichita Falls, the county seat, was the business center of the boom.

Thousands of people were pouring into Wichita County, and, as in the current shale oil boom, locals were waking up to find themselves instant millionaires. They were building fashionable new houses in town, trading buggies for Studebakers and Fords faster than dealers could supply them. In Wichita Falls, stocks worth thousands of dollars were being traded on downtown street corners. Oil companies and brokerage houses were frantically doing business in hastily erected tents. Lots were being flipped in a matter of minutes.

"There was an absolute frenzy of crude-oil trading, and people were just crazy with money," local architect Dick Bundy was telling me the other day. Bundy, a historic preservationist, is co-owner of the "skyscraper."

Along comes J. D. McMahon, a Philadelphia oil man and promoter. (Or maybe he was from Amarillo; historians can't pin him down.) Seeing his chance to take advantage of the urgent need for office space, McMahon drew up blueprints for a multistory structure and set about peddling $200,000 in stock, the equivalent of nearly $3 million today. Investors could envision in their fevered brains another Dallas rising from the plains. A new office building would doubtless be the first of many thrusting toward the blue Texas sky.

McMahon somehow failed to mention that he didn't have the Oklahoma property owner's permission to build or that the space available was only ten by sixteen by two-thirds feet. The investors didn't ask, or as Robert Palmer, chairman of the Wichita County Historical Commission, suggested, they lived back east and didn't know. All they cared about was McMahon's tout that the building would go up across the street from the thriving Saint James Hotel, that it was near the busy train depot and that oil companies were clamoring for office space.

One more thing McMahon forgot to mention (according to legend, that is): the scale of his blueprints was in inches rather than feet. The Newby-McMahon Building, as it was called, would soar not forty stories high but four. It would be twelve feet wide by twenty feet deep and stretch all of forty feet into the air.

By ribbon-cutting time in 1919, McMahon had skipped town and, according to Palmer, was never heard from again. Investors stormed into court but were told they had no case. They'd seen the blueprints, the judge reminded them; McMahon had built exactly what they had approved.

McMahon used his oilfield construction crew to erect the skyscraper. "It was very well built," Bundy said.

The neoclassical-style red-brick and cast-stone building may have been tiny, but six oil companies immediately rented desks on the lower floor. When the boom played out in the mid-1920s, the tenants left, and the building sat vacant until a 1931 fire rendered it useless except for a warehouse on the first floor. The city acquired it in 1980 and six years later turned it over to the Wichita County Heritage Society, which couldn't figure out what to do with it. Talk of demolition was in the air.

Meanwhile, the city hired Bundy's firm to stabilize the roofless, burned-out building. The modest little structure, its interior filled with several feet of pigeon droppings—feet, not inches—intrigued the architect, who arranged a partnership with a business owner across the street from the building. The partners purchased it for $7,500 and spent about $180,000 remodeling. These days the building looks great.

"It made no business sense to buy it," Bundy said, "but we'd love to see it self-sustaining."

He considered approaching the writer Larry McMurtry about expanding his used-bookstore operation in nearby Archer City into the building, but he heard that the Archer City native and occasional resident was trying to downsize. These days the building is home to an attractive consignment shop called Hello Again! "This is a destination location," shop owner Marcie Brow told me. "I'd say ten to twenty people a week come in just to see the building."

That continuing interest suggests that maybe there's an additional use. The historic structure could be a museum of graft, greed and boomtown mania, complete with photos and exhibits from Spindletop to the Permian Basin, from Hogtown/Desdemona to latter-day Houston. Plenty of Texans can relate—but only a handful at a time could visit.

September 28, 2014

★ You can buy, or be, a fixture at Canton market ★

CANTON—J.R. Martin was in the market last Sunday afternoon for antique naked-lady bottle openers, and Bob Locke—aka Doorknob Bob—had what he was looking for. Door-Knob Bob, sixty-seven, is a retired accountant who lives in Ardmore, Oklahoma. He's been selling at First Monday in Canton for twenty years, specializing in antique glass doorknobs.

"Everyone that's decorating has to have one," he told me. He also sells door fixtures and old license plates.

Martin bought five of the buxom little cast-iron ladies for a dollar apiece. I asked the Ennis retiree what he planned to do with his find.

"Sell the hell out of 'em!" he said before puttering toward other merchandise tables on his motorized scooter.

At the largest, grandest flea market in America, that's what several thousand vendors were doing, although the sales pitches were low-key. In the heart of the sprawling maze of booths, pavilions, sheds and a civic center, Locke and his fellow vendors were chatting with funnel cake–eating folks strolling by, patiently waiting for browsers to become buyers and answering any questions they might have. Unlike the typical clerk at a big-box store, these sellers know the merchandise and are happy to chat about it.

Last Sunday was sort of a slow day, Linda Boston, the city's First Monday operations supervisor, told me. Maybe 30,000 men, women and children wandered through the 500-acre site looking for bargains. The Thursday-through-Sunday total would likely be between 300,000 and 350,000. Canton, sixty miles east of Dallas, has a population of less than 4,000.

You can find pretty much anything you might want at First Monday, whether it's clothing, shoes, used tires, cowboy hats, painted signs ("Life's Too Short to Fish with Dead Crickets"), branding irons, '50s-era school lunch boxes, jewelry, cowhides, jams and jellies, yard art and on and on and on across what was East Texas pasture land not many years ago.

Dollar Debbie is the sign painter ("Hot Baths 50 Cents / Clean Water Extra"). Debbie Bassett-Bales, sixty-three, lives in a log cabin in the Ozarks outside Bakersfield, Missouri. The friendly, dark-haired woman in faded, paint-splattered overalls started painting brightly colored slogans, sayings and puns on pieces of wood to get her daughter through college. That was in 1988.

"I paint anything you want as long as it ain't dirty," she said.

I asked her about a sign that had tickled my brothers and me in a swimming pool dressing room on Lake Whitney long ago. It read, "We don't swim in your commode, so please don't pee in our pool."

Debbie laughed. She said she didn't consider that dirty.

Like Motel 6, her moniker no longer reflects what she actually charges. A replica of that old swimming-pool sign, painted on the spot, would cost me $5.

Like most of the vendors, Debbie plies the flea-market

circuit—Bowie, Winnie, Dallas, McKinney and elsewhere—but Canton, she says, is the best. "None bigger, none better," she told me. "It's the biggest, friendliest market in the United States."

I heard that from several of the vendors. When Danny Pilgrim of Brownsboro fell off a horse and broke his collarbone, he quit cowboying and started selling western hats with his wife, who adds the "sparkles, twinkle and glitter." They've sold hats to Canton visitors from Canada, Russia, all over.

"What's so wonderful about Canton is it's so large and it's world-known," Angela Pilgrim said. "People want to come to Canton first."

"Canton was an accident," Boston said. "In the 1850s, the circuit judge would arrive on first Monday, and people would come in to town and watch the trials and trade horses on the courthouse square."

Through the decades the Van Zandt County seat became known all over Northeast Texas as the place to buy, sell or swap horses, hunting dogs, donkeys, mules. That tradition is still alive in Dog Alley, down by the creek, although the dog market has gotten more commercialized in recent years. It's not as much fun as it was when hunters sat around swapping coon dogs and telling tales.

By the 1950s, First Monday had gotten so big, bothersome and unwieldy that the locals were ready to run the operation out of town. In 1965 the city bought acreage north of the handsome WPA-era courthouse and moved the market to where it is today, and where it continues to expand.

First Monday is actually five separate operations; the hundred-acre city operation is only one of the five. And it's still called First Monday, even though it's no longer on Monday. People have to go back to work on Monday, Boston pointed out.

"On our worst days it's controlled chaos," she said, laughing. "On our best days it's controlled chaos."

Cantonites still might grumble about the once-a-month traffic in their otherwise tranquil little town, but they don't grumble about the benefits. For eleven years, homeowners paid no property taxes, thanks to First Monday; these days, the extravaganza helps keep the tax rate low. First Monday brings in $3 million annually in rental revenue alone.

"It's a growing town; it's a thriving town," said Dorothy Hardin, who with her husband Gary owns the Canton Square Bed & Breakfast in a former mortuary. (Talk about a good night's sleep!) The Hardins moved to Canton twelve years ago from Houston. "First Monday keeps it going," she said. "Canton relies on it."

And will continue to rely on it, apparently. "A bad economy has been good for us," Boston said.

I left at four in the afternoon, a couple of hours before closing, and cars, trucks and SUVs were still taking the Canton exit off I-20. First Monday fans come for the bargains, but of course, they come for more than that.

A *Smithsonian* magazine writer once described flea markets as "museums of the not so long ago." At the sprawling makeshift museum that's First Monday, you'll likely find a piece of your past, whether you need it or not. Wander around long enough, and you're bound to see something that stirs up emotions and memories.

We don't have a backyard pool at our house, so I didn't have Dollar Debbie make me a sign last Sunday. But I was tempted. I could hear, from long ago, three little boys laughing.

May 11, 2014

★ On the day JFK was killed, the past, present and future collided ★

DALLAS—Hugh Aynesworth officially had the day off that Friday, and the thirty-two-year-old space and aviation reporter for the *Dallas Morning News* was miffed at his newsroom bosses. Just back from a reporting trip to Cuba, he found that every other reporter had some assignment related to the president's momentous visit to Dallas, but he had nothing. He felt left out.

He wandered into the newsroom anyway, had lunch in the *Morning News* cafeteria and then strolled three blocks over to Market and Main to watch the presidential procession. Under a blue sky, he stood with a couple of acquaintances across the street from the Texas School Book Depository, an unremarkable building he'd hardly ever noticed. Standing among the crowd about ten feet from the curb, he saw the limousine glide by, saw the president and First Lady. Then he heard the shots.

Ninety miles to the south, it was game day at Waco La Vega High School, just as it was in towns large and small across Texas. For the Pirates and their opponent, the University High Trojans from across the Brazos in South Waco, it was the final football game of the season. Neither team had been particularly successful, but a victory against its archrival almost made up for a season of futility.

Shortly after lunch the Pirates' quarterback, a seventeen-year-old senior, was sitting in study hall in jeans and his Columbia-blue game jersey, waiting for Coach James to call him to his office for a last-minute strategy session.

At about one, the loudspeaker crackled on. A somber radio voice announced, "In Dallas today . . ."

Everybody in the room sat stunned. When they changed classes shortly afterward, only the sound of girls sobbing broke the hallway silence.

As Aynesworth surged toward the front door of the school book depository, he realized he had no pen and nothing to write on except a couple of unpaid bills in his shirt pocket. He noticed a child in his father's arms; the little boy clutched a fat, jumbo pencil in his hand. The young reporter found two quarters and bought the pencil off the kid, then plunged through the panicked crowd into the building. Interviewing as many people as he could before police moved in, he happened to hear the radio on a police motorcycle report that an officer had been shot in Oak Cliff, across the Trinity from downtown. He had a feeling that the cop shooting was connected to the assassination, although he couldn't explain why.

After school the quarterback and his teammates waited at home to find out whether high school football games across Texas would go on that night. At about five, the University Interscholastic League gave the go-ahead. (Sticking to a playoff schedule trumped commemorating the death of a president.) About an hour later, with both teams warming up on the La Vega field, a norther blew through, and a warm evening turned cold and blustery. It somehow seemed appropriate. Many in the stands, which were only half full to begin with, went home.

For the quarterback, the game was a disaster. When he tried to throw into the cutting wind, his passes floated like Wiffle balls. Four times, they ended up in the arms of a University High defensive back. Running was no better; the Trojans kept the Pirates offense bottled up all night. Shortly before the half, the Trojans quarterback, a friend of his, lofted a desperation pass into the end zone—and completed it. That was it: Trojans 8, Pirates 0.

That afternoon, Aynesworth had hitched a ride to Oak Cliff with a radio reporter, eventually making his way to the lobby of the Texas Theater. The suspect, twenty-four-year-old Lee Harvey Oswald, was sitting in the gloom. *Cry of Battle*, starring Van Heflin, was showing on the screen.

From his vantage point in the lobby, Aynesworth watched as two men methodically moved from the front of the theater up the aisles. Oswald sat quietly. When the officers got to him and ordered him to his feet, he muttered, "Well, it's all over now." He made a gesture of surrender, then socked one officer in the face with his left fist. With his other hand, he pulled a .38-caliber Smith & Wesson from his belt. Aynesworth watched as several officers managed to subdue him.

Helmet in hand, the quarterback trudged into the messy, crowded locker room. Stepping over crinkled, stripped-off tape and sweaty jerseys, he hugged teammates, shook hands with townspeople, listened to parting words from Coach James. Standing at his locker and stripping off gear, he suddenly began crying.

The tears surprised him; he never cried. His dad walked up, draped an arm around his shoulders. "It's okay," he said quietly. "It's not your fault." Still, he couldn't stop the tears.

It took him a long time to understand that they were tears of loss—of a game, perhaps, but also the loss of a dream he had nurtured since childhood and, on that particular weekend, a loss of innocence. It was a loss he and the nation shared.

On Sunday, Aynesworth was home with his wife when he turned on the TV and learned that Oswald was still at the police lockup awaiting transfer to custody of the Dallas County sheriff. They threw on some clothes and raced to city hall.

By then a huge out-of-town and international press contingent had converged on Dallas, and the basement echoed with voices and jostling as reporters tried to glimpse Oswald being escorted to a waiting police cruiser.

"Then, in the midst of it all, came that pop sound again," Aynesworth recalls. "It was 11:21 a.m. Detective Thomas McMillon later testified that Ruby snarled, 'You rat son of a bitch!' at Oswald as he shot him. But all I heard was that pop! Just once this time, muffled and faint. Jack Ruby's Colt Cobra .38 sounded like a toy."

Years later, the old quarterback was working with the Dallas County Historical Commission as it tried to determine what to do with the schoolbook depository—remodel it, ignore it, perhaps raze it. He stood in the open window of the sixth floor, where Oswald stood. It was eerie. Staring down at the street and realizing how close it was, he thought to himself, "I could have shot him."

Aynesworth, now eighty-two and still in Dallas, could never have imagined on that momentous weekend that he would be writing about the Kennedy assassination for the next fifty years. For the *Morning News* and the *Dallas Times Herald*, UPI, *Newsweek*, the *Washington*

Times, Life magazine, ABC's 20/20 and in several of his seven books (most recently, *November 22, 1963: Witness to History*), he's explored the characters, complexities and conspiracy theories, cockeyed and otherwise. In Jim Lehrer's words, "It was Hugh's story from day one."

A few days ago the old quarterback and the old journalist, both of us now grizzled and age-worn, were sitting in Aynesworth's home office. After all these years

Aynesworth still believes Oswald was a troubled loser who acted alone. He also told me he's looking forward to November 23. "There's a chance that after November 22 I'll never mention JFK again, ever," he said.

Glancing around the office, with its clutter of notes, books, articles and assassination memorabilia, I'm guessing the chance is pretty slim, for him and for the rest of us.

November 17, 2013

★ In Paducah, the only thing growing is the cemetery ★

PADUCAH—Drive through this little northwest community, and what you see is a dying town. The 1930s-era Cottle County courthouse is hemmed in on all sides by abandoned brick buildings, several of them collapsed in on themselves. When residents look at the once-sturdy structures, they remember thriving cafés, drugstores, a couple of department stores, a variety store, hardware stores, a large hotel. Along red-brick residential streets a few blocks away, empty houses blasted by sand and West Texas wind slowly crumble.

This once-thriving agricultural town calls itself "the crossroads of America," because U.S. Highways 70 and 83, both of which run cross-country, intersect near the square. In recent decades, those roadways have been one-way: out of town. A population of more than 3,000 in the 1970s has shrunk to about 1,100.

"The only thing growing here is the cemetery," said Paducah native Lindy Jordan, president of the First National Bank. Jordan, enjoying a backyard beer with

his old friend and neighbor Tommy Brown one evening, smiled and shook his head. "It's sad," he said, "but there's nothing you can do."

Sad it is, and yet Jordan, fifty-five, would be the first to tell you that the little town on the plains, like so many other country towns across this state, doesn't die easily. He and his neighbors have made a choice to live in Paducah, even if it means spurning a better-paying job in Fort Worth or Wichita Falls or making the sixty-mile round trip to Childress to work in the state prison.

"Paducah is more than the sum of what you see here," basketball coach and school principal Jay Cantrell told me. "The people here are Paducah. It's not those buildings."

I got to thinking about Paducah a few weeks ago when I noticed in the *Houston Chronicle*'s Saturday rundown of high school football scores that the Paducah Dragons, a six-man team since 2004, had whomped Motley County, 107–68.

I knew that the six-man game is often a track meet, but a 100-plus game seemed unusual.

"That's the first time I've seen it," said head coach Johnny Willis, who came to Paducah in 2006.

Willis's orange-and-black-clad Dragons—sixteen in all, most of whom play both ways—are still a point of pride for the beleaguered little town, following in the tradition of back-to-back state championship basketball teams in the 1980s and Paducah's eleven-man football teams in its more populous past.

The six-man story is what I expected to tell, but I soon realized that the real story had to do with boll weevils and a bad economy, nagging drought and the perils of dry-land farming, a government program that took farmland out of production—those things that have cost Paducah its reason for being. The county boasted more than seventy farmers in the 1980s; now there are seven.

"Anywhere there's cotton, it's the same story," Jerry Pate Long told me as we drank iced tea at Paducah's local gathering place, Double Gs Restaurant. "Most people were operating on borrowed money, high interest, with everything getting more expensive than what they sold."

The son of cotton farmers, Long, sixty-eight, grew cotton himself until he went broke. After working for a number of years as an insurance agent, he became a dowser (also known as a water witch). Now he uses his witching skills to find water and oil for clients around the world. Standing in his front yard one morning, he showed me how he works, using a dowsing device consisting of what looked like a spring from an old-fashioned screen door, the spring connected to a plastic rod about three feet long.

I tried it, dowsing for a shiny gold coin Long tossed in the grass. I could feel a bit of movement in my hands as the rod bent downward, but, to be honest, it might have been that old Ouija-board effect of something moving because you want it to.

Paducah could use a dowser's divinations, but so far the hydraulic fracturing boom has not made its way to the area. The school district is the largest employer. Efforts to attract industry have been unsuccessful.

"People need to get out of a surviving mentality and into a thriving mentality," Paducah native Brett Hoffman told me one afternoon over iced tea—at Double Gs, of course.

Hoffman, fifty-three, is the local Disciples of Christ minister and a newspaper rodeo columnist. His wife, Christie, is the Methodist minister. "Our vision is not big enough," he added. "That's why Joel Osteen is one of my favorite preachers."

Chamber of Commerce president Ronnie Manley is trying. Manley, fifty-four, who with his wife, Pam, runs the Hunter's Lodge Motel, suggests trying to entice at least 1 percent of the graduating class to come home after college and start a business in one of the vacant buildings. Stay five years, and the building is theirs for free.

"We want to get these places back on the tax rolls," he said.

On a cool Friday evening, I made the sixty-mile drive from Paducah to Turkey, where the Dragons were taking on the Valley High Patriots in a vital district game. Having been in town a couple of days, I'd gotten to know the coaches and players, and my hope, of course, was that a Dragon victory would symbolize the grit and courage of a little town that's down and out for now but refuses to give up.

It was not to be. Penalties and a porous pass defense snuffed out the Dragon fire, 68–31.

I was standing on the sidelines with school Superintendent Troy Parton as the clock wound down, a silvery quarter moon gleaming above. An ex-football coach himself, the soft-spoken school man put the loss in perspective. "They're young," he told me. "They're gonna be good."

<div align="right">October 20, 2013</div>

★ John Graves found his voice in Texas ★

SOMERVELL COUNTY—Despite my peripatetic ways over the years—Dallas, New York, Austin, San Antonio, San Diego, D.C., and elsewhere—I've always admired, maybe even envied, people who found their one true place on this earth, who rooted themselves in a community and drew sustenance from their surroundings. I've envied writers in particular—Eudora Welty in Jackson, Mississippi, Faulkner in nearby Oxford, Wendell Berry on a Kentucky farm.

If there's one Texas writer who embodies that rootedness, it's John Graves, who died a few days before his ninety-third birthday on his 400-acre farm near Glen Rose. Author of the justly acclaimed *Goodbye to a River*, he found his voice once he found his place, in Texas.

It took a bit of wandering. Born in Fort Worth, he got his undergraduate degree at Rice University, went off to war in the South Pacific, where he lost an eye to a Japanese grenade, studied at Columbia and then decamped to Spain. If you had read Hemingway in the '40s and '50s and you had writerly aspirations, you knew that's what you had to do. You had to live life and live it fully before you could write about it with authenticity.

Graves got a few articles published, quaffed a lot of red wine with expatriates and hung out now and then at the bullfights. A couple of times, he encountered Papa himself, once in Pamplona, where he was wielding a bullfighter's cape for a bevy of hangers-on, and once at Harry's Bar in Venice. Graves said he thought about walking up and introducing himself but decided not to, since at that point he hadn't written anything of note.

When he came back to Texas in 1955—just for a while, he figured—something happened that he wasn't expecting: he found a voice for telling the stories he wanted to tell, a writer's voice that was natural, unforced and eminently readable.

I remember him telling me one time that he could have stayed in Spain or New York or Mexico and written perfectly respectable stories and books, but they wouldn't have been distinctive. To be the writer he longed to be, he had to reestablish himself in the place that he knew better than any other place in the world. He had to learn to trust the voice that spoke most naturally. He had to be in Texas.

Everything—place, voice, the Texas past and his naturally ruminative nature—came together in 1957 when he set out to write an account of his three-week canoe trip down the Brazos, accompanied by his dachshund pup Waddy. The result was *Goodbye to a River*, a Texas classic

that has never been out of print since it was published in 1960.

I like what Steve Davis of Texas State University says about the book: "His prose is understated and elegant, yet shimmers with lyrical beauty. Its quiet rhythms mirror the river's natural currents."

Read his masterpiece, and you'll quickly realize that Graves was a stylist of the first order, and yet the first time I saw the stocky, middle-aged man in horned-rim glasses and khaki work clothes, I mistook him for a farmer selling fresh peaches door-to-door. Actually, he was dropping by the office of Encino Press in Austin, where I worked, to read the proofs of *The Last Running*, his deeply moving tale of a band of elderly Comanches importuning a Texas rancher for one last buffalo to kill.

By then, he and his wife, Jane, and their two daughters, Helen and Sally, were living at Hard Scrabble, the farm near Glen Rose, where he wrote for three or four hours every day, rebuilt the old house, kept bees, cleared brush and raised cattle and goats. Jane, who worked as a designer for Neiman-Marcus, lived with the girls in Fort Worth during the week.

The area around Glen Rose isn't as well known as the Hill Country, but there's quite a bit of resemblance—the dark-green cedar-choked hills, chalk-white limestone ledges, the flowing creeks and big sky. As the old-timers often reminded Graves in the beginning, it was a hard land for making a living and yet, after a while, it was hard to imagine Graves, both the writer and the countryman, living anywhere else. The rugged beauty of the place and the hard physical work combined with the peace and quiet to nurture the writing he worked so hard to perfect.

"If I hadn't wasted so much time building and chasing cows," he told *Texas Monthly*'s Gary Cartwright in 2010, "I could have written a whole lot more. But what the hell, that's how it was."

"He didn't publish a whole lot of books," Austin writer Steve Harrigan said, "but the ones he published were perfect."

I went to see him once on a cold winter day many years ago. There were patches of snow on the ground, but when I got to the house above White Bluff Creek I found Graves outside working. I helped out a bit—seems like we were trying to jump-start an old pickup—and then we went inside for lunch, bacon-and-fried-egg sandwiches and coffee. I was interviewing him for a magazine article, and, friendly as he was, he wasn't an easy interview. He just didn't like talking about himself.

Leaving the farm later that afternoon, I was thinking about how this one-eyed writer saw things that most of us tended to miss; I resolved to do better myself with my own two eyes. As I drove along the narrow gravel road back to the highway, I glanced up at a tall, winter-bare tree. What I saw on its branches were peacocks, dozens of them, their iridescent blue and green feathers shimmering in the sun. I toasted John Graves and laughed out loud at the beauty and strangeness of what I was seeing.

August 4, 2013

★ Long-ago UFO-ria in a North Texas town ★

AURORA—The year is 1897, an April morning shortly before sunup, and you are sitting half-awake on the back steps of your farmhouse outside Aurora, Texas. Suddenly, a flash of light streaks across the purple predawn sky; seconds later, a terrific explosion jolts you awake and jiggles your coffee.

Realizing that the explosion has come from Judge J. S. Proctor's house across a nearby pasture, you set down your cup and hurry over to find his windmill crumpled and fire-blackened. There at the foot of the collapsed tower and busted water tank, near the Proctors' flattened flower garden, you see . . . you see . . .

What you see, the *Dallas Morning News* and UPI reported a few days later, is some sort of airship; a neighbor tells you he watched it moving slowly over the Aurora town square shortly before it crashed. Peering closely at the smoking metallic debris, you make out some sort of writing that resembles hieroglyphics.

But that's not all, not by a long shot: there among the charred and broken pieces of windmill blade and flying machine is the diminutive body of a pilot.

"The pilot of the ship is supposed to have been the only one aboard and, while his remains were badly disfigured, enough of the original has been picked up to show that he was not an inhabitant of this world," the *Morning News* reported.

Examining the body, you and your fellow Aurorans conclude the pilot is a Martian. Later in the day, you give it a Christian funeral service, inter the body in the town cemetery and heave the mysterious metal pieces down a well. You'd just as soon avoid the notoriety that would surely descend upon Aurora in the wake of such an incredible occurrence.

That was 116 years ago, but for this metroplex bedroom community—just this side of Paradise in Wise County—the story has never died. Commemorated by a state historical marker at the cemetery, it has drawn UFO enthusiasts and UFO skeptics, visitors wielding metal detectors, a couple of movie-makers, as well as History Channel documentarians. Unfortunately, someone has stolen the alien's headstone, so locals are no longer sure exactly where he was buried.

Toni Kelly, Aurora's city administrator for the past eleven years, gets regular inquiries about the incident, including a couple of retired U.S. marshals from New Mexico who investigate mysteries for a hobby. They dropped by recently to test their theory that the airship was a zeppelin piloted by invading Germans blown off course.

"I think it would be completely naive to rule out that there's other life-forms," Kelly told me as we sat in the city council meeting room of Aurora's tiny city hall. In a chair beside her was a blow-up doll version of "Ned," her pet name for the alien pilot.

Kelly, thirty-nine, would like to see her hometown exploit its notoriety. If she had her way, Aurora would

be Roswell—Texas style—with a lively annual festival featuring little Ned. It could happen, but she first would have to overcome objections from Aurora old-timers who remember when ufologists sued the Aurora Cemetery Association in 1973 for the right to exhume the alien remains. The association prevailed, but the other-worlders were a bother.

Kelly suggested I visit Jim West, an Aurora resident and retired American Airlines pilot who has written three novels inspired by the incident. West, sixty-seven, stables horses and runs a few cattle when he isn't writing "DNAlien" and its science-fiction sequels. He doesn't dismiss the incident as simply a hoax concocted by an inventive Auroran.

"In 1897, the Wright Brothers hadn't flown," he noted, "and there were people all over North Texas and Oklahoma that said they saw this thing flying back and forth. The only thing you could have that would do that would be a blimp or something. Something was there, so if I had to believe a story, I'd believe that one (Aurora)."

Earlier in the day, I had gone looking for West. I knew his Check Six Ranch was just behind Tater Junction Cafe, but he didn't seem to be at home. When I inquired about him at a nearby gas station, a white-haired man in jeans and work shirt followed me out and proceeded to tell me his own UFO experience, circa 1980.

A Fort Worth police officer at the time, he was on his way home late at night when he saw flashing red and green lights just off Texas 114 near Aurora. Pulling off the road, he was able to make out an object maybe twenty feet tall, shaped like a child's toy top (the large kind with a plunger that sets it spinning). With lights circling and flashing, the object was hovering over a stock tank and a stream of water, like a water spout, was rising upward into an opening at the bottom.

He watched for about ten minutes, until the water settled back into the tank and the craft accelerated upward. To this day, he said, he doesn't know what he saw—and he doesn't share his story all that often, either. (He didn't want his name used.)

At Tater Junction I found out why I hadn't been able to get hold of West. "Phones are out all over town," the waitress grumbled, running my credit card manually. "Who knows why?"

I didn't say anything, but I knew why—and you do too. Visiting our own little Roswell, it's best not to ask many questions. You never know who might be listening.

May 5, 2013

Three horses, birds on a wire, east of Silverton, 2004

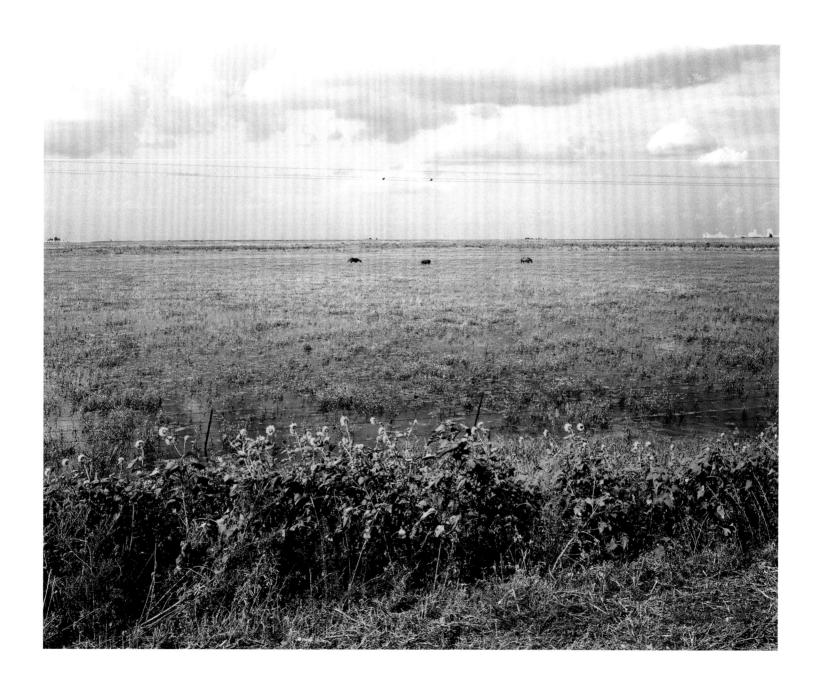

Ruin, windmill and Angus cattle near Higgins, 2010

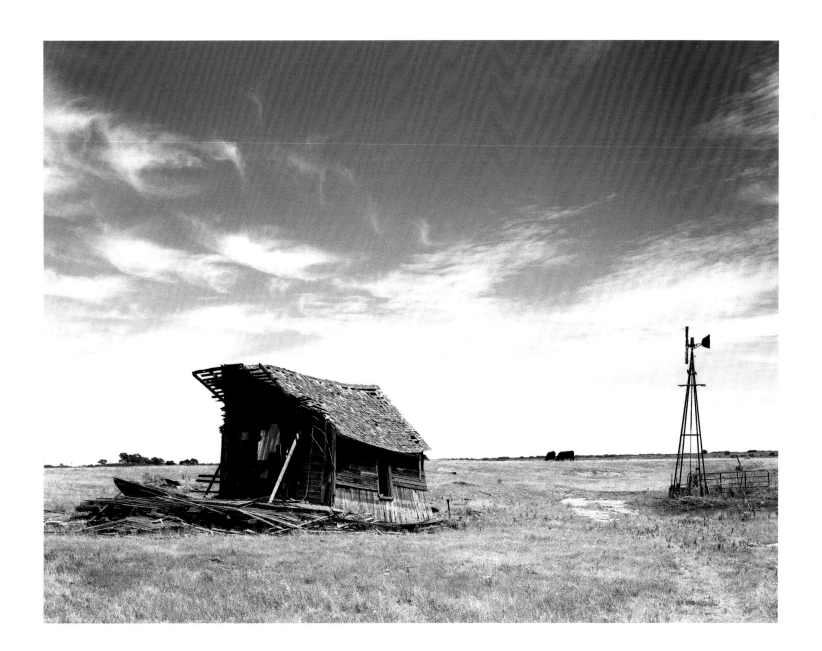

Farmer near Allison, 2010

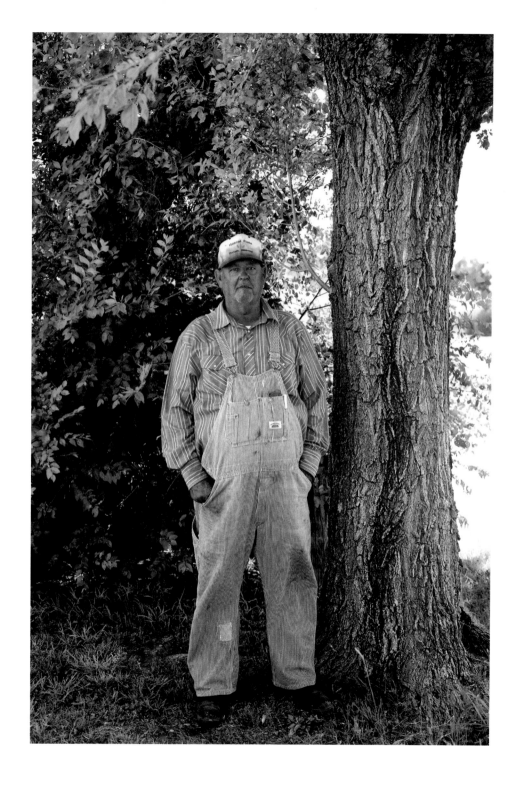

Small roadside jail and horses, Dozier, 2010

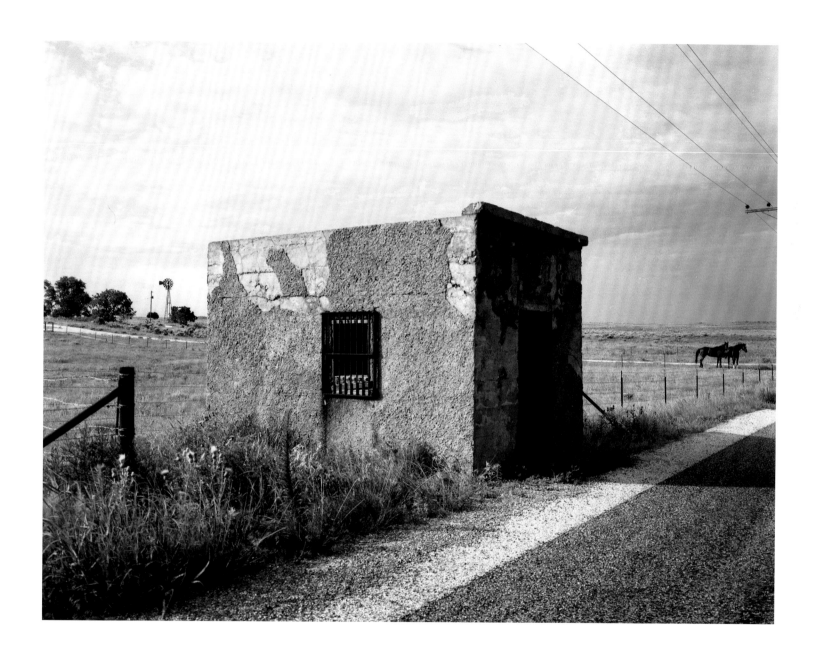

Rest Haven Cemetery, Lipscomb County, 2010

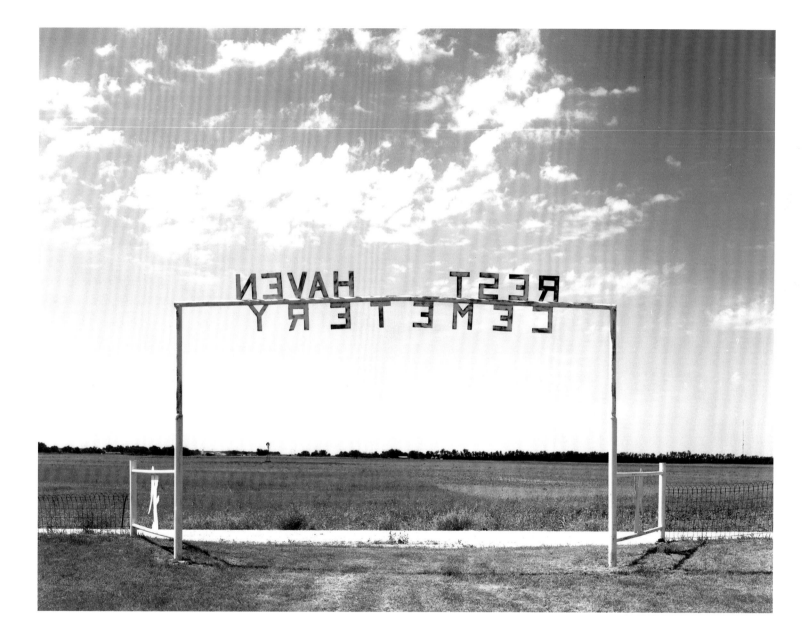

Grain elevator and abandoned railroad tracks, Cottle County, 2003

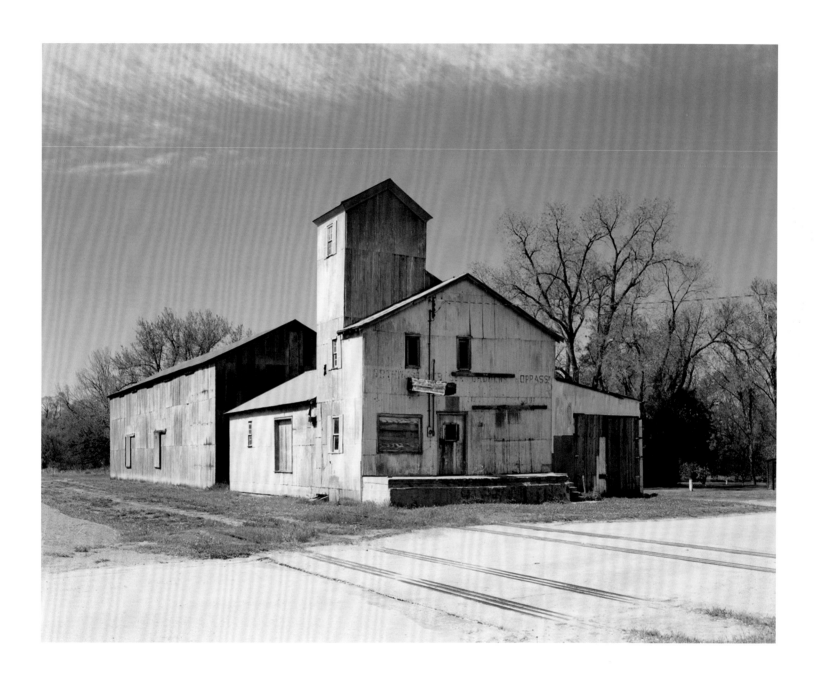

Roadside memorial and signs, Allison, 2010

"Irish State Winners" sign, Shamrock, 2010

Congratulatory signs, state baseball champions, Windthorst, 2010

Three dogs, Follett, 2012

Grain elevators, Pastor Lopez, Michoacana restaurant, Perryton, 2010

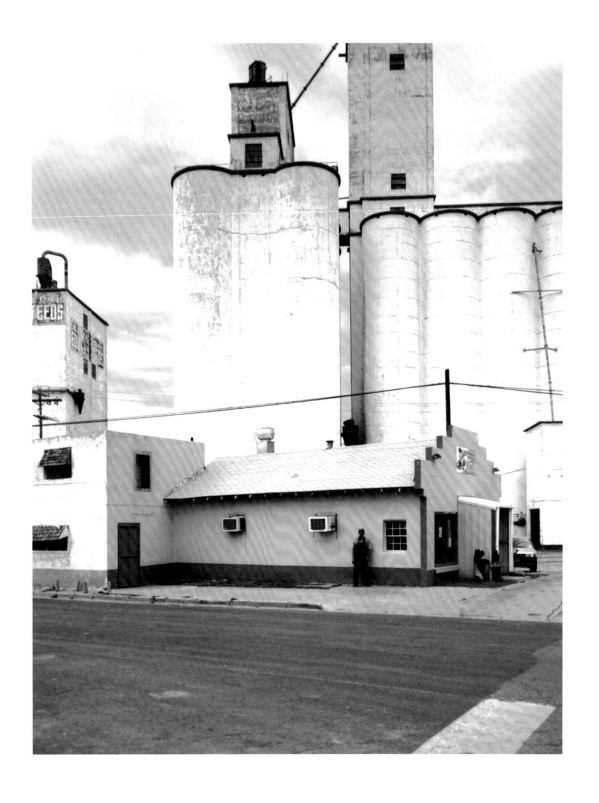

Backstreet and converted pickup truck, Paducah, 2016

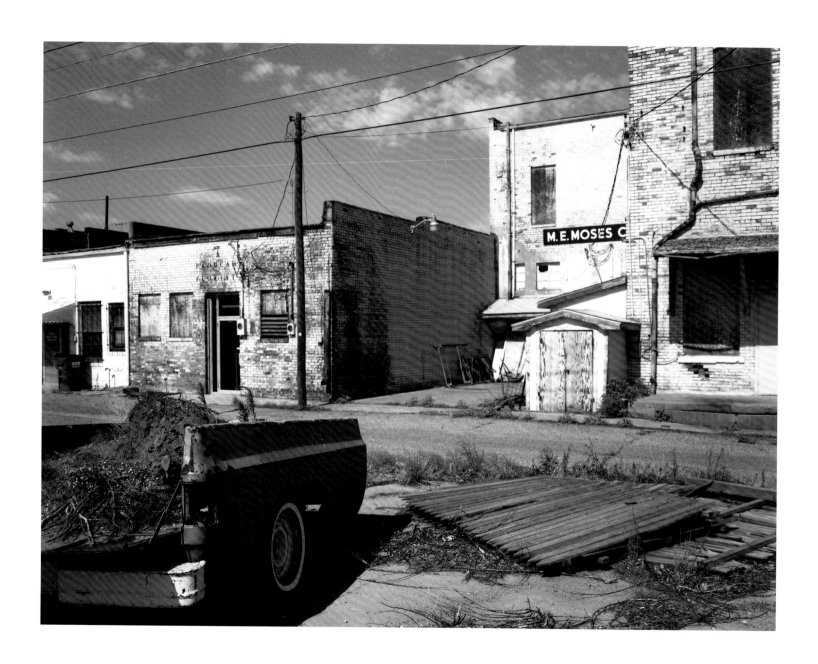

Drummond Lumber Co., Paducah, 2010

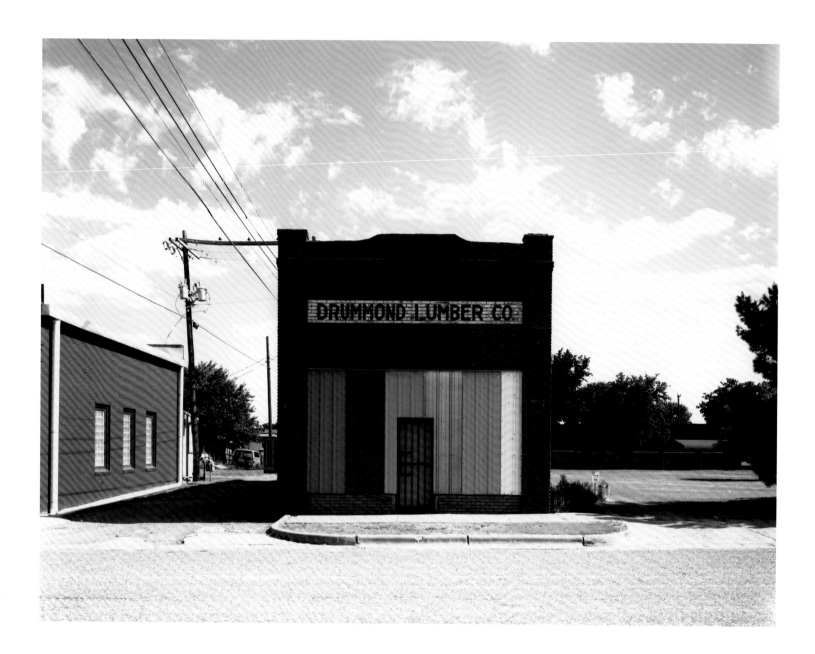

Ivanhoe State Bank, Lipscomb, 2010

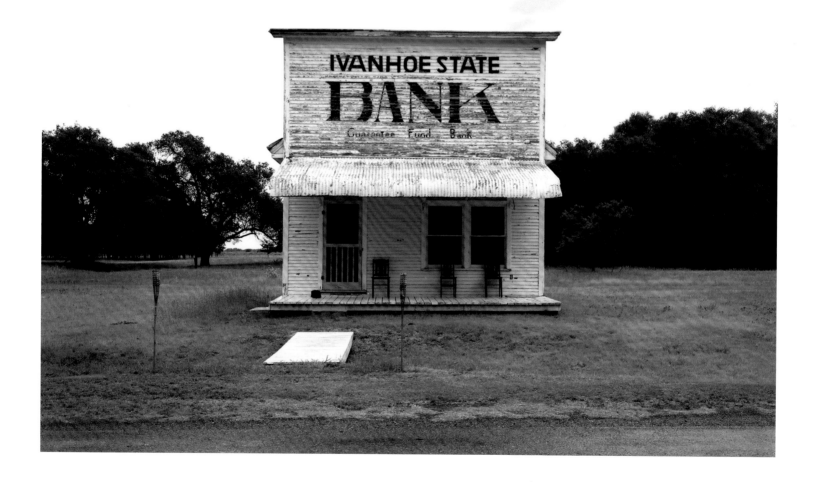

CENTRAL TEXAS

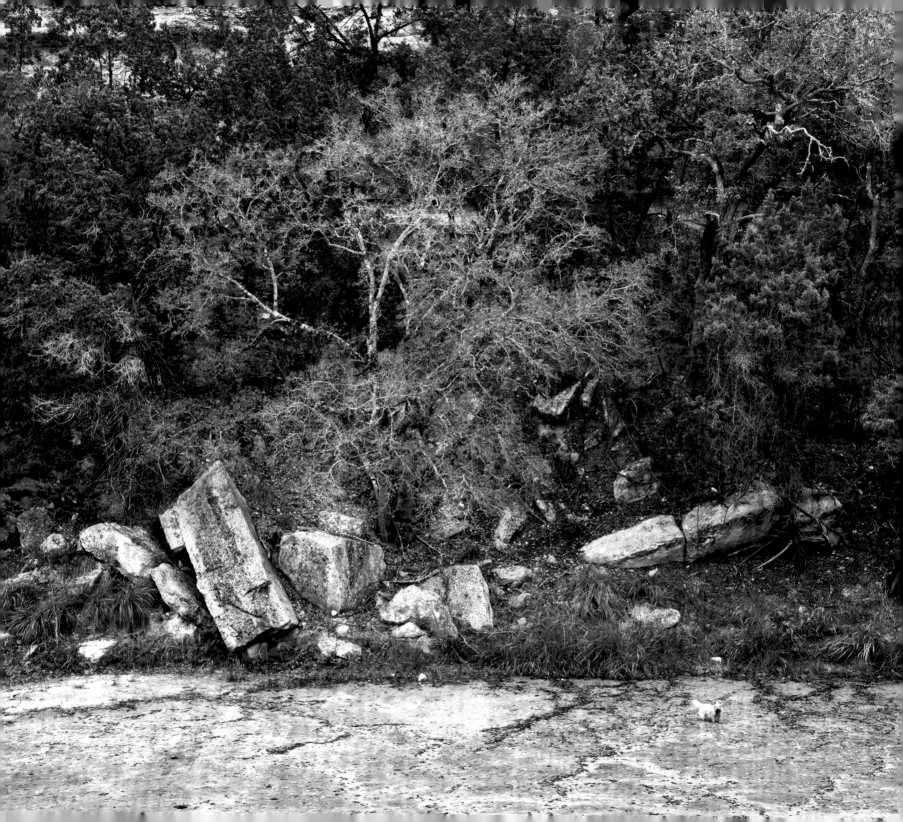

☆ Of little Comfort: Nueces River once ran red with Unionists' blood ☆

COMFORT—The Nueces River near a tiny community called Laguna, north of Uvalde, was a happy place last weekend. Kids splashed and waded in the cool, green waters, while their parents relaxed in lawn chairs along live oak–shaded banks.

Although I didn't ask, I'm guessing none of the folks enjoying the July Fourth weekend had any idea that the clear spring waters of the river not far from where they were celebrating ran red with blood on an August morning more than 150 years ago. They're not likely to have known that for three years the bodies of nineteen victims of a Civil War encounter lay strewn along the river bank, prey to the vultures and coyotes. The story of the Nueces Massacre—or battle, depending on your perspective—begins a hundred miles to the northeast, in Comfort, the tidy little German town on the banks of the Guadalupe. On a quiet residential street across from a school, a twenty-foot-tall limestone obelisk commemorates the men from Comfort and environs who

lost their lives on the banks of the Nueces in 1862. The monument, the oldest Civil War memorial in the state, is one of only two in Texas dedicated to the Union. Unlike statues of Jefferson Davis or courthouse memorials to the Confederacy that are up for debate these days, this monument won't be going anywhere, despite the controversy it's engendered off and on through the years in our Confederate-sympathizing state.

In 1860 some 30,000 German immigrants were living in Texas, making up 5 percent of the population. Many were small farmers who had fled endless wars and conscription in the Old Country, while others were highly educated Freethinkers who had immigrated to Texas after a failed democratic revolution in Germany in 1848. The Freethinkers helped found Comfort and Sisterdale, Hill Country communities free of organized religion, dedicated to civil liberties and committed to science and education.

"They were ready to set up their form of social democ-

racy, and they weren't well-received," said Anne Stewart, whose ancestors arrived shortly after Comfort was founded.

Bookish and idealistic, these German intellectuals dedicated themselves to founding a communitarian utopia. Comfort had no church until 1892 and still has no formal government. Stewart noted that when the town has its Fourth of July and Christmas parades, spectators and participants are expected to clean up after themselves, since there's no municipal trash service. Unlike more traditional Texas towns, like nearby Center Point, where Confederate battle flags flutter in the town cemetery on holidays, Comfort has always seen itself as set apart.

Needless to say, Comfort's Freethinkers, like most Texas Germans, abhorred slavery, so when Texas seceded in 1861, much of the Hill Country was in direct conflict with the new government. Hill Country Germans not only felt an abiding loyalty to the federal government but also relied on federal troops to protect them from the Comanches.

In May 1862 the commander of the Confederate military in the state placed all of Texas under martial law and appointed provost marshals to enforce the Confederacy's newly enacted Conscription Act. Gov. Francis R. Lubbock appointed Capt. James Duff to round up reluctant volunteers, particularly Hill Country Germans.

Duff is an interesting character, although most Texans have never heard of him. According to *The Handbook of Texas*, he was a San Antonio merchant whose wagons were used in 1856 to transport a large meteorite (now known as the Wichita County Iron) to Austin. He had been a sergeant in the U.S. Army before the war but had been court-martialed and discharged.

In the spring and summer of 1862, Duff and his Partisan Rangers conducted nothing less than a reign of terror in and around Fredericksburg. Duff's method of rounding up German settlers trying to evade conscription included hanging men on the mere suspicion that they harbored Union sentiments and then burning their crops and homes. German residents of Fredericksburg and other Hill Country communities would hide in nearby woods at night in fear of Duff and *Die Haengerbaende*, "the hanging band." Hundreds fled to Union states, to Mexico or back to Germany.

On the night of August 1, 1862, a group of about seventy men gathered at Turtle Creek west of Kerrville and set in motion plans to leave for Mexico. They would make their way to Monterrey and then over to Veracruz, where they would board a ship bound for Union-occupied New Orleans and join up with the Union Army. They chose Fritz Tegener, a county treasurer who lived in Comfort, as their leader.

When word reached Duff that a band of Unionists was headed to Mexico, he immediately organized a ninety-four-man detachment led by Lt. C. D. McRae, along with an assortment of regular Confederate cavalry. McRae's party caught up with the Unionists on the night of August 9, as they camped among the oaks and cedars on the banks of the Nueces. They were fifty miles from the Rio Grande.

As Tegener and his men slept, the Confederates attacked. The Unionists, armed with hunting rifles and six-shooters, managed to repel the first charge, killing two Confederates, but a second charge broke through.

The Confederates killed nineteen of Tegener's men. Nine were wounded and taken prisoner. The rest fled toward the Rio Grande or tried to make it back home.

As the sun rose, McRae's men were caring for the Union wounded, until one of McRae's lieutenants ordered them moved into a nearby cedar thicket. There, the Confederates shot all nine through the back of the head. It's unknown to this day whether McRae ordered the executions or perhaps lost control of his unit. Stewart, a retired librarian and amateur historian, maintains that a doctor from nearby Fort Clark advised McRae that he could do nothing more for them and they ought to be shot. Two months later McRae tracked down remnants of Tegener's party on the Rio Grande and killed eight more.

On the Nueces, the Confederates buried their dead in a long trench but left the bodies of the Unionists on the riverbank. On the third anniversary of the battle, a few families made their way to the river and brought home the bones of their loved ones. They buried them, along with those who had been hanged, under the obelisk in Comfort beneath a thirty-six-star flag, the only flag in Texas that to this day flies permanently at half-staff. Along with their names is the inscription in German *Treue der Union*, "Loyal to the Union."

July 10, 2015

✪ Czechs have been dancing in Dubina for a great many years ✪

DUBINA—Ed Janecka has had what you might call a checkered career. After growing up on the family farm in this tiny Czech community, he's been a 1960s-era drama major at Sam Houston State, an actor, an Army man in Vietnam, a stand-up comedian in Vegas, a salesman, a farmer and, for the past twenty-five years, county judge of Fayette County. A lifelong Democrat, he switched parties last fall in light of the fact that 80 percent of his county these days votes Republican and most pull the straight-ticket lever.

"It didn't make a damn bit of difference," the man known countywide as Judge Ed said a few days ago. "I'm still the same guy I always was."

We were standing in the shade of a venerable live oak with multiple trunks in the yard of Sts. Cyril & Methodius Church, one of Fayette County's famous painted churches. Nearby were four sturdy live oaks planted on election day in 1988. Their names: Bush, Quayle, Dukakis and Bentsen.

This pastoral community is considered the first Czech settlement in Texas, and its name means "oak grove." Just off state Highway 90 between Weimar and Schulenburg, Dubina is calm, peaceful and green, particularly this summer after all the rain. Janecka (pronounced ya-*nech*-ka) hopes it stays that way, even though more and more urban Texans are discovering the charms of the small towns and rolling terrain around Fayette County.

The old stand-up comic remains quick with a quip—"The *Houston Comical* still exists?"—but he's

serious about the church. Since before he can remember, it's been the focal point of his life, just as it was for those early settlers who arrived in the area in 1856. They sailed from Bremen, a seaport in the Austro-Hungarian empire in those days, and landed in Galveston after an arduous fourteen-week Atlantic crossing. Men, women and children made their way to what would become Dubina during a slashing sleet storm in November. Their only shelter was a large live oak.

It was hard those first few years, and the unsettled nature of pre–Civil War Texas made it even harder. A number of newly arrived Czech immigrants were drafted into the Confederacy, even though most spoke little or no English, had little idea what the fighting was all about and abhorred slavery. Some of the men, including Janecka's great-grandfather, hid out in the creek bottoms. Others died in battle.

"They brought their faith with them," Janecka told me. Atop their first church, built in 1877, was an iron cross made by a freed slave and blacksmith named Tom Lee. That church was destroyed by a hurricane in 1909. Lee's cross still tops the present church, completed in 1911 and featuring an interior rich with colorful frescoes and stenciling.

In 1952 parishioners decided the old church needed cleaning and updating, so they painted over the brilliant colors and bountiful illustrations that covered the walls and ceiling. Sts. Cyril and Methodius remained a handsome little country church, but the new paint job effaced its distinctive personality.

A few years later, Janecka, then a fresh-faced altar boy, noticed that when the sun streamed through the windows at a certain angle, he could faintly see beneath the whitewashed walls what seemed to be colors and designs. His dad told him what had happened.

"My dad was one of those who painted over it, and it just hurt him to put that paint over those angels," Janecka said. "You have to understand that back in the '50s, after World War II, people really wanted modern. My mother had a beautiful old table, but she would much rather have something with a Formica top. People just wanted to get rid of some of the old past. It's interesting how that is, because our grandfathers built the things, our fathers destroyed a lot of them and we're now trying to repair."

Janecka came back to Dubina in the late 1970s, at a time when the church again needed repairs. He suggested to his fellow parishioners that while they were at it, they restore the original art. "And they said, 'Great! Go ahead!'" he recalled. They were happy someone else was taking the lead.

After conferring with experts at the University of Texas and elsewhere, he decided church members could do the job themselves; everyone agreed with that decision as well. For about six months they set up scaffolding after Sunday mass and carefully removed the two coats of white paint. Painstakingly, they restored the robin's-egg blue ceiling, the beautiful stenciling, the hand-painted frescoes of angels and vines and, some years later, the gold stars set against the blue sky.

"Everything is pretty much exactly the way it was," Janecka said. "The ceiling is the original dark blue. . . . The flowers around the altar were all one color, but we decided to make 'em a bunch of different colors."

The result, my friend Melissa Aguilar says, is like stepping into an Easter egg.

Janecka and his wife, Margie, go to Europe yearly and have been enthralled by the magnificent churches of Germany, the Czech Republic and elsewhere. Their own parish church draws visitors as well, but for a different reason. "This one is interesting because it's so simple," the judge said. "It's elegant in its own way."

These days Janecka spends a lot of time around the church and expects to spend even more when his term as county judge is up. At sixty-eight, he's decided not to seek reelection, which means he'll also have more time to spend with his five grown children and their families and with his birds—chickens, guineas, quail, chuckers and eighteen peafowl.

Don't tell the judge I mentioned it, but the church is holding its annual saint's day picnic on Sunday, an event open to the public and featuring polka music from the Shiner Hobo Band and the church's famous Dubina-style fried chicken, the crust made from flour, eggs and cracker crumbs. Some two hundred volunteers started their preparations on Thursday.

I hesitated to mention the event, because Janecka, who with his wife is in charge of planning, is concerned that a horde of *Houston "Comical"* readers will descend on his peaceful little community and eat up all the chicken. He's even more concerned that they'll stay.

He's sort of kidding, but then again he's sort of not. He likes Dubina just the way it is.

July 3, 2015

★ The ugliest courthouse in Texas has to be Austin County's ★

BELLVILLE—Jeff Boyd has delivered an opinion. The Texas Supreme Court justice pronounced a few years ago that the ugliest courthouse in Texas is Austin County's, here in Bellville. It's his own opinion, of course, not the court's, but it's firmly held. "I can't think of anything I've seen since then that would convincingly change my mind," he told me by phone.

After spending a couple of hours in this pleasant, little county seat, I would have to agree, although I did find at least one person who begs to differ with the judge and me. Sort of.

Boyd's opinion carries weight, in large part because he's seen nearly every courthouse in the state. Beginning in October 2013, he's been working on getting a picture of himself in proximity to all 254. Now at 207 and counting, he's thinking that five more trips in the coming year will complete the odyssey. (He also visits Bellville regularly to see his in-laws.)

Boyd—like most Texans, I'm guessing—prefers the spectacular vintage courthouses. Built in the 1880s and 1890s, they are, in the words of historian Lonn Taylor, "Romanesque and Renaissance Revival wedding cakes with towers and cupolas and mansard roofs and rusticated arches, and all the exuberant paraphernalia of late Victorian architecture, an architecture that perfectly expressed the period of rampant economic growth that Mark Twain called 'The Great Barbecue.'"

Taylor, who grew up admiring the Tarrant County

courthouse on a bluff at the head of Fort Worth's Main Street, also admires the majestic Second Empire–style courthouse at the head of Marfa's main street, not far from his Fort Davis home. (His choice for ugliest is not Austin County but Midland County.)

The architect of record for the pink-stucco Marfa structure is James H. Britton, but Taylor says it was probably designed by San Antonio architect Alfred Giles, who designed eight other courthouses in the 1880 and 1990s as well as banks and other public buildings throughout Texas and northern Mexico.

The most prolific courthouse architect was James Riely Gordon, who built eighteen, with twelve still standing. Gordon's best-known are the pink granite and red sandstone pile built in 1895 in Waxahachie (Ellis County) and the slightly smaller duplicate in Decatur (Wise County).

Boyd told me that one of his favorites is the Hopkins County courthouse in Sulphur Springs, another Gordon design in the Romanesque Revival style. As the judge noted, the stately courthouse, built in 1895 of granite and sandstone, occupies the northeast corner of a spacious town square, not the center. The unusual placement leaves room for a bandstand, a small yard with trees and benches and a water park.

Bellville had a Victorian beauty of its own until 1960, when the stately three-story structure built in 1886 burned to the ground on the night of April 5. Taylor said he happened to be driving through Bellville the next morning. "The courthouse ruins were still smoking and fire engines were still parked around the square," he recalled in an e-mail message. "I pulled into a filling station and asked the attendant what had happened.

'We think those bastards from Sealy did it,' he replied, 'but we'll get even.'"

A fourteen-member commission—including members from gridiron rival Sealy—decided not to replicate the old building, as Hill County commissioners would do when their Victorian gem burned in Hillsboro in 1993. Instead, the group chose what County Judge Carolyn Bilski calls "civil defense architecture, bomb-shelter architecture." The concrete and granite bunker is jarringly out of place, particularly in its old town-square setting, but Austin County residents must have felt assured back then that they could do more than just "duck and cover" in case the Russkies launched a missile their way.

"It was Cold War time," Bilski noted, "and when I came into office (in 1995) we threw out rotten cots, rotten blankets still from the 1960s. We had tin jars of lemon drops and crackers that had never been cracked. All this radiological medical equipment that was there, provided by the federal government for that impending disaster."

The basement of the rock-solid structure is still used as the county's emergency management center.

Bilski, a fierce fiscal conservative who's running in a January 13 special election for the Texas House, says she understands the impetus for what her predecessors did, even though she admits that the building is, if not ugly, less than appealing. "This is a very fiscally conservative community," she said, "and I would imagine that people thought they were doing the right thing by going with the bondsmen, the architecture that got presented and getting something going as quick as they could to restore the order of county business."

The architect was Wyatt C. Hedrick of Fort Worth, designer of seven Texas courthouses as well as Houston's famed Hotel Shamrock. Until the 1990s, trees softened the stark lines of Hedrick's midcentury modern design, but Bilski had to have them taken down. They were staining the marble exterior, and their roots had wrecked the sewer system. There's hardly room for patches of grass on the cramped courthouse square, but rose bushes in brick planters—the blossoms are Bellville red—are an effort to soften the look of the building these days. With pavement running within a few yards of the front and back entrances, the planters also offer some protection from errant big-rig truckers confused by state Highway 36 looping around the building.

Bilski can't quite get to ugly. "It's functional, it's practical," she insisted. As we sat at a table in the small commissioners courtroom where she presides, she allowed herself a hint of nostalgia. Had the old courthouse not burned, she mused, her courthouse would rival the multicolored Fayette County beauty in La Grange, with its red and blue sandstone, pink granite and white limestone, along with a palm court that features a cast-iron fountain. It, too, was designed by James Riely Gordon.

"Golly, that courthouse is awesome," Bilski said, looking around at her own utilitarian digs, where white drapes block the view of pedestrian and vehicular traffic just outside the window. "We're not ugly. We just don't have charm," she added. "But it has served us very well."

The Atomic Age courthouse in the heart of town isn't going anywhere. "I don't think there will ever be any urgency to replace it," Bilski said, "because voters have put in leaders that are very fiscally conservative." (Did I mention she's running for office as an ardent fiscal conservative?)

I heard grumblings about the building around town, but I headed back to Houston thinking that not even a justice of the state supreme court could budge it. Maybe not even an atomic bomb.

December 27, 2014

★ General store's owners are "heartbeat of Fayetteville" ★

FAYETTEVILLE—Ask Jerry Chovanec about the range of merchandise he carries in his general store on Fayetteville's town square, and he's likely to tell you about the famous musician who dropped by not long ago. The man was looking for a particular style of khaki pant he'd bought a few years earlier.

"Baby, what was that fellow's name?" Jerry asked his wife, Shirley. "Lyle . . . Lyle . . . Lyle?"

Although he had to rummage through the attic, Lyle Lovett found what he was looking for. ("He wore, what was it, a twenty-eight or a thirty?" Shirley tried to remember.)

Most people, in fact, find what they need in this most general of all stores, whether it's a loaf of bread and a gallon of milk, hardware and plumbing supplies or items more difficult to categorize. Standing around the

store on a recent Saturday morning, I noticed a wide range of bandsaw blades and drill bits hanging on one wall and a crutch (just one) hanging on another.

The question these days isn't whether Jerry and Shirley have it—they probably do—but how much longer Fayetteville's favorite store is going to last.

"You sell thermometers here?" a woman asks as Jerry and I talk.

"I have only the big ones right now," he tells her. "The middle counter all the way to the back."

Former Houstonians Joan and Jerry Herring first visited the store not long after buying Fayetteville-area property in 2008. They overheard a customer placing an order with Jerry for ten pounds of pig lard.

"We found out it was a local caterer, and that's when we knew we were in the country," Joan said. "It was great!"

A steady stream of Saturday customers includes a family of four gathering up picnic supplies for a daylong outing on nearby Fayette Lake; two guys remodeling a house who buy a couple of Bud Lite tallboys and a box of batteries; the owner of Joe's Place, who needs a half-gallon jar of mustard and three sacks of flour for his café; and three youngsters who need a large bag of Doritos for a midmorning snack.

In his Czech-tinged accent Jerry tells me that plumbers from nearby La Grange routinely drive over because they know he'll either have the fixture or the fitting they need, or he'll know where they can get it. Fishermen drop by for dominoes and packs of cards. "You can't fish 24/7," he observes.

Pat Sury, a Fayetteville resident for fifty years, stops in for groceries—and more. "There's always something going on," she says. "This is where I find out things."

Jerry's father opened the store in the little Czech and German farming community in 1941, after his cotton farm on the banks of the Colorado between Bastrop and Smithville "got drownded out" three years in a row. Jerry grew up in the store, working for three dollars a day until Uncle Sam called. Back home after his army stint, he eventually took over the store from his dad.

Shirley, who grew up in Houston, met Jerry in 1964 when an aunt arranged a Christmas blind date at the legendary Shamrock Hilton, her first date ever and, as it turned out, her last. ("I never dated nobody. I thought you kissed a boy you got pregnant," she says, laughing.)

They married the next year and, except for a brief period, have run the store ever since. They may be the most cheerful and compatible married couple I've ever met.

Shirley, sixty-seven, has trouble getting around these days without a cane, and Jerry, three years older, moves a little slower as well. That's what standing on a concrete floor seven days a week for nearly half a century will do to you.

They sold the store a few years ago and then watched, aghast, as the new owners proceeded to run it into the ground. They took it back.

"They tried to sell health food!" an incredulous Shirley exclaims. "These are Czech people! They've got to have their sausage and beer and kolaches!"

Even worse, the new owners were rude and inconsiderate to their customers. In a town as small as Fayetteville, that's a sure-fire recipe for failure. In less than a year, Shirley says, "They went belly-up."

The store's still on the market. A couple of serious

offers fell through when area banks refused to loan the money—even though the Fayetteville–Round Top area has been discovered by Houstonians and Austinites and is more prosperous than it's been in decades.

"We have some ritzy people moving in," Jerry says. "They've got money. I don't have anything against them, 'cause they spend money, too."

"I like what they're doing with the older houses," Shirley says. "They're like older women. You put a little makeup on 'em, and they're good!"

Whoever buys the store will have a hard time filling the community niche the Chovanecs occupy. The Chamber of Commerce, religious groups and civic organizations all have lines of credit at the store, and Shirley is the unofficial bookkeeper for several of them. The store is where you buy tickets for fund-raisers,

where you leave a check for a repairman you might have missed. It's where you find out who's sick, who's died, who has a new grandbaby. Joan Herring calls the Chovanecs "the heartbeat of Fayetteville."

When and if they retire, Shirley and Jerry think they might do a little traveling. "She won't go on a boat, and she won't fly," Jerry says, "so we'll be drivin'."

It's getting toward lunchtime and Shirley is checking out customers at the front counter. (The store just started accepting credit cards three months ago.) Jerry surveys the store that's been his life, making sure that shoppers are finding what they need.

"It's been real good to us," he says, "but we're playing out. We've been humpin' that booger every day, seven days a week, for forty-eight years."

January 26, 2014

⭐ Strong-willed women got what they wanted ⭐

BELTON—Happy Mother's Day!

You know, had there been a Mother's Day in the 1860s and had a family member expressed that heartfelt sentiment to Martha McWhirter of Belton, one of the most unusual utopian experiments in Texas history might not have been born. As it was, God spoke to McWhirter before her husband or one of her twelve children got a good word in, and the result was the Sanctified Sisters of Belton.

The year was 1866, and the forty-year-old wife of a prominent merchant and attorney was walking home on a hot August evening from a Methodist revival. Having recently lost a brother and two of her children,

she was sorely troubled, and her Christian beliefs increasingly offered little comfort.

A disturbing voice in her head kept urging: "Ask yourself if this is not the devil's work." She stayed up most of the night praying for an explanation.

The answer came the next morning as McWhirter whipped up a batch of her famous biscuits. God was telling her to "sanctify" herself from the impure of the world—including unsanctified husbands—and live a life of godliness and service. Thus began a decades-long experiment in communal living and female-headed entrepreneurship unheard-of in Texas.

Belton, to me, has always been Tigers football, catfish

at Frank Smith's former restaurant on the lake, a fine old courthouse. I had never heard of the "sancties," as the locals called them, until I saw an exhibit at the Bell County Museum.

That's where I learned about the McWhirters, Martha and George. Prominent Beltonians a century and a half ago, they helped establish an interdenominational Sunday school; Martha organized a women's prayer group that met in members' homes. The group became the focal point for other women who were unhappy with traditional religion, abusive husbands and society's treatment of women in general.

One woman told of objecting to her husband's sale of a sick mule to an unsuspecting buyer; when she dared say something, he broke her arm. Another said she had been "long brutalized" by a drinking spouse. Others were fed up with backbreaking toil, frequent childbearing and their husbands' unreasonable demands.

Gradually, as a result of McWhirter's guidance, the woman came to believe that they, too, needed to be sanctified. Relying on their leader's frequent visions, they began to separate themselves from their undevout husbands. McWhirter instructed them to stay in their homes and perform their domestic duties but to remain celibate.

As you can imagine, the husbands were not happy. Some reacted violently, and the McWhirters' large, comfortable house on the banks of the Nolan River became a refuge for the distraught women. Several brought their children.

To the dismay of their estranged families, the women began hiring themselves out as cooks, maids and nurses to families in the Belton-Temple area. They began marketing eggs, butter and milk. They chopped wood in the cedar brakes near town, hauled it into Belton and sold it off a horse-drawn wagon. They did laundry, shoed horses, cobbled boots and made rugs. One woman taught herself to be a dentist.

George, meanwhile, was not particularly pleased with his wife's beliefs or with the permanent visitors to his home, but he was a patient man—a saint, his Belton neighbors said—and managed to endure for several years. Finally, after Martha accused him of flirting with the maid, he moved out permanently. Martha helped him fix up an apartment above his downtown store. The McWhirters never divorced, and when George died in 1887, he left everything to his strong-willed wife.

Operating as a commune, the group had become financially independent by 1879. Four years later, a house inherited by the same woman whose husband had broken her arm had become a profitable boardinghouse, and the Sanctified Sisters built more houses. In 1886 they opened a commercial laundry and broke ground on the Central Hotel in downtown Belton. The thirty-five-room hostelry was near the railroad depot and soon became the place to stay in Belton. The Sisters also acquired three farms; the fresh produce supplied the hotel's acclaimed dining room.

The people of Belton, after years of ostracizing the Sisters as sexual deviants, religious fanatics and homewreckers, eventually granted them a grudging acceptance. McWhirter became the first woman elected to the Belton Board of Trade, forerunner to the Chamber of Commerce. She contributed $500 to help entice the Santa Fe Railroad to town, and in 1903 the Sisters' book collection became the Belton Public Library.

As the women got older and their children began to leave home, yet another vision prompted McWhirter to relocate the group to the nation's capital. Incorporating in 1898 as the Women's Commonwealth of Washington, D.C., and using savings that may have totaled $200,000, the Sisters bought a large, comfortable home close to downtown as well as two working farms in Maryland.

McWhirter died in 1904 at age seventy-five. The commonwealth itself lived on until 1983, when its last surviving member, age 101, joined her Sanctified—now celestial—Sisters in a commune far beyond the skies.

May 12, 2013

☆ West vows to bounce back from tragedy ☆

WEST—By their kolaches we have known them over the years. Now, when we think of West, we'll think of courage, selflessness and fortitude. [*Author note:* On April 17, 2013, an ammonium-nitrate explosion at a fertilizer company near downtown West killed 15 people, injured 160 and damaged or destroyed more than 150 structures.]

Anyone who grew up within sniffing distance of a West bakery, as I did, knew that the little farming town just north of Waco was a Czech community, settled in the late 1800s by people with names like Kubala, Mashek, Holub or Nemacek. We knew kolaches long before kolaches were cool (or maybe I should say as they were cooling, with a morning cup of coffee).

Driving to West on a Thursday evening—radio newscasts bouncing breathlessly between unbelievable developments in Boston and incredible tragedy in a small Texas town—I was thinking about my own West connections. Eons ago, I scored my first high school touchdown against the mighty West Trojans (although I think they were the lowly Trojans that year). My first real job—with the state of Texas, no less—had a West con-nection. Every summer morning, I would loop a scratchy tow sack around my neck, sharpen a nail hammered into a broomstick and begin trudging up I-35 spearing trash and keeping an eye out for roadkill. Getting to West meant—praise the Lord—that my long, hot day was done.

We Wacoans also knew that beer flowed a bit more freely in West than it did in our own "Jerusalem on the Brazos." The good people of West, 85 percent of them Catholic, were more adept at having fun—or, in the words of Rev. Ed Karasek, pastor for the past twenty-five years of West's Church of the Assumption, "We know how to party hard."

A guy named Willie, from nearby Abbott, knew that about West as well. He played some of his earliest gigs at the NiteOwl, a West beer joint on the old Dallas highway. Not surprisingly, Willie Nelson is planning a benefit concert in Austin for his West neighbors in the next few weeks.

On the wall of the venerable Village Bakery in down-town West—where, it is said, the first kolaches were sold commercially in the United States—are yellowed

newspaper clippings of a nearby explosion more than a century ago.

In 1895 a passenger agent for the Missouri, Kansas and Texas (Katy) Railroad named William George Crush proposed a planned train wreck as a publicity stunt. The next fall, two steam locomotives backed up along a four-mile track and, with forty thousand spectators on hand, hurtled toward each other. When they collided with a thunderous, grinding crash, the boilers exploded, filling the air with jagged pieces of flying metal. A number were injured, including a farmer more than a mile away who was blinded by a flying fragment. Three people were killed.

Fun-loving or not, the people of West have neither the time nor the inclination for such foolishness today. They're busy rebuilding their lives and their town. They're mourning the loss of friends and family members—often one and the same in this closest of communities.

"It's family," said Susanne Nemmer, who manages the Village Bakery. "It's the lineage. So-and-so's married to somebody's cousin; you know somebody's brother. It's tight-knit, and the roots are deep."

With bakery customers swirling around her, she added: "Right now, we're just trying to figure out who we lost, and, in this town that means how many friends we lost."

"I was raised that way; that's number one," said Jody Orsag, a boyhood friend of mine who lives in Waco. "You help family, no matter what. They come first. It's very cliquish. If you're not from West, it can be tough."

Orsag is Czech, so he understands. Cliquish it may be, but he deeply admires how the town cares for its own, "how it's pulling together."

Of course, most small towns take pride in their connectedness, but EMS medic Mel Priest says it's even more pronounced in West. That's one reason why she's chosen to volunteer in West over the last few years instead of other Central Texas towns.

"It just clicked with West," she told me. "They were helpful and sincere." West's first responders "were a family," she said. And now her "family" is grieving.

On Friday, she sneaked through police lines to look for a friend, volunteer fireman Cyrus Reed—"just a big ol' bear," she called him.

"His truck was there with the windshield mushroomed in, but he wasn't," she said. "There's probably nothing left to find."

At a special mass on Friday evening it was hard to watch West people walk up to their volunteer firefighters in their distinctive red T-shirts, those who survived, hard to watch them hold each other and sob.

I thought of what Father Ed had told me earlier in the day. "They're tough people," he said. "They came here many years ago to make for themselves a better life. They're tough, but they also passed it on to their kids to give back."

"We will not be defined by what happened," Methodist minister Jimmy Sansom told the mourners. "We will be defined by who we are."

April 21, 2013

★ The man who bought a town ★

MARTINDALE—My friend Carlton Carl always knew he would come home to Texas, but when a year in D.C. turned to two and two became ten, then twenty and beyond, he realized he had to do something to jolt himself out of middle-aged inertia. In 2005 the Houston native did just that. He bought himself a Texas town.

Carlton's town, Martindale, is in Caldwell County, about seven miles southeast of San Marcos, on the San Marcos River. He happened to come across its availability while googling real estate investment opportunities. He knew immediately he'd found his way back home. Selling his Capitol Hill townhouse, he became the proprietor of Martindale's downtown, most of it abandoned. He moved into a venerable home a block off Main Street in 2007.

"I wanted to have an interesting, fun project near Austin, on the water and with historic buildings," he told me on a recent Saturday afternoon as we drove back from a barbecue feast at Smitty's Market in nearby Lockhart.

"One thing that drew me to this particular place is because you drive down from Austin to San Antonio, and it's almost totally developed. You don't see a lot of this," he said, pointing toward gray, late-winter pasture and rolling wooded hills.

What he bought initially were six sturdy brick buildings on Main Street, two corrugated-tin warehouses, sixteen silos and three hundred feet of river frontage. In decades past, Martindale had been home to two cotton gins, mercantile stores, banks, cafés, feed stores, a blacksmith shop. It was a prosperous country town.

At harvesttime in the fall, sharecroppers from area farms would take their mule-drawn wagons piled high with cotton to one of the gins. The iron rings where they tied their mules and horses are still embedded in the Main Street sidewalk. After selling their cotton to the gin and their cotton seed to Harper Seed Co., they'd visit the general store to pay their bills and buy supplies, maybe have a burger as a rare eating-out treat.

It's the same old story: the Depression and the '50s-era drought gradually sucked the life out of the little farming community; consolidating the local school with San Marcos in the mid-1960s pretty much meant the end of Martindale as a thriving community (although it's still a bedroom community for about 1,100 people).

Since becoming proprietor, so to speak, Carlton has worked to revive the neglected little community. He had design students from nearby Texas State University do a study to determine what might work, and he's managed to attract three businesses—a photography studio and gallery, an artist's studio and a nifty resale shop that Frances Lucio and her husband, Steve, have just opened.

A few small movie productions have used the buildings as well, maintaining a movie tradition that includes—before Carlton's time—several Hollywood features. One of the buildings was a bordello in Clint

Eastwood's *A Perfect World* and a bank in Richard Linklater's *The Newton Boys*. *The Great Waldo Pepper*, with Robert Redford, also filmed in Martindale.

The town is home to a couple of tubing outfits on the cypress-lined banks of the San Marcos, which tumbles over a falls at Martindale. Barri Hamilton and her husband, Bill, who makes his living refurbishing vintage Porsches, transformed what used to be the elementary school into a lovely home and are opening a B&B. The twenty-four-foot-tall silos next to the old gin would make great artist studios, Carlton will tell you.

He imagines a place like Gruene, the charming village on the Guadalupe River outside New Braunfels, but he needs something like Gruene Hall or a restaurant like the Gristmill in Gruene—a catalyst, so to speak—to jump-start the revival.

When he bought Martindale, the town had been dry since its founding in the mid-1800s, and by the time he got up a petition and persuaded residents to allow alcohol, in 2010, the recession had scared off potential investors. In his mind's eye, he can see a brewpub and restaurant in the 10,000-square-foot building that once housed a bank and the Martindale Mercantile Co. The loading dock would become a deck overlooking the cool, clear waters of the San Marcos.

Over the years, the bushy-bearded former politico, now sixty-seven, has spent a lot of time and money renovating his buildings, shoring up high ceilings and refurbishing hardwood floors from the turn of the twentieth century. With the economy coming back, he says he's seeing a revival of investor interest.

"I can see a couple of decent restaurants and bars," he said as we wandered through the old buildings, our voices echoing off the stone walls and lofty ceilings. The two of us seemed to be the only people in town on a Saturday afternoon.

"All we need is a little bit of vitality, people wandering around doing something besides looking at old buildings," he said.

Carlton's still having fun, and he remains hopeful about his town, his hobby. With a Canadian developer buying up several thousand acres a few miles away and a Dallas home builder clearing land for a huge development nearby, plus a growing San Marcos and the new Formula One racetrack just up the road, he expects he won't be waiting much longer for things to start popping.

"I just want people to come downtown and use these buildings—people who live here, people who are going to live here," he said.

March 24, 2013

★ He picked up more than trash alongside a Texas highway ★

WACO—The Labor Day weekend got me to thinking about my first real paying job and about my work partner for that summer, Rufus Forrest Cochrum. We worked for the state of Texas, Rufus and I, for what was then called the Texas Highway Department. Our job was to pick up dead animals and trash along I-35 between Waco and West. We had no union, but we certainly labored.

Rufus was fifty-two that long-ago summer, an old man in the eyes of a callow seventeen-year-old. Slender, with a protruding Adam's apple and a receding chin, he wore baggy jeans and a floppy-brimmed straw hat that resembled my Aunt Eunice's when she worked in her flower garden. Fair-skinned, he buttoned the sleeves of his blue work shirt to the wrist, while I, eager for an impress-the-girls tan, wore sleeveless T-shirts. (I'm paying for my foolishness these many years later.)

Rufus and I were a smoothly functioning team. We started our day early, Rufus behind the wheel of our yellow converted gravel truck, me riding shotgun with my foot propped on the dashboard as we crept along the shoulder. We had our eyes peeled for a telltale lump on the horizon that marked a dog's demise. We didn't specialize. We picked up everything but skunks. Once we found a sheep.

One morning we spotted a little brown puppy lying beside the road. I got out, deposited the little carcass in the bed of the truck and we went on our way. An hour or so later, I found the little guy wagging his tail and sniffing the piles of garbage all around him. Just stunned, I suppose. Maybe the smell had brought him back to life.

He rode up front with Rufus and me the rest of the day, maybe the happiest day of the summer. We couldn't stop talking about it. That evening the puppy went home with another garbage guy, a Texas Aggie working that summer on another truck.

To begin the trash portion of our day, we stopped in the shade of an overpass, hopped out of the truck and wielded a file to sharpen the nail on the business end of our broomsticks. Rufus would drive away, and I would loop around my neck a thin strand of rope tied to a tow sack. I would begin trudging toward the truck, which Rufus would have parked a couple of miles up the road. Meanwhile, he was walking away from the truck.

Spearing soiled napkins, crumpled newspapers and all the drivers' detritus that settled hour after hour, day after day, into the dusty, parched grass along the interstate—this was twenty years before "Don't Mess with Texas"—I'd get to the truck, empty my sack and drive toward Rufus. We'd repeat the process, leapfrogging beneath the merciless sun until we drove to the county garbage dump at five in the afternoon. I loved that stifling, smelly dump, my ordeal's-end Mecca.

A failed blackland cotton farmer, Rufus had been walking the interstate for nine years. During our half-hour lunchtime under a tree or during the mornings

while we drove along together looking for dogs, he often told me in his high-pitched drawl about his retirement plans, thirteen years away. I had trouble imagining thirteen more days, let alone thirteen years.

I may have grumbled at the tedium and at set-in-his-ways Rufus, but after a while I grew to respect the man. I hated it when the grader driver, the Cat operator, the asphalt patching crew—the guys with the manlier jobs—called me Little Rufus. Now, I'm embarrassed that I was embarrassed.

The truth is I got something out of that summer job besides the $1.05 an hour and the George Hamilton caramel hue. For one thing, I learned never to look down on anybody who works hard, no matter the job.

I learned to appreciate competence and craft. "Soulcraft," the writer Matthew B. Crawford calls it in a book about the intrinsic satisfaction of manual work. Rufus had perfected his craft, however humble, and he took pride in doing it right. He made sure that the high-

way department and Texas taxpayers got their money's worth every working day of his life.

I wrote a novel a few years ago that includes a faux Rufus Cochrum. With retirement still a distant dream, the fictional Rufus finally cracked. On an insanely hot summer afternoon he tilted the garbage-filled bed downward, gunned the engine and with trash streaming along I-35, with the tailgate clanging and throwing sparks against the pavement, he headed for his pie-in-the-sky fishing cabin on Possum Kingdom Lake.

I never saw Rufus after our summer together, but I know he would never have done such a thing. He was too conscientious, too duty-bound. Plus, he needed a job.

I remember his retirement dream. I hope he got to fish a little in his golden years. I hope he raised some juicy red Big Boy tomatoes and real good black-eyed peas. I hope somebody carried the trash out for him every day of his life.

September 1, 2013

Lee Griffin, Cooper's Old Time Pit Bar-B-Cue, Llano, 2015

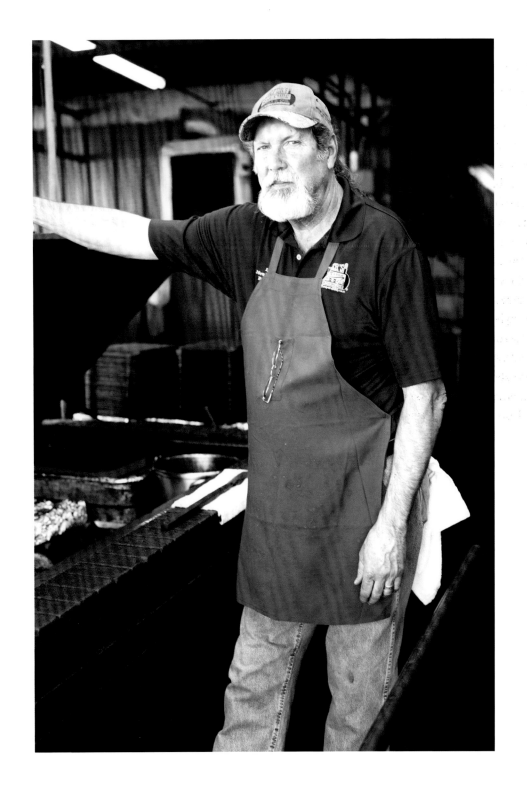

Cowboy boots, Moulton, 2015

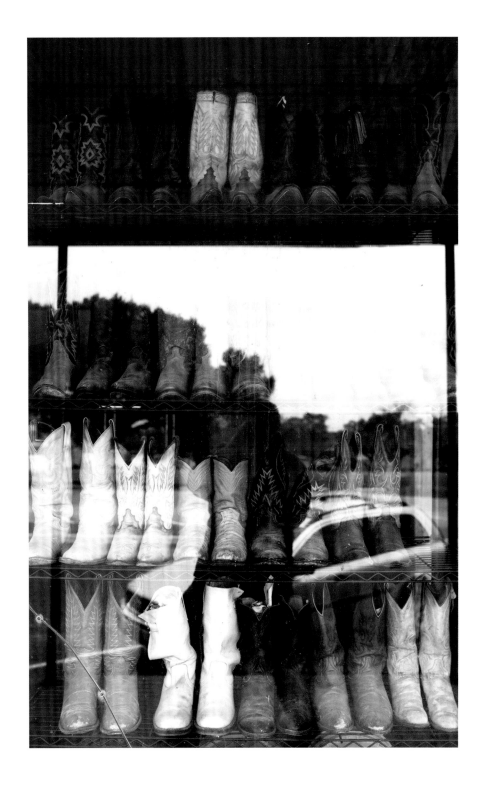

Christmastime, Edna, 2015

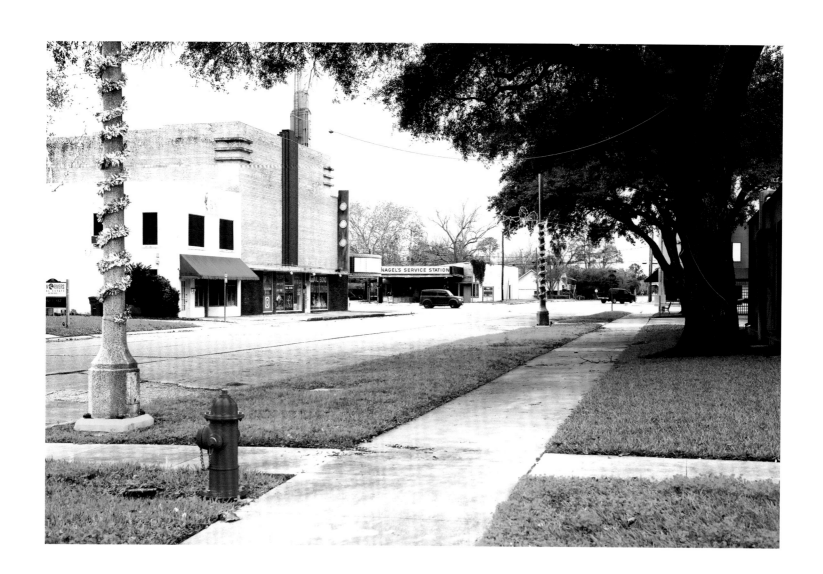

Erma's Beauty Shop, Utopia, 2015

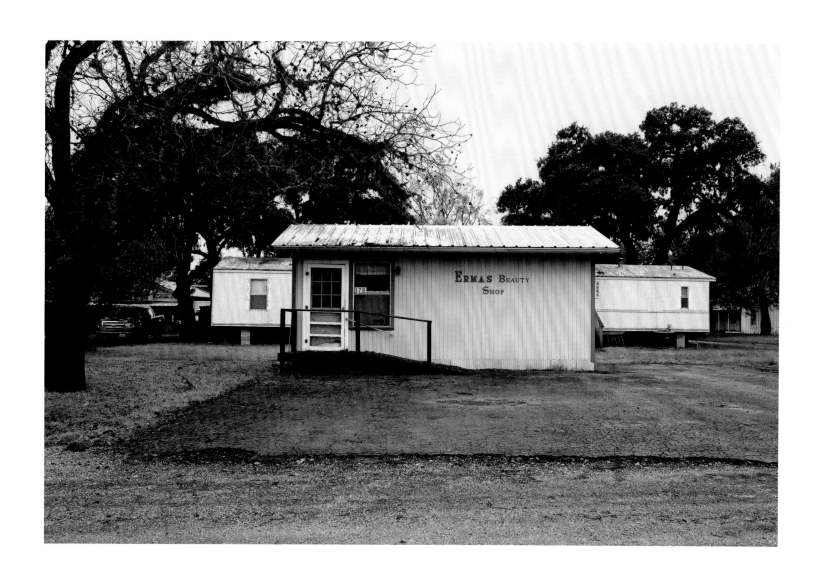

Shirley Chovanec, co-owner of Jerry's General Store, Fayetteville, 2014

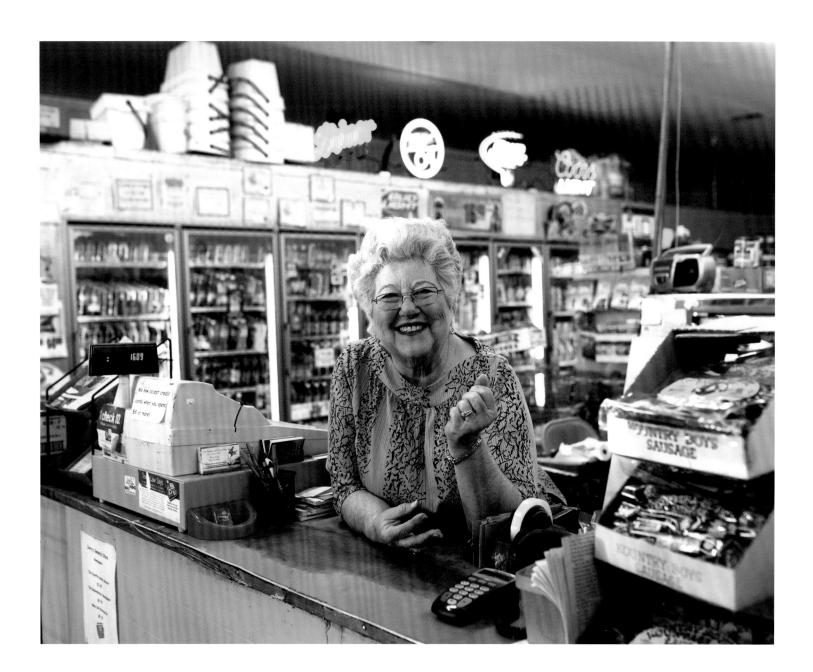

Family photographs on counter, Jerry's General Store, Fayetteville, 2014

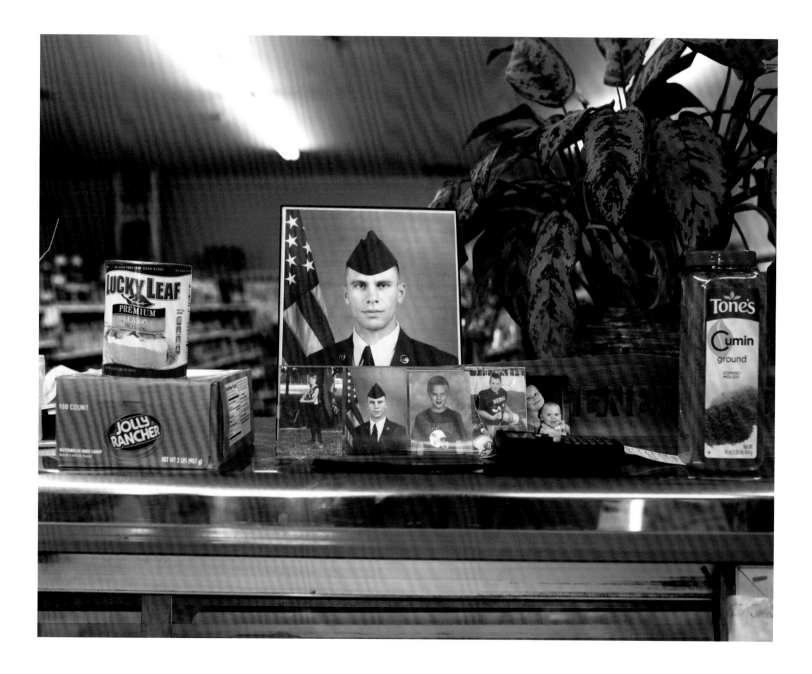

Martha Taylor, Bread of Life Mobile Ministry, Bynum, 2014

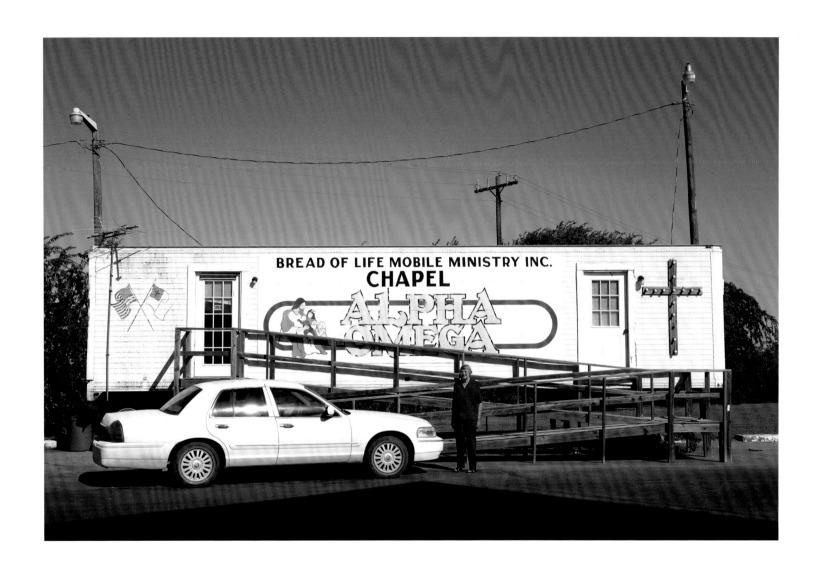

Sunset with courthouse and water tower, Llano, 2015

World War I monument and leaping deer, Llano, 2015

American flag mural and woman with rolling bag, Calvert, 2014

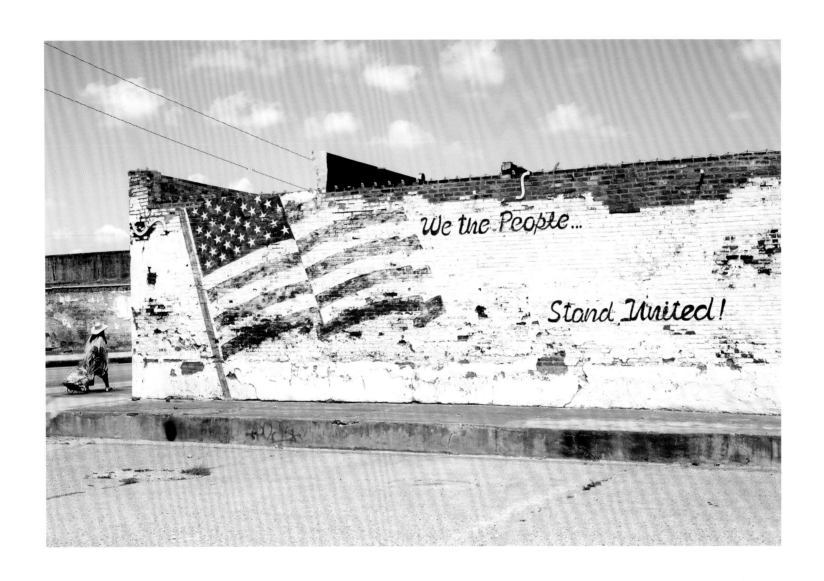

Barbershop with Mackie, Utopia, 2015

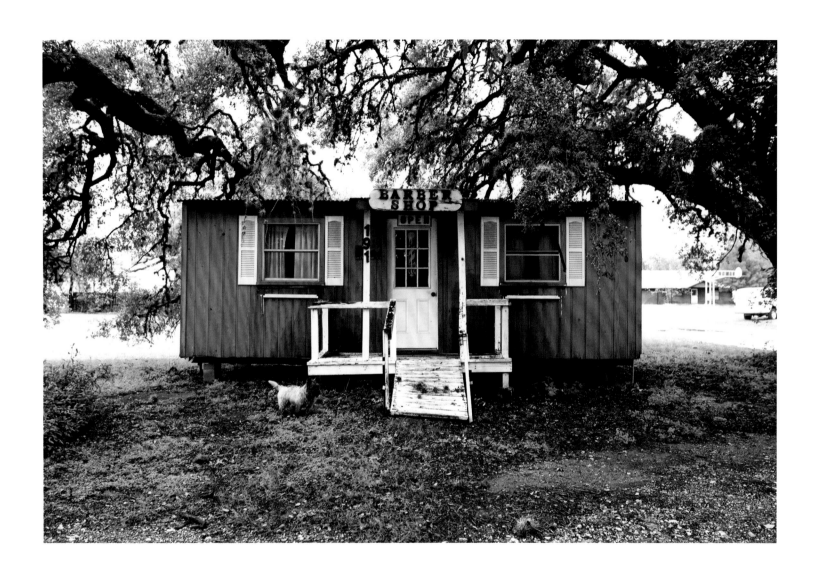

Duck pumpjack and railroad tracks, Luling, 2015

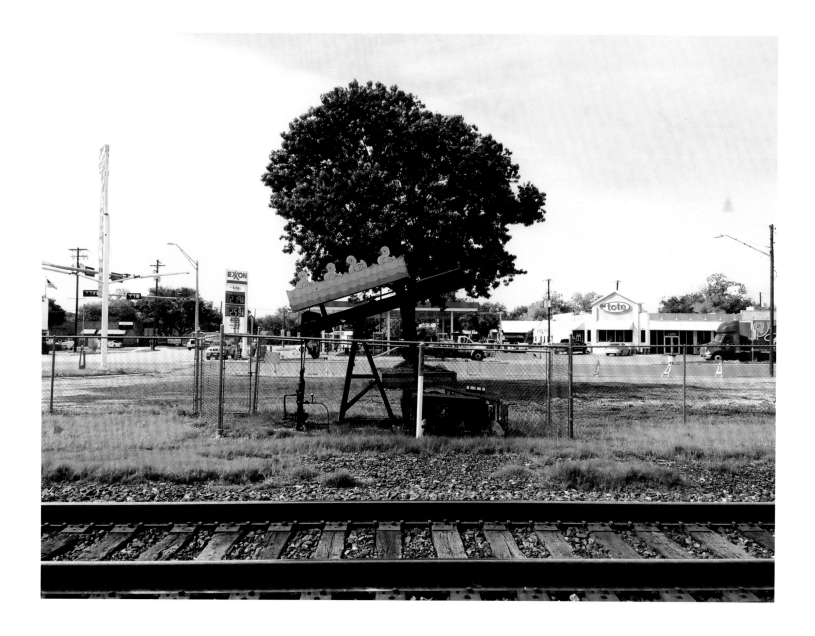

Odeon Theater (the oldest continually operating movie theater in Texas), Mason, 2015

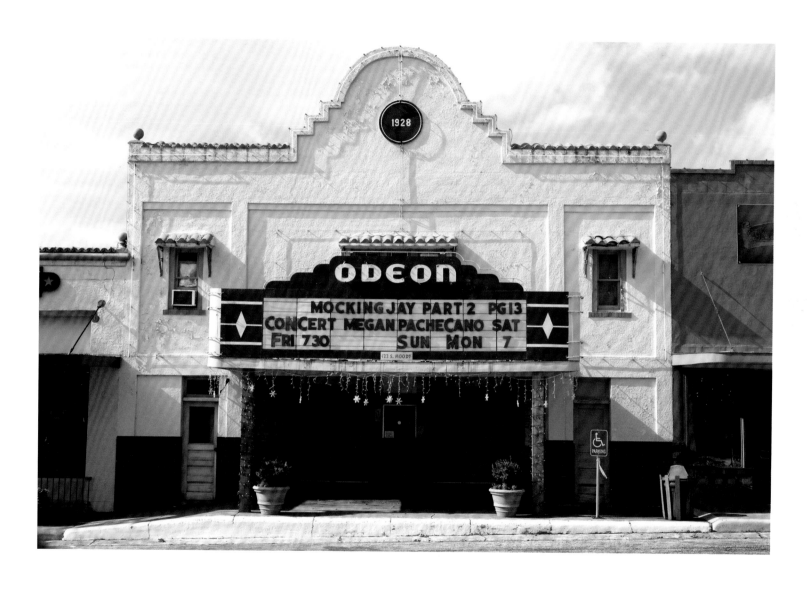

Marcus Fettinger dove hunting with Britta, Brady, 2012

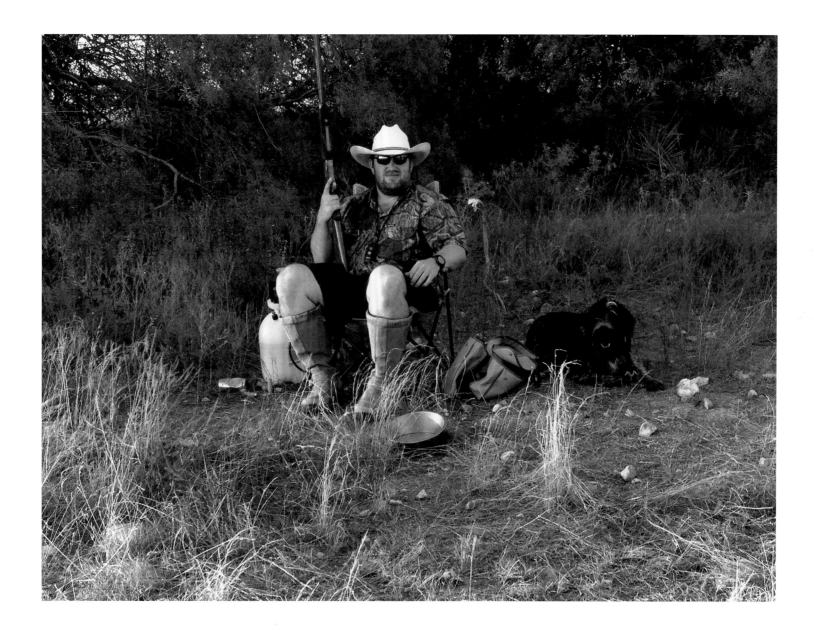

Fall grasses, Pipe Creek, 2013

Wichita pecans, Sam Hensley, south of Bandera, 2015

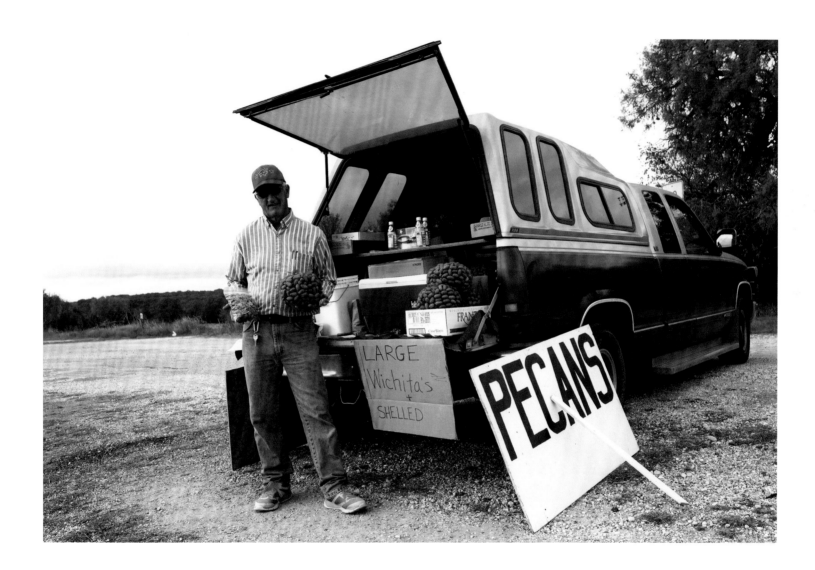

Painted ceiling, Sts. Cyril and Methodius Church, Dubina, 2010

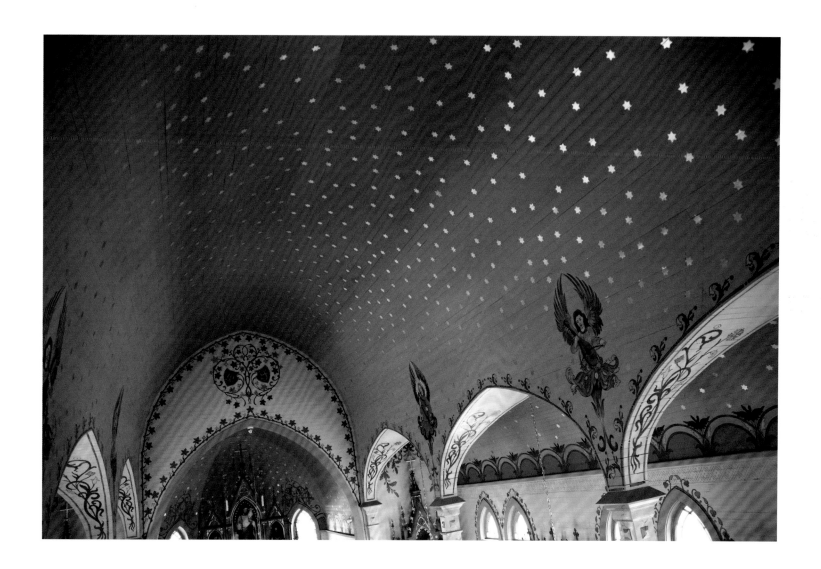

SOUTH TEXAS

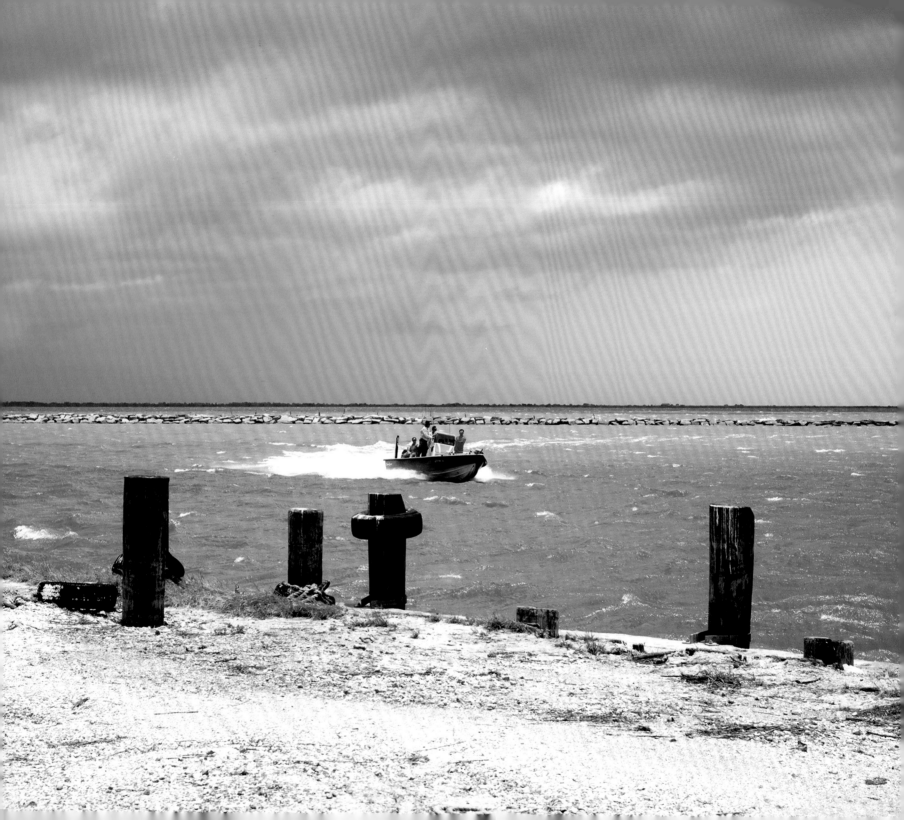

☆ Hope springs for once-grand San Antonio hotel ☆

SAN ANTONIO—The roofless, buckling brick walls, the charred window frames and the overgrown brush make it hard to imagine what used to be, here on the city's South Side, but there was a time when the Hot Wells Hotel and Spa welcomed the likes of Theodore Roosevelt, Douglas Fairbanks Sr., Sarah Bernhardt, Rudolph Valentino and Mexican president Porfirio Díaz. They were among the wealthy and the well known whose stays at the luxury hotel were highlighted by a dip in the hot, restorative mineral water (106 degrees and smelling of sulfur) that bubbled up from a well on the banks of the San Antonio River.

But that was long ago. When I first saw Hot Wells in the early 1980s, it had badly deteriorated, although the once-grand building, long abandoned, still had a roof, and a pool was usable. In my mind I almost could see myself, say, in 1915, luxuriating in the odorous, healing waters in baths reminiscent of a European spa. Afterward, I'd dine in tuxedoed elegance, take a spin on the dance floor to the music of an orchestra from back east and then, before retiring, perhaps take a late-night stroll on the spacious, parklike grounds that gently sloped to the river. The next morning I'd watch ostrich races on the hotel grounds—yes, ostrich races—and if I got serious about betting, I'd visit with a bookie who kept an office in the hotel.

In the three decades since my visit, fires, vandalism and neglect have reduced the site to ruin. Just the other day, a brick wall toppled after a heavy rain. The fallen bricks left an interesting pattern on the ground and a lump that resembled a body underneath, although Justin Parr, an artist who lives on the site, assured me it was a downed tree trunk. (By the way, ghost hunters love the place.)

Cindy Taylor, the ebullient founder of the Hot Wells Conservancy, has a more vivid imagination than I do, and, as of a couple of weeks ago, she has Bexar County's backing to begin the restoration of the Hot Wells prop-

Fishermen, coming storm, Palacios, 2015

erty. Phase one, she says, is scheduled to begin in four to six months. A restored Hot Wells won't be the luxurious spa and hotel from a century ago, but neither will it be a sad, neglected ruin on the banks of the river.

Hot Wells owes its origin to the discovery in 1892 of a sulfur artesian spring on the grounds of what was then called the San Antonio Lunatic Asylum (later the San Antonio State Hospital). After fire destroyed an early bathhouse and hotel on the site, Pearl Brewery founder Otto Koehler purchased the property in 1902 and reopened it as a three-story brick hotel with eighty rooms, hot and cold running water, steam heat, electric and gas lights and individual telephones. The octagonal bathhouse adjacent to the hotel featured forty-five private baths with marble partitions and porcelain tubs. Visitors could take a dip in one of three swimming pools—one for men, one for women and one for those with "skin diseases."

In 1911 Southern Pacific railroad tycoon E. H. Harriman visited Hot Wells and decided to build a spur to the site to accommodate his private railroad car. Other rich and famous visitors, including Bernhardt, also brought their private railroad cars. In 1910 and 1911 the Star Film Company made a number of silent movies in and around Hot Wells, including *The Immortal Alamo*, the first movie ever made about the iconic battle. (Much of my Hot Wells history information comes from Gregg Eckhardt's superb *Edwards Aquifer* website.)

The elegance began to fade toward the end of World War I, and the passage of Prohibition sealed the fate of Hot Wells as a high-end resort. In 1923 the property was sold to a Christian Science congregation that used it for a school. Over the years it's also been a tourist court, a

trailer park and the site of a popular bar and grill called the Flame Room, which closed in 1977. The well that once produced 180,000 gallons of water daily was plugged last year.

A succession of owners include, most recently, San Antonio developer James Lifshutz, founder of the Blue Star arts complex. Lifshutz acquired the property on the steps of the Bexar County courthouse for back taxes in 2001. He envisioned a fine restaurant, elegant cabins and a destination point for high-end RV travelers. Nothing ever came of his plans, and in 2012 he donated the property (four acres out of about nineteen) to Bexar County. Courthouse wags say he was greatly relieved that his old friend Nelson Wolff, former mayor and long-time county judge, was willing to take the "donation" off his hands. The county has agreed to spend $4 million on phase one improvements, including stabilizing the ruins, cleaning up the property and installing lighting, signs and connections to hike-and-bike trails running along the river to the nearby missions.

Taylor, sixty, former president and CEO of the South San Antonio Chamber of Commerce, put together the Hot Wells Conservancy three years ago and named herself executive director. "We had nothing but a vision, a wing and a prayer and a blessing from above and all the community support that we needed to keep chipping away at the county," she told me over migas and coffee at a neighborhood taqueria.

An effusive woman who loves to joke and tease, she's dead-serious about her vision. In five years, she told me, visitors to Hot Wells will see schoolkids learning about gardening, food production and food marketing; they'll stroll through a small museum, a gift shop and a

152

farmer's market; groups and organizations will use the restored third floor of the old hotel as a meeting space; as in the old days, movie companies will use the site. The well will be unplugged, and, in Taylor's words, "people coming up off the river will be able to twinkle their little toes and hands in some sort of water feature where they can learn about the history of the water, the healing powers of it, the chemical makeup. Learning, learning, learning as you're soaking, sitting, feeling, smelling."

She goes on and on as we eat breakfast, ideas bubbling up like—well, like water from a hot spring. She's aware that she's only the latest in a lengthy line of Hot Wells dreamers, all of whom saw their dreams dashed. This time, though, the dreamer has a few things going for her, in addition to her energy and enthusiasm and her obvious love for the tattered old place. She's put together a high-powered board that includes former San Antonio mayor Lila Cockrell and philanthropist Edith McAllister, she has the county on her side and San Antonio development is inexorably moving southward toward Hot Wells. She's worked on the project for a long time and has no doubt it's going to happen.

"A lot of years, a lot of years," she said, her voice breaking. "I'm really happy."

October 24, 2015

★ Alamo hero reemerges from history's shadow ★

SAN ANTONIO—Texans who remember their seventh-grade history know the name: Joe. They remember that Joe was a slave, that he was owned by Col. William Barret Travis. They may be aware that he was one of the few Texans who survived the Battle of the Alamo. Beyond that, there's not much more that any of us, even the historians, have known about Joe. Until now.

In their fascinating new book, *Joe: The Slave Who Became an Alamo Legend*, Ron L. Jackson Jr. and Lee Spencer White fill in the biographical details of a man who deserves credit for assuring that Texans would always "Remember the Alamo." At age twenty-one, Joe was at Travis's side during the siege, he watched him die early in the battle, and for the next four decades or so he continued to tell the Alamo story. Jackson and White also made the stunning discovery that Joe was the younger brother of the celebrated abolitionist William Wells Brown, who, with the 1853 publication of *Clotel; or, The President's Daughter*, became the first African American novelist.

Fredericksburg resident White, a historian and preservationist, got interested in Joe in her duties as founder of the Alamo Defenders' Descendants Association.

"He's always been a mystery," she said during a phone conversation this week. "I wanted to know whatever happened to that guy."

What she and Jackson, an Oklahoma journalist, discovered during more than eleven years of research is that Joe—whose last name would change over the years, depending on who owned him—was probably born on a farm near Lexington, Kentucky, in 1815 and was one of dozens of slaves brought to the Missouri Territory the

next year by a doctor named John Young. His mother, Elizabeth, was a mulatto slave who had seven children and who may have been the daughter of legendary trailblazer Daniel Boone, whose farm was adjacent to the Young plantation in rural Missouri. ("We don't know for sure," White said, "but he was in the right vicinity.")

Young later transferred his operations to Saint Louis. When he ran into financial difficulties, he began selling off his slaves, including Joe's mother and her children. Still a teenager, Joe ended up with a man named Isaac Mansfield, who owned a tin-manufacturing plant on the bustling Saint Louis riverfront. When Mansfield was beset with his own financial woes, he decamped to the Mexican colony of Texas, taking Joe and five other slaves with him to Harrisburg on Buffalo Bayou. They arrived in the spring of 1833.

One hundred sixty-five years later, Jackson and White made a key discovery in their search for details about Joe's life. At the Austin County courthouse in Bellville, they came across Mansfield's probate, filed in 1838: "Isaac Mansfield deceased . . . in the Town of San Felipe de Austin . . . this the 22nd day of December 1834 proceeded to sell at public auction a negro man slave named Joe about nineteen years of age . . . John Cummings being the highest bidder . . . for the sum of four hundred and ten dollars."

Cummings was the brother of Rebecca Cummings, Travis's fiancée at the time he entered the Alamo. Jackson and White also found a bill of sale between Cummings and Travis prior to Travis's fateful arrival in San Antonio de Bexar in February 1836. The Mansfield probate led them eventually to Joe's remarkable older brother. The writings of William Wells Brown, who rivaled Frederick Douglass as a prominent black abolitionist, opened windows onto Joe's early years.

"What were the odds that Joe would have a relative who left a memoir?" Jackson writes in the preface. "A hundred thousand to one? A million to one?"

"It's a stunning discovery," said North Carolina State University historian James Crisp, who specializes in nineteenth-century Texas history. "The idea that this material they've drawn from was lying there for years and nobody was taking advantage of it is just astounding."

Crisp, who's written extensively about the Alamo, also noted: "It's so hard to re-create African American lives from the age of slavery. This material allows us to know something about the personal life of this young man that we otherwise would have known nothing about."

Joe followed Travis into the Alamo. During the siege, the two young men slept, no doubt fitfully, in the same small mud-plastered room. On the fateful morning of March 6, both men grabbed their rifles and sprinted up an earthen ramp next to the north wall. "Come on, boys!" Joe heard Travis shout. "The Mexicans are upon us, and we'll give them hell!" Minutes later, Joe saw the young colonel take a bullet to the temple.

In the chaotic aftermath of the battle, two Mexican soldiers tried to kill Joe, but an officer saved him because he was a slave. Fearing he would be forced into service with the Mexican Army, he slipped out of town the next day and headed toward Gonzales, meeting up along the way with Alamo survivor Susanna W. Dickinson. In Gonzales, the two reported what had happened.

"Many of the citizens of Gonzales perished in this wholesale slaughter of Texans, and I remember most

distinctly the shrieks of despair with which the soldiers' wives received news of the death of their husbands," a resident recalled many years later.

Joe continued eastward, caught up in the Runaway Scrape with thousands of other Texans. At Washington-on-the-Brazos, as in Gonzales, colonists listened to the frightful story that "Travis's Negro" conveyed. "I heard him interrogated in the presence of the cabinet and others," wrote land agent and attorney William Fairfax Gray "He related the affair with much modesty, apparent candor and remarkably distinctly for one of his class."

Joe—still a slave, despite his bravery at the Alamo—stayed around Washington-on-the-Brazos for a year. He worked at a tavern and boardinghouse before being sold to John Rice Jones, who had recently purchased a Brazos River plantation near Columbia. On the night of April 21,

1837, Joe, wearing a new pair of white cotton pantaloons, escorted Jones and his wife to a glamorous ball being held in the new town of Houston to commemorate the anniversary of the Battle of San Jacinto. After dropping the couple off at an unfinished two-story building where the festivities were taking place, he slipped away into the night. A notice in the *Telegraph and Texas Register* offered fifty dollars for his return.

For forty days, Joe trudged eastward through Louisiana, Mississippi and into Alabama, into the dangerous maw of the slave-holding South. His destination was Conecuh County, Alabama, home to Travis's relatives.

The family took him in. He seems to have stayed in Alabama, again in the shadows of history, for the rest of his long life.

April 25, 2015

★ *Boyhood* kindles memories of 1950s summers in Bigfoot ★

BIGFOOT—The other night, my son Pete and I took in *Boyhood*, the movie masterpiece by Austin writer-director Richard Linklater. As most moviegoers know by now, Linklater filmed *Boyhood* for a few days every year for twelve years, using the same ensemble of professional and nonprofessional actors each year.

Pete and I were enthralled, not only because the movie takes place in Austin, Houston and San Marcos, cities we know well, but also because it captures so compellingly the flow of everyday life that all of us experience. Afterward, we sat in the car, in the dark, and talked about time and change and life's elusive meaning, issues

that the movie in its calm, understated way will surely prompt most viewers to think about.

As we talked, Pete was moved to ponder his own Austin boyhood. I was thinking about my own distant youth and the recent death of a cousin.

I've written before about how my two brothers and I in the long-ago 1950s spent portions of our boyhood summers in Bigfoot, the Frio County village where our mother grew up and where our widowed grandmother still ran the Red & White grocery store. Although there's never been much to Bigfoot—population less than three hundred, then and now—we loved the dusty little place.

We especially liked being there when our New York cousins, Diane and Donald, were visiting at the same time.

Their mother, Violet, our mother's younger sister, met and married Herbie, who was stationed at San Antonio's Kelly Field during World War II. (Bigfoot, near Devine, is forty miles south of San Antonio.) Violet was seventeen when Herbie took her home to faraway New York, first to Brooklyn and then to Long Island.

To us, Herbie was the quintessential Yankee—fast-talking, fast-walking and full of life. Before the war, he had been a tap dancer, and with his curly black hair and irrepressible smile, he reminded me of a fellow I'd seen on TV, Eddie Fisher. Herbie was our Jewish uncle, but he happily slid into the pew at the Bigfoot Church of Christ on Sunday mornings, shaking hands and clapping shoulders along the way. Though he was probably the only Jew the Bigfoot Christians knew (besides Jesus), they enjoyed being with him as much as we did. We loved the guy.

We cousins, close in age, had the run of the town, from our grandmother's store—she lived in back—to our Aunt Edith and Uncle Happy's little white stucco house up the road and around the corner past the school. The store and the post office, along FM 173, Bigfoot's "main street," were unofficial community centers. Our grandmother's best friend, Lizzie Thomas, was the postmistress. When she was a little girl, her family took in the old frontiersman Bigfoot Wallace, the Texas legend who bequeathed his name to the town.

Every weekday morning at ten or so, when Lizzie got the mail sorted, the locals would drop by to pick up their letters and packages and then stroll over to the store for a soft drink and the latest gossip. The women usually went inside and visited with our grandmother, while the men stayed on the porch and smoked.

Sitting at the edge of the porch, my back against a column, one bare foot smoothing out the sand and flattened bottle caps below me, I would listen to the men talking. A few of the old-timers would sit on the red wooden benches for most of the morning, chewing tobacco or dipping snuff and telling lies about the good ol' days. Everyone else had work to get back to. The weather was almost always a topic—"Hot enough for ya?"—along with the peanut and watermelon crops. This was the 1950s, a time it never rained. What looked like dry beach sand spilled out of the fields and onto the road in small dunes.

Before it got too hot, we kids would wander in a pack to our aunt and uncle's house, where we'd play with Chula, their stubby-legged Heinz 57 mix. My brothers and I would be in shorts, maybe a T-shirt and always barefoot, despite the grass burs and hot sand. I'm sorry to say we teased Donald, our Yankee cousin. He'd be wearing clean seersucker shorts, a collared shirt and sandals. We Waco boys thought he needed toughening up.

In later years I would imagine Donald as Dill from *To Kill a Mockingbird*. Like Dill, he was funny and inventive, fun to be around, despite our teasing. He may have been a sandaled tenderfoot, but as we got older, we realized he was becoming a miniature version of his gregarious, fun-loving dad.

In the evening, when it had sort of cooled off, we'd wander up to the Bigfoot School and play on the swings and slide. We had to be careful, because the slide, after

all those hours in the burning sun, might still be too hot to touch.

On Sunday mornings, the cousin pack would hurry along a dusty path through an abandoned cotton gin on a shortcut to church. We had to get there before the little congregation arrived, so we could place hymnals and cardboard fans on the pews, the fans courtesy of a funeral home in nearby Devine. We were in a race each Sunday with an elderly woman who believed we were usurping her God given duty.

The years passed, and we cousins grew apart. Deep into our own adult lives, we saw each other mainly at family funerals. We always shared our Bigfoot stories.

I didn't fully understand through the years that life had been hard for Don; I didn't know that he'd been in bad health for a long time. My niece told me that ever since his mother died, the carefree kid we had known in Bigfoot no longer wanted to live. He died in his sleep a few days ago.

Just once more I'd like to be sitting on that Bigfoot porch on a summer evening, the sun setting behind a stand of mesquite across the road from the store. Diane and Don, my brothers and me, the adults who loved us, we'd all be there together; maybe neighbors would drop by too, as they often did. Once more in the gathering darkness, I'd hear the quiet murmur of country voices, the occasional passing car or truck, the soughing of doves settling in for the night in the majestic live oaks nearby.

Memories of my Bigfoot boyhood fade. My grandmother's combination house and store has been gone for years, as has Lizzie Thomas's post office. Most of my Bigfoot people are gone too, Don the most recent.

I still detour off I-35 when I get the chance. Bigfoot's actually thriving these days, but it's not really my Bigfoot anymore. When the old live oak that divides the road comes into view, I think of lines from a poet, lines as sweet and melancholy as those doves we used to hear on a summer evening: "There is nothing more to say / They have all gone away."

✭ Tejanos made a difficult decision ✭

HOUSTON—On this day 178 years ago, a restive, ragtag army of Texans under Gen. Sam Houston set up camp on the coastal prairie between Buffalo Bayou and the San Jacinto River, engaged in a few exploratory skirmishes with the vastly larger Mexican army camped about a mile away and, as night descended, settled in to ponder their fate.

As every Texan knows, that scruffy, mud-caked army, concerned that a Mexican attack was imminent, took the fight to the Mexicans the next afternoon.

Marching into battle to the beat of a popular love song, the Texans overwhelmed Gen. Antonio López de Santa Anna's forces in minutes and then unleashed their post-Alamo, post-Goliad fury upon fleeing Mexican

troops, killing some seven hundred men. The Texans lost nine.

Among Houston's men on that April day in 1836 were a unit of "Tejanos," Texans of Hispanic descent who had made the difficult decision to cast their lot with the mostly American-immigrant volunteers who made up the Texan army.

Their decision was difficult, but not necessarily because of ethnic differences. Like most settlers of long standing, they were deciding how best to hold onto their land and businesses, how best to keep their families secure. They probably weren't thinking a whole lot about the heroic abstractions that would be touted in the textbooks and speeches during the decades to come.

The Tejanos are on my mind after I sat in last Saturday on a symposium exploring the Tejano side of the Texas Revolution, sponsored by the San Jacinto Battleground Conservancy. Not surprisingly, the full story is richer and more complex than myth, legend and popular history suggest. As North Carolina State University historian James Crisp put it, appropriating a Mark Twain line: "There are lies, damned lies and Texas history."

The Tejanos had been in the valley, in San Antonio and South Texas, in Nacogdoches and East Texas for generations. As citizens of a frontier province in the newly independent nation of Mexico, they viewed the Texas struggle "through a Mexican lens," University of Houston historian Raúl Ramos said.

They were well aware of the civil war roiling Mexico even before the Texas unrest; fighting in Texas began as an extension of that war. They were well aware, as well, of American expansionist aspirations, particularly among slaveholders in the American South. They knew that if "illegal immigrant" Americans, many funded by New Orleans business interests, came pouring across the Sabine and forced some kind of secession, Tejano lives and livelihoods would be forever changed.

"The vast majority of Tejanos didn't pick up a weapon," Ramos said. "They left town."

Craig Roell, a Georgia Southern University historian who grew up in Victoria, illustrated the difficulties and divisiveness of the Texas Revolution by contrasting his hometown with nearby Goliad. The two communities were divided, and so were families.

"In choosing sides," he said, "these Tejanos were striving to do what they thought best for their Texas, which brought them into uncomfortable alliances with those with whom they were at odds."

Roell noted that most rancheros from Goliad thought of themselves as defending their homeland against what they saw as American aggression and an attempt by Anglo Texans to separate Texas from Mexico. Their leader was a prominent rancher named Carlos de la Garza, whose land on the lower San Antonio River had been in the family for four generations. De la Garza and his men had to align themselves with a man they hated, Santa Anna.

In Victoria, twenty-six miles away—in Roell's words, "the longest twenty-six miles in Texas" at the time—rancheros led by Plácido Benavides defended their homeland against Santa Anna's policies. They played a key role in the Texas Revolution's early goal of preserving the Mexican Constitution of 1824.

"This required their alliance," Roell said, "with Anglo Texans and even with American mercenaries, who

generally considered Mexicans to be inferior and who envisioned the goal of the revolution as making Texas independent of Mexico altogether—and even becoming a part of the United States. But this was a vision that Tejanos, being proud Mexicans, could not truly embrace or else accepted only with much soul-searching."

After the revolution, Anglos drove Benavides and his family out of Texas altogether. Something similar happened to the most visible Tejano hero of the Texas Revolution, Juan Seguín. A friend of Stephen F. Austin's, an Alamo defender until he was dispatched to gather reinforcements, and a member of Houston's army at San Jacinto, Seguín was the only Tejano senator of the Texas Republic as well as San Antonio's first and only Hispanic mayor until Henry Cisneros was elected nearly a century and a half later.

Seguín got along well with the Americans pressing the revolution. His goal was an independent republic of Texas, free of Mexico and the United States. Although he fought in almost every campaign of the Texas Revolution and took it upon himself to bury the remains of the Alamo defenders with high honors, he was betrayed by Anglo-Americans. A decade hence, he would be fighting against the Americans in the Mexican War.

Seguín's Texas reputation would eventually be rehabilitated, but he remains a controversial figure among certain historians. To me, he remains a symbol of the richer, larger story to which we Texans are heirs.

"When we tell the story of the Tejanos during the revolutionary and Republic periods of Texas, the only way that we can note the full history of this era is to deal with the Tejanos as whole men and women," historian Crisp said. "Because only in telling their full stories can we appreciate the full story of Texas, including the less comfortable aspects of our common history."

April 20, 2014

★ Backwater Indianola not yet ready to die ★

INDIANOLA—To be honest, the charms of this little backwater beach community are not immediately obvious. Instead of the broad, sandy beaches and breaking waves of Port Aransas, the Indianola waterfront holds back the bay with riprap, broken-up pieces of highway pavement. Instead of South Padre's hotels and condominiums, Indianola has more than its share of ramshackle fishing cabins and rusted-out mobile homes.

Massachusetts native George Ann Cormier has lived in a comfortable bay-front home in Indianola since 1994. As director of the Calhoun County Historical Museum in Port Lavaca, she certainly loves the history, but she also loves her bay-front way of life.

"It has its own charms," she told me. "Calhoun County has more species of birds than any place in North America. Plus, we have alligators and bobcats, just an incredible amount of wildlife. Recently, we had a turkey at the beach, which is something we've never had before."

On a gray and windy afternoon last Saturday, I stood in an old cemetery on a low rise within sight of Matagorda Bay. At my feet were two flat stones,

the names so crudely carved I could barely make out "William 'Bud' Miller" and "Henry Miller." The brothers died within days of each other in 1951; Bud was sixty-nine, Henry sixty-six. Two big men—almost giants, people said—they were the last direct link to old Indianola, a remarkable town that blazed like a shooting star across early Texas and then disappeared forever.

The Miller brothers—the family name had been Mueller before World War I—were born into a family of thirteen children; their parents were Indianola pioneers. Lifelong beachcombers, master net-makers, fishing guides and oystermen, the men lived together with their dogs in a shack near the beach. They never wore shoes, partly because their feet were so big they couldn't find any to fit, but mainly because they didn't like feeling confined. They slept on pallets on the sand floor of their shack; their dogs slept on the bed.

The brothers were content with the simple life, but their forebears had much bigger dreams. On the western shore of the bay that Robert de La Salle had explored three centuries earlier, they dared build a city. For a little while, they succeeded, perhaps beyond their grandest dreams.

Standing in the forlorn graveyard, looking out at the bay and coastal wetlands, it's hard to imagine bustling wharves with ships unloading freight and passengers from New Orleans and New York City, hard to imagine trains trundling into town from Chihuahua and California. It's hard to envision shell-paved streets lined with buildings and crowded with carts and wagons, wooden sidewalks filled with people and a half-mile-long pier that shipping magnate Charles Morgan built for his New York–based steamship line.

Had we lingered awhile in Indianola a century and a half ago, we might have enjoyed succulent bay oysters from one of the town's fine restaurants. Maybe we would have stayed at the Casimir House, a luxurious hotel that could accommodate 150 overnight guests.

With a population of more than five thousand at the beginning of the 1870s, Indianola saw itself as a competitor to Galveston and New Orleans, its future as bright as sunshine on the waters of the bay.

It was not to be.

On the night of September 15, 1875, a monster hurricane blew in from the Caribbean. The tide broke over the beach and rushed in fifteen-foot-high torrents through the streets. Ships tore loose from their moorings and slashed into the city; a large schooner ended up five miles inland. Wharves and warehouses broke up, houses and buildings disintegrated. As the next night approached, the intensity of the storm only increased.

The eye of the storm gave the battered town a midnight respite, but then the ferocious wind returned, this time from the opposite direction. Millions of tons of ocean water the storm had driven twenty miles inland came rushing back. Sturdy buildings that had withstood the inland surge were torn off their foundations, broken up and carried into the bay.

At least nine hundred people died.

In the days and weeks that followed, a number of survivors packed up whatever they had left and moved to Port Lavaca, Victoria and other points farther inland. Incredibly, others decided to stay and rebuild.

In the summer of 1886, an even larger hurricane hit. Survivors decided not to tempt fate again.

These days, old Indianola is a ghost town, but it hasn't

completely disappeared. The foundation of the old courthouse, now about fifty yards offshore, is visible on cold, clear days when the tide is low. And people still live here—Houstonians with second homes, retirees and folks who prefer being away from it all.

Gwen Salyer and husband Shannon, a landscape artist and Calhoun County assistant district attorney, have lived since 2000 in an airy house up the beach a mile or so from Cormier. Salyer has planted hundreds of palms along the beach, has written grant proposals for money to replace the riprap, and has pushed to enforce the county's trash ordinance.

The first time I met her, she told me about walking along the beach road one day picking up cans when a longtime Indianolan pulled up beside her. "Why are you doing this?" the woman demanded angrily. "Don't you know that the nicer you make this place, the more people we'll have moving in here?"

Salyer tried to assure the woman that she didn't want to change the basic character of Indianola. She could have mentioned that in her heart were her two old uncles, barefoot beachcombers who wouldn't approve of too much change.

Gwen Salyer's Indianola has to be a place where Uncle Bud and Uncle Henry can still rest easy.

February 9, 2014

★ LBJ the teacher learned a thing or two ★

COTULLA—On this day fifty years ago, Lyndon Johnson had been president for only a matter of hours, but he already was deep into the process of putting together his presidency. From the moment he was informed at Parkland Hospital in Dallas that John F. Kennedy was dead, he had in mind its shape and focus.

"He was finishing the New Deal," said Mark Updegrove, director of the LBJ Library in Austin and the author of a recent book about Johnson. The Texan who understood the use of power more than any other person in Washington was willing to use the Kennedy legacy as a tool to accomplish his own ends—he evoked the martyred president's memory more than five hundred times—but it was his own vision he was implementing, not necessarily his predecessor's. And that vision was molded deep in the heart of Texas.

It was cast initially in Johnson City, where LBJ grew up. These days Johnson City is a pleasant, unpretentious Hill Country town, a favorite spot for second-home Texans and retirees. In the early years of the twentieth century most Hill Country residents, including residents of Johnson City, were so poor and so isolated that their lives resembled something "out of the Middle Ages," a Hill Country woman told Johnson biographer Robert Caro.

"Poverty and back-breaking work—clearing cedar on other men's farms for two dollars a day, or chopping and picking cotton; on your hands and knees all day beneath that searing sun—were woven deep in the fabric of Lyndon Johnson's youth, as were humiliation and fear: he was coming home at night to a house to which other Johnson City families brought charity in the form of

cooked dishes because there was no money in that house to buy food," Caro recounts in *The Passage of Power*, the fourth volume of his monumental biography.

What rescued the Hill Country, as Johnson would never forget, was aid from the federal government. Government money would build dams to tame the Colorado and provide electricity to farmers still doing every chore by hand and to their wives, made old before their time by lives of inconceivable drudgery. Federal money would help build highways and connect the isolated hamlets to the rest of the world.

Johnson, who escaped the constraints of rural life by attending the region's one and only college, Southwest Texas State Teachers College (now Texas State University), took time off between his junior and senior years to teach school at Cotulla, a scruffy little Brush Country town between San Antonio and Laredo. Teaching Mexican youngsters in a school on the "wrong" side of the tracks, the college boy encountered poverty beyond anything he had known in the hardscrabble Hill Country.

Cotulla, to be honest, is still a scruffy little Brush Country town, but it's being transformed by the Eagle Ford fracking boom. Truck stops and motels are springing up, mesquite-filled pastureland is being scraped clean for RV parks and roadways are being pounded into disrepair by incessant truck traffic.

"We like progress," said Danny Garcia Jr., owner of Dan's Furniture & Butane, "but it's certainly different than what we're accustomed to. We're used to going to the grocery store and knowing everybody there and not waiting in lines to fill up your car with gas."

In 1928 Garcia's father was one of LBJ's students at Cotulla's Welhausen School (a one-story red-brick building, now owned by the city). "He used to tell us this country was so free that anyone could become president who was willing to work hard enough," the elder Garcia told Caro.

Those impoverished youngsters weren't forgotten. Decades later, soon after the former Cotulla teacher had himself become president, he used his vast legislative experience and his immense powers of persuasion (or bullying, depending on your point of view) to set in motion a legislative agenda, including a War on Poverty, that would become one of the most ambitious and far-reaching in the nation's history.

One example, as cited by Larry Sabato of the University of Virginia: Kennedy also had considered a program to combat poverty. Shortly before he left for Dallas, he told an aide, Walter Heller, that he would consider signing off on a pilot program in a few cities, as long as it avoided big-spending, budget-busting welfare subsidies. Heller met with LBJ the day after the assassination, and the new president—with Johnson City and Cotulla seared into his consciousness—endorsed the effort but swept aside Kennedy's caution.

"That's my kind of program. It's a people's program . . . ," Johnson told Heller. "Give it the highest priority. Push ahead full tilt."

As Updegrove and I sat in the Johnson suite at the LBJ Library, the rooms furnished as they were when the Johnsons used them in the postpresidential years, the library director ticked off the long list of programs LBJ marshaled through Congress: the 1964 Civil Rights Act, the 1965 Voting Rights Act, more than sixty education bills, federal support of the arts and humanities,

Medicare, urban renewal, to name just a few. "In so many ways LBJ forges modern America," Updegrove said.

It's hard to argue with that assessment, although given the fact that LBJ is one of the most controversial public figures of the twentieth century, I suspect folks will still be doing just that—arguing—on the hundredth anniversary of the Texan's star-crossed presidency.

November 24, 2013

☆ Politics and population pressures put strain on valley preserve ☆

BROWNSVILLE—Jouncing along a dirt trail along the Rio Grande, with Max Pons behind the wheel of his grimy, well-used Dodge pickup, I'm thinking of border metaphors. On a map the border is, of course, a precise black line. In the minds of Washington lawmakers trying to reform the nation's immigration laws, it's a daunting fence that separates irate Americans on one side from desperate Mexicans on the other.

In the world that Pons inhabits, the border is a fact of life, to be sure, and yet a more apt metaphor would be a watercolor swath that bleeds and blends in both directions, just as it has since the state of Texas was born.

As manager of the Nature Conservancy's thousand-acre Southmost Preserve along a meandering bend of the lower Rio Grande, he spends his days with Mexican sabal palms and cat-eyed snakes, bobcats and coyotes, citrus groves and wetlands. He works to sustain a wilderness area gradually giving way outside the preserve to population pressures and the politics of immigration.

These days, the rare and fragile habitat Pons oversees is under threat from a gargantuan intruder, a rust-colored wall nearly twenty feet tall that costs $1.5 million a mile to build and that disrupts life for all God's creatures along the border. It's a small part of the 110-mile Texas section of congressionally mandated barrier that's supposed to deter drug smugglers and illegal river-crossers.

The river's wide floodplain in the lower valley precluded constructing the wall precisely along the border, so it's set back more than a mile in places and built atop the earthen levees that protect Cameron County from floodwaters. That left Pons's home and Conservancy headquarters stranded on the wrong side.

Pons, fifty-two, lived behind what he called "a gated community" until he was forced to move recently. "With my gated community, the wall is just a little taller," he tells me as we sit on boxes in what had been the living room of his home. "I'm just still trying to figure out what kind of damages are we going to see to the animals that have to move to and fro. I've already seen coyotes having to shift in their territories. Other predator mammals are having to move away."

Wiry, with a gray goatee and an easygoing nature, the lifelong naturalist pours me a glass of homemade wine from grapes he's experimenting with in a tiny vineyard he planted in the front yard.

He explains how the wall vastly complicates wildlife

management efforts. With only a four-inch gap between the bars, set into a nine-foot-deep concrete trench, animals can neither get through nor burrow under. It could mean the demise of the endangered ocelot, whose breeding population has dropped to below a hundred.

The wall can legally ignore environmental laws.

"I used to have a family of bobcats that were very familiar with me," Pons tells me. "In fact, the older mother and the younger mother would bring their babies to the fence at night for me to look at with a flashlight. And I'd walk within five feet of them, but with a fence between us. They have since moved over about a quarter of a mile."

Pons himself has had to move about twenty-five miles, to Port Isabel, where he lives with his wife, Linda, and their son, Trey. It's not his natural habitat.

"Cities scare me. I'm still having a hard time; I don't sleep," he says. "There's too much noise in the city. Not that there aren't noises out here, but it's sounds I'm familiar with."

Where he would rather be is among the magnificent sabal palms that once grew in vast groves, from the mouth of the Rio Grande westward to Roma and northward all the way to Corpus Christi. The trees in the preserve are one of only two remaining large stands in Texas. Growing up to forty feet tall, each palm shelters countless creatures—lizards, rodents, insects, birds.

"A lot of things live in here," Pons says as we stare up at a rugged old specimen. "And then you have your bobcats, your coyotes, your possums, your raccoons. And then you have a lot of really unique snakes that occur here. We have the speckled racer, black-striped snakes, cat-eyed snakes—a Mexican species at their northern limit. A cat-eyed snake is a really cool snake. They're so rare, I encountered my first one three years ago after twenty-six years of looking for them."

Pons, a fifth-generation Texan who grew up in the small South Texas town of Premont, points out that he's helping restore what his great-great-great-grandfather helped remove. John "Spanish" Pons, an Alsatian who came to the United States in 1868 from Barcelona, was a red-haired ship's captain who sported a copper earring. The sabal palms were ideal for wharf pilings, and as shipping grew along the Gulf Coast and up the Rio Grande they were harvested almost to extinction.

Max Pons loves his work and loves South Texas, the only place he's ever lived. "It just feels like this is where I was meant to be," he says.

The same goes for the ocelots, bobcats and cat-eyed snakes, not to mention the sabal palms, but as Pons would be the first to tell you: we're not making it easy for them.

June 2, 2013

★ "City girl" finds new life on valley ranch ★

MCCOOK—On a recent weekday morning at the McCook Mercantile Company, a general store in the tiny Rio Grande Valley community of the same name, store owner Eugene Pilarczyk is updating neighbors Betty and Susan about his niece.

A couple of weeks earlier, he says—pausing occasionally to bite into a homemade double-meat burger—the Border Patrol had some kind of immigration operation going on near her home, and all day the dogs had been barking incessantly. When the barking started up again after dark, the exasperated young woman stepped out her back door, without a flashlight, intending to give somebody a piece of her mind. The short, sharp puncture she felt in the skin of her sandaled foot told her immediately that it wasn't Border Patrol agents or whoever they were chasing that had gotten the dogs riled up.

Before seeking medical help, she stepped back into the house, retrieved her shotgun and dispatched the offending rattlesnake. Then she called her parents, who drove her to the hospital in nearby Edinburg.

Pilarczyk's niece is all right—after five days in the ICU and a $100,000 medical bill.

For Susan Thompson, fifty-six, the Pilarczyk snake tale was a reminder, as if she needed one, that life in rural South Texas, even today, can be harsh. It was a reminder, as well, that she was a long way from fecund and fragrant Uptown in New Orleans, where she had grown up, and a long way from green and leafy West Austin, where she and her former husband had raised

their two sons and where she had lived for nearly twenty years.

Even after she made the difficult decision in 2006 to move to the ranch, she wasn't sure she would stay. Wasn't sure she could stay. Sure, the boys were grown and on their own and the bitter divorce was finally done, and sure, she knew that she and Betty loved each other after a years-long, long-distance relationship.

But the ranch, a dozen miles from the Mexican border, was 2,600 acres of prickly pear and mesquite. It was poisonous snakes and brown-recluse spiders and, in recent years, a debilitating drought that covers everything with a pall of powdery dust.

"Susan's a city girl," Betty teased one evening recently as the three of us finished off juicy steaks in the rustic, mesquite-shaded ranch house the women share. Their five good-sized dogs lounged nearby, alert to scraps that might fall their way.

For Betty Perez, sixty-one, the drought is a fairly recent cause for worry, but ranch life itself is nothing new. Both sides of her family have been in the valley for generations, on both sides of the border, and her maternal grandfather, M. D. Cavasos, began acquiring the ranch land in the 1930s. Her grandfather and later her father, Frank Perez, were the Pearl Beer distributors for the area.

Betty grew up in Mission and couldn't wait to leave. Graduating from high school early, she fled to faraway Gonzaga University in Spokane, Washington. She came

back to Texas and got her degree at the University of Texas at Austin, and then stayed in Austin for the next twenty years. She moved to the ranch in the mid-1990s when her dad needed help and none of her relatives wanted to take on the task. She's been a rancher ever since.

"You can't make money off this ranch, but we're trying," she says. "These days, everybody's trying to sell their cattle."

"It's the worst I've seen in twelve years," said Ciro Gomez, who dropped by the McCook general store for a soft drink while Pilarczyk was telling about his niece. Gomez and his three brothers, who have done quite well in the construction business, acquired Lloyd Bentsen's 10,000-acre Arrowhead Ranch some years ago and have had to sell off most of their cattle—some two thousand head—since the drought set in.

With the sparse grass dry and parched, Betty and her neighbors are having to buy hay to supplement their herds' diet. It's an expensive way to raise cattle, so she and Susan are trying to diversify.

"We're going to have to do deer leases, maybe even a B&B," Betty said. They would rent out two comfortable guest houses near the main house to anyone inclined to experience South Texas ranch life or to birders who flock to the valley each spring.

Betty's primary responsibility is the cattle operation, with Susan's help. Susan's primary project, with Betty's assistance, is a native-plant business that sells to local garden centers and to the U.S. Fish and Wildlife Service for revegetation efforts in areas disrupted by the border wall.

The burgeoning business not only contributes to ranch income but also gives Susan a sense of belonging, a feeling that she's doing something worthwhile.

"Some days," she says, smiling, "I tell myself I could no longer live anywhere else it's so beautiful out here, and then the next week it's a dust storm. You have to appreciate the subtlety of browns."

After getting gas at the general store, we drive back to the ranch in the women's battered Dodge pickup past parched fields of brown in the shade of desolate. The gray clouds above us surrender a spit of moisture. I say something about the spattered windshield, but Susan shushes me.

Too late. I've jinxed it. On this day, as usual, there'll be no restorative rain.

April 7, 2013

Cash Creek and coastal prairie, Matagorda County, 2015

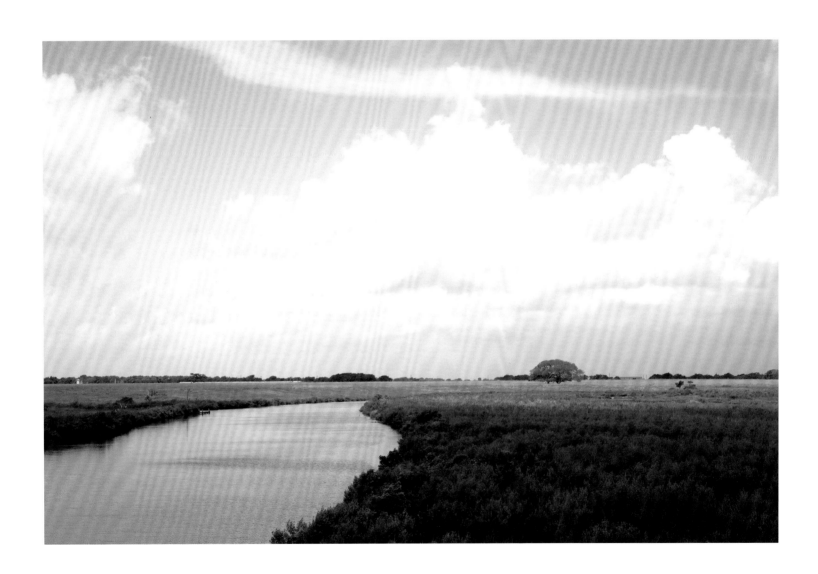

Plowed field, palm trees and truck, Rio Grande Valley, near Vega, 2015

Coastal prairie, Red Brahman cattle and egret, near Collegeport, 2015

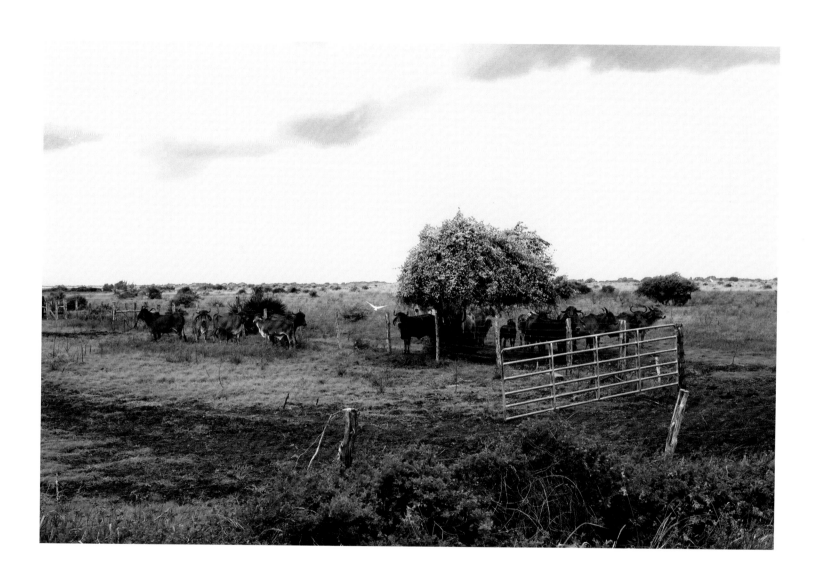

Mason Holsworth, rancher, and Ida Red, Collegeport, 2015

Boca Chica development, Fisherman's Village, Carancahua Bay, 2015

Shrimp boat, Palacios, 2015

Fruit stand north of Edinburgh, 2015

Baby seats near Progreso, 2015

East Kleberg Avenue, Christmas decorations, Kingsville, 2015

Hair salon, barbershop and boot repair, Kingsville, 2015

Palacios Volunteer Fire Department, Palacios, 2015

Abandoned Rig Theater, dog sculpture, palm tree, Premont, 2015

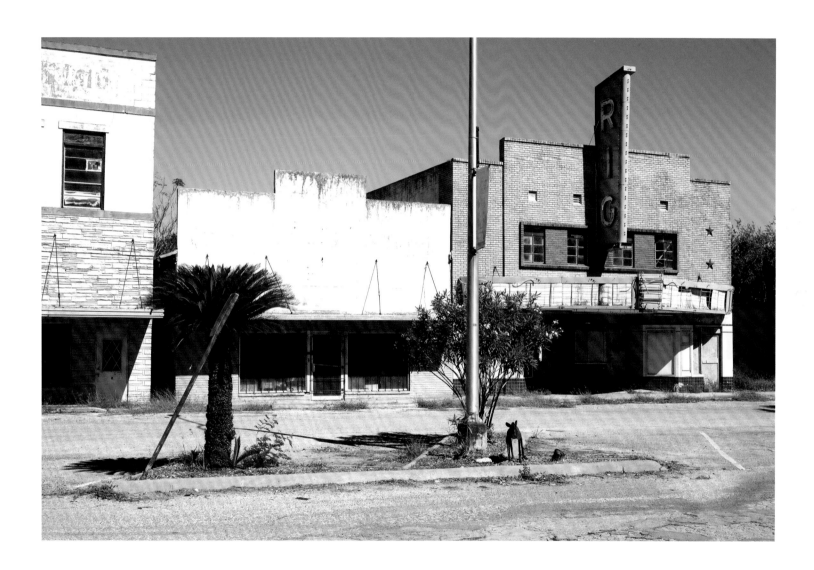

Industrial centers, Military Drive, McAllen, 2015

Sorghum field with blackbirds near Falfurrias, 2015

EAST TEXAS

★ Malakoff Man remains a hard-headed mystery ★

MALAKOFF—My friend Jim Bankston is a Malakoff man, having grown up in this Henderson County town east of Dallas. His dad was the Ford dealer, and his boyhood on the nearby banks of the Trinity resembled an East Texas Tom Sawyer's. But the retired senior minister of Saint Paul's United Methodist Church in the Museum District is not the Malakoff Man, as he reminded me over lunch last Sunday.

To get to know the Malakoff Man, I made the three-hour drive up Interstate 45 to Corsicana and then turned right on state Highway 31. In Malakoff, nine miles west of Athens, I also got reacquainted with another favorite son, one who shares with the Malakoff Man a connection to the timeless yearnings and mysterious impulses of artistic expression.

Malakoff, along with Moscow, Odessa and Sebastopol, is one of four Texas towns named after places in the former Soviet Union. Early settlers preferred either Mitcham or Purdon, but U.S. postal authorities told them those names were already taken. They suggested naming it after a Russian fort that had recently been captured by the British during the Crimean War. That was fine with the East Texans, despite having no ties to Crimea or the 1855 Battle of Malakoff.

Lignite coal was discovered in the area in 1912, and for the next three decades as many as eight hundred miners worked the veins beneath the red clay soil. Meanwhile, brick-makers took advantage of the clay itself. The mines played out in the mid-1940s, but brick production remains Malakoff's major industry.

In 1904 Thomas A. Bartlett, owner of the Malakoff Pressed Brick Co., discovered a means of producing white brick, a discovery that won him a blue ribbon at the 1904 Saint Louis World's Fair. When he decided in the late 1920s to build an elegant home for his family just outside the plant, he realized the structure would have to withstand the shock waves from dynamite used to blast out the clay. He would build the home out of his

trademark pale brick and concrete reinforced with steel rebar.

On November 2, 1929, quarry workers in the Trinity River bottoms about five miles west of Malakoff were mining pea gravel for the concrete to be used in the house. Their shovels clanged against something hard and substantial, and when they pushed away the gravel, they found themselves staring at a large stone head. With crudely carved ears, nose, mouth, teeth and eyes, the egg-shaped head seemed to be staring back. (Diggers found a second head in 1935 and a third in 1939.)

As the story goes, the workers left the ninety-eight-pound head on the front steps of the Bartlett house-to-be, outfitted with a hat. Was it a hoax someone had carved with modern metal tools, or was it an unbroken Humpty Dumpty sculpted by an ancient artist and cosseted for thousands of years in its pea-gravel container? If authentic, who carved it? And when?

Bartlett contacted a University of Texas archaeologist, who concluded that the head, dubbed the Malakoff Man, was the work of early Paleo-Indians and might be at least 50,000 years old. That was thousands of years before any known humans were in the area. Other experts would date the three heads as 3,000 to 4,000 years old, largely because they resemble the so-called Colossal Heads from the Veracruz area made by craftsmen of the Olmec civilization. And some suggested that at least one of the heads, the one discovered in 1939, may be a "geological peculiarity," carved by erosion or other natural forces, not by a prehistoric sculptor. The site where the heads were uncovered is now at the bottom of Cedar Creek Lake.

University of Texas at Tyler anthropology professor Tom Guderjan insists they're frauds and that somebody used a screwdriver to carve the second and third heads. He told the *Tyler Morning Telegraph* a couple of years ago: "I have people bring rocks to me all the time saying, 'Does this look like a face?' and I say, 'Maybe after a bottle of wine.'"

The Malakoff Man and one of his pals reside today at the University of Texas Archeological Research Laboratory in Austin; the other is at the Navarro College Library in Corsicana. Pat Isaacson, former Malakoff mayor, now director of the Malakoff Chamber of Commerce and also president of the Malakoff Historical Society and Museum, showed me castings from the original heads that she has on display in a small glass case at the museum. She's pretty sure Malakoff Man and friends are authentic.

"I like to think they're real, and archaeologists came so close to proving it," she told me as she readied the cluttered little museum for its holiday display. "They did carbon dating and everything else, but the museum people decided that ten years was enough time to work on it, so they pulled the archaeologists off."

My Malakoff tour guide, Lyn Dunsavage Young, knows about preserving history. She's credited with preserving the historical integrity of Dallas's Swiss Avenue neighborhood before she and her husband moved to a farm near Malakoff in 1981. Relying on an early assessment by E. H. Sellards, head of the Texas Archaeological Memorial Museum at the time Malakoff Man was discovered, she believes the heads were images carved by a people who propped them on wooden stakes beside the Trinity as a signal of their presence. Their village,

she believes, overlooked plains inhabited by giant sloths, camels and mastodons; fossilized bones were found in the same excavated area. She's drawn to the notion that long before recorded history, mankind was attempting to find meaning to life, to signify existence. The arc of that artistic impulse extends to the present.

"Everybody knew about the heads, growing up," Malakoff native James Surls told me by phone from his home in Carbondale, Colorado. "They were absolutely believable as a child, although I can't say how believable they are as an adult. But they were a big deal."

Surls, of course, is the renowned sculptor who makes sublime art, he told *Garden & Gun Magazine* recently, "from green grass, trees, sticks, rivers and rocks."

Houstonians knew him as a University of Houston art professor in the 1970s and as founder of the ground-breaking Lawndale Art Center. He and his wife, the artist Charmaine Locke, worked out of a 10,000-square-foot studio in the piney woods outside Splendora. They still own the studio and, as Surls told me a couple of days ago, "are renegotiating our psychological intent in Splendora."

"I can't say that Malakoff Man influenced me," he said by phone, "except on a subliminal level. I had an over, above and beyond interest in anthropological stuff, and when I went off to San Diego State, I was an anthropology major, not an art major."

Authentic or not, Malakoff Man intrigues this son of a Malakoff carpenter. "Seeing a face is probably the oldest conjured image in human history," he said. "It goes back to our oldest ability to see, to be cognizant. I don't think it's a stretch to see faces in a rock."

November 21, 2015

☆ From twisted tale of greed and murder sprang a park ☆

HOUSTON—My friend Juan Palomo, a columnist in years past for the late *Houston Post*, lives across the street from a Midtown park that's within a couple of blocks of the constant drone of U.S. Highway 59. Juan is a calm, understated sort, and so is the park. A green square block in the midst of condos and townhouses that have sprouted like toadstools in recent years, it's one of my favorites in the city.

I never thought about the name, Elizabeth Baldwin Park, until I started investigating Charlotte Allen, the "Mother of Houston," and found a 2008 article in the *Houston Business Journal* by local historian Betty T. Chapman. In the article and in a conversation Chapman and I had earlier this week, she recalled the park's connection not only to early Houston but also to a web of intrigue, including murder, that's as tangled as the limbs of massive live oaks that grace the park.

It's named for Charlotte Allen's niece. Shortly after Charlotte Allen arrived in Houston with her husband, Augustus Chapman Allen, and her brother-in-law John Kirby Allen, her brother Horace followed her to the raucous hamlet on the banks of Buffalo Bayou. Horace Baldwin, like his sister, became an integral part of the community and was elected mayor in 1844.

Baldwin had two daughters: Charlotte, who married Frederick A. Rice, and Elizabeth, who married James Brown, "who seems to have been unremarkable in every way," a biographer of William Marsh Rice noted. (Rice would become Elizabeth Baldwin Brown's second husband.)

Elizabeth—she liked to be called Libbie—apparently was more colorful than husband Brown. Capt. James A. Baker Jr. described her as "a brilliant woman, unusually handsome, tall and straight as an Indian. Nature favored her with wondrous eyes and a handsome suit of hair.... She loved people and was always happiest when doing for others." That was Baker's public description. In private he said "she was fond of society and fond of being in the public eye." Others described her as "imperious."

Libbie's husband died in 1866, and the next year she married Rice, the brother of her brother-in-law and one of the richest men in Texas. He was fifty-one, she thirty-nine. A ship owner, cotton planter, sugar dealer, rancher, hotel owner and banker, Rice had a knack for seeing opportunity and making the most of it. (So did Libbie, apparently.)

For the next twenty-five years or so, William and Libbie divided their time between Houston and New York City, and at a country estate they owned in New Jersey. They usually wintered in Houston, in a suite at the Capitol Hotel (forerunner to the Rice Hotel). In April 1896 Libbie suffered a severe stroke that left her right side paralyzed and affected her speech. William brought her to Houston for treatment.

She may have been sick but was not too sick to craft a lengthy new will in June at the urging of a friend whose husband was a lawyer.

Under the new will, she directed that $250,000 be set aside to endow a home for "indigent gentlewomen" in Baldwinsville, New York (her birthplace), to be known as the Elizabeth Baldwin Home; another $100,000 for the Elizabeth Baldwin Park in Houston; $15,000 for the William M. Rice Library Building, designated specifically for the purchase of portraits of "my beloved husband William M. Rice and my aunt, Charlotte Allen."

Left out of the 1896 will was any mention of a free coeducational institution that her "beloved husband" had long envisioned for Houston. He had formalized his plan for the William M. Rice Institute of Literature, Science and Art five years earlier.

Elizabeth Baldwin Brown Rice died in July 1896. You can imagine the aging millionaire's dismay when he discovered that her executor had filed a secret will for probate. Baker, his attorney, went to work to get it overturned on grounds that Libbie was not mentally capable of knowing what she was doing at the time of its writing.

As the case made its way through the courts, the executor of Libbie's will hired a New York attorney named Albert Patrick to assist in validating that the Rices were Texas residents, not New Yorkers, which would empower her, under community property laws, to dispose of one-half of the vast wealth her husband had acquired during their marriage.

Patrick, a Grimes County native in his mid-thirties, had practiced law in Houston but had fled to New York to avoid disbarment after being accused of taking fees from both sides in a divorce case. In New York, according to Rice biographer Andrew Forest Muir, he craved money and social position.

Rice at the time was living in the swank Berkshire Apartments on Madison Avenue in New York, where he was assisted by a young man named Charles Jones. A son of Harris County tenant farmers, Jones was the old gent's chambermaid, cook, secretary and valet. Although growing a bit eccentric with age, Rice at eighty-four was in relatively good health, his mind still sharp.

Jones, twenty-one when he moved to New York to work for Rice, needed money. "Not surprisingly, in view of his youth and good looks, he had considerable success with the ladies, and this became expensive," Muir writes.

Patrick concocted a scheme to divert Rice's fortune to himself, a scheme that required Jones's help. In early August 1898, the lawyer had a question for the young valet: "Don't you think Rice is living too long for our interests?"

Jones agreed, and on the night of September 23, 1900, he took a small sponge Rice used to clean his clothes, placed it inside a towel and pinned it into the shape of a cone, as Patrick had shown him how to do. He poured about two ounces of chloroform into the sponge before clamping it down on the old man's face while he slept. Rice never awoke.

The tangled webs of intrigue got sorted out eventually. On the twelfth anniversary of Rice's death, September 23, 1912, Rice Institute opened its doors. That same year, Albert Patrick, sentenced to death for murder, was granted a pardon by the governor of New York. The alleged mastermind of Rice's demise headed west to Oklahoma, where he practiced law without a license and sold cars and air-conditioners. He died in 1940.

Charlie Jones was allowed to return to Texas with a brother, where he disappeared from sight until 1954, when he shot himself in his brother's Baytown home.

Elizabeth Baldwin Rice got her park. In 1905 the sum of $9,250 in her estate was used to purchase the 4.88 acres in what's now Midtown, as directed in her will. The city of Houston bought the acreage from her estate for $10.

"Kids from the high school around the corner play over here, people walk their dogs, lovers have their lunchtime trysts—it's a nice park," my friend Juan told me the other day. It is, indeed.

October 23, 2015

★ Mother of Houston misses out on naming rights ★

HOUSTON—You should be living in Charlottesville, dear Houstonian. In fact, you would be living in Charlottesville if Sam Houston had gotten his way. Not Charlottesville, Virginia, but Charlottesville, Texas. As the story goes, the hero of San Jacinto graciously told Charlotte Allen at a dinner party one night that she was the reason the settlement on Buffalo Bayou even existed, and she, not him, should get credit for it. Allen, pragmatic businesswoman that she was, told ol' Sam that he was the one everybody knew; his illustrious name would put the city on the map.

As it turned out, Charlotte Allen's husband, Augustus,

and her brother-in-law John got credit for founding the city they called Houston. The third founder—some would say the first among equals—was relegated to history's shadows. These days, Charlotte Allen is about as obscure as Allen's Landing is to most Houstonians.

Toni Lawrence, a former three-term Houston city council member, has been on a mission to correct that historical slight, ever since she was in the audience during a 2007 event commemorating the Allen brothers at Founders Memorial Cemetery on West Dallas Street. Sitting next to her that day was local historian Betty T. Chapman. "Well, that just figures," Chapman grumbled as the program concluded. "They didn't even recognize Charlotte as a founder."

Lawrence, a former Cy-Fair High School history teacher, went back to her office, Googled "Charlotte Allen" and found very little information. "I told myself, 'OK, I am definitely going to get busy on this.' That's kind of how it got started."

That effort culminated in a trip Lawrence took to Baldwinsville, New York, the small town near Syracuse where Allen grew up. With Suzan Deison, CEO and president of the Greater Houston Women's Chamber of Commerce, as her traveling and research companion, she found what she considers proof that Allen deserves much more credit than she's received as a founder of Houston.

She was born Charlotte Marie Baldwin on July 14, 1805, in Onondaga County, New York, and grew up in Baldwinsville, the town named for her family. Her father, Dr. Jonas Baldwin, and his wife, Eliza, settled in the area in 1808 and immediately began developing the community. The Baldwins erected a dam to harness the energy of the Seneca River, constructed a private canal, which became a section of the Erie Canal, and built a bridge to enhance the town's position on a north–south trading route. B'ville, as the natives call it, soon was a prosperous industrial mill town.

The Baldwins made sure their seven children had everything materially they would ever need, as indicated by Jonas Baldwin's will. On their trip to Baldwinsville, Lawrence and Deison examined the will and also discovered that Charlotte as a young woman lived in a house the locals called "the castle," a structure larger than the Baldwin family home. "That's how we knew she had money," Lawrence said.

In 1831 twenty-six-year-old Charlotte married a young man who had been a mathematics professor in the nearby town of Chittenango, New York. His name was Augustus Chapman Allen, and he had grown up in a little town called Orrville, also near Syracuse. His brother, John Kirby Allen, worked in a hat store in Chittenango.

In 1832 the three Allens made the long, tedious journey to Texas, settling first at San Augustine and then Nacogdoches. They had a business plan, Lawrence believes, that relied on Charlotte's money to succeed. She contends the Allen boys, both in their twenties, didn't have money of their own, although Allen family descendants vigorously dispute that notion. Lawrence also contends that the brothers relied on Charlotte's family involvement and experience with an inland port.

"You always hear about the Allen brothers being opportunists," Deison said. "I feel like they saw the opportunity, or Augustus did, to go and set up a business, and Charlotte was the ticket to do that. Charlotte, on the other hand, saw him as her ticket out of

Baldwinsville. As a woman, she couldn't own land, she couldn't start a business, so she was helpless by herself. She had to partner with someone."

In August 1836 the Allen brothers purchased half a league of land (about 6,600 acres) on Buffalo Bayou for $5,000. Because of the prohibition against wives controlling property, Charlotte's name does not appear on the deeds, even though she may have put up a sizable portion of the money.

Four days after the purchase, the Allens began advertising the establishment of a prosperous new city in the most salubrious of climates. Mosquito-swatting settlers poured in, and the fast-growing community became the capital of the Republic of Texas. The brothers built the first statehouse at their own expense, near Charlotte and Augustus Allen's home at Prairie and Caroline Streets. Sam Houston lived next door.

As it turned out, the official cofounders of Houston didn't stick around that long. In 1838 John Allen died of "a bilious fever" (either yellow fever or malaria) at age twenty-eight. Augustus and his four surviving brothers quarreled over the settlement of the estate, owned "conjointly" and valued at $814,462.50. Charlotte got roped into the family feud.

The couple couldn't resolve their differences and separated in 1850 without divorcing. Deeding everything he owned in Texas to his wife, Augustus scraped the Houston mud from his boots and left town, settling first in Mexico and then in Washington, D.C., where he died in 1864. He's buried in Brooklyn.

"We're not trying to take anything away from the Allen brothers," Deison told me a few days ago. "They truly are founders, but Charlotte should have her place there with them. What they did took money and know-how, and she provided both."

Despite the intriguing research Lawrence and Deison are doing, Charlotte Allen's role in the city's founding may always be debatable. Her subsequent role as "Mother of Houston," as our Houston forebears called her, is unimpeachable.

She lived in Houston for forty-five years after her husband left and was a developer, businesswoman and philanthropist. She raised cattle and had her own brand. In 1857 she got $12,000 for the capitol site, which had become the location of the Capitol Hotel, later the Rice Hotel. She also deeded property to Houston for the first of its city halls, now the site of Market Square. A new steamer on the Buffalo Bayou was named in her honor, as was an elementary school.

When Charlotte Allen died in 1895 at age ninety, flags in Houston flew at half-staff. The "Mother of Houston," a woman who came to this town and stayed, is buried at Glenwood Cemetery.

October 30, 2015

✦ Young Dilue Rose Harris was a Texas tornado ✦

COLUMBUS—I fell in love last week. That's why you're reading another column about Dilue Rose Harris, the feisty, adventurous eleven-year-old who lived through the harrowing Runaway Scrape in 1836 and then, six decades later, published a remarkable reminiscence about life in early Texas. Relying on her father's diary and her own vivid recollections, she begins with an 1833 entry, when she was eight, and continues through April 1837, a year after she and her family made their way back home and began rebuilding their lives, while looking forward to a time when her father expected Texas to "gane her independence and become a great nation."

She was born in Saint Louis on April 28, 1825, to Dr. Pleasant W. and Margaret Wells Rose. The family got to Texas in April 1833 and lived temporarily at Harrisburg before moving to Stafford's Point (now Stafford). After the Battle of San Jacinto, the Roses moved to Bray's Bayou, where Dilue attended school until, at fourteen, she married Ira A. Harris, a former Texas Ranger. She and her husband lived in Houston—on the site of what years later would become the Shamrock Hotel—until 1845, when they moved to Columbus, where he served as Colorado County sheriff. He died in 1869 and was survived by his wife and nine children.

Dilue Rose Harris would have been lost to history had she not sat down in 1898 with a cheap grammar-school tablet and commenced to writing about her childhood.

A widow for nearly three decades, she was by then living with a daughter and son-in-law in Eagle Lake. She died in 1914.

Her reminiscences were published in 1900 in what's now the *Southwestern Historical Quarterly* of the Texas State Historical Association, and the manuscript ended up in the San Jacinto Museum of History. In 2000 the late Bill Stein, librarian and archivist at the superb Nesbitt Memorial Library in Columbus, published the manuscript in its original form in the library's journal of Colorado County history. Stein retained her spelling and grammar eccentricities, believing they gave a more accurate rendering of her personality than the cleaned-up version the historical association had published a century earlier. (Both are available online.)

She may have been Delia Rose Harris. Laura Ann Rau, whose family restored the Harris home in Columbus, remembers some of her descendants calling her that, but her idiosyncratic spelling means we may never know for sure whether "Dilue" was her rendering of "Delia." Regardless, her sharp, funny and insightful memoir makes for delightful reading.

In her entry dated December 1833, she recalls the family's move to Stafford Point: "Mother sister and I slept in the cart brother and dogs underneath. the men sit up to guard the stock. Bray's Bayou was near. we were surrounded by wolves and water . . . we could hear the

owls hoot all night. Mother said . . . the owls were singing a funeral dirge. the wolves and buzzards were waiting to bury us."

Once the family got settled at Stafford, Dr. Rose began plowing, but Dilue explains that he had been an army surgeon and had no farming experience. Fortunately, his wife had grown up on a farm and knew how to spin and weave. "We had plenty of milk butter honey venison and small game. when one man butcherd a beef he devided with his neigbors," Dilue writes in her February 14, 1834, entry.

On that same day, Mrs. Rose sent her two daughters to visit neighbors, who had nine-year-old twin girls the Rose children were eager to meet. When they got home that evening, "to my great delight I found a little sister had arrived while we were gone." The family then proceeded to name the baby. Dilue's choice for a name was Louisiana, her father wanted Texas and her brother, mother and sister favored Missouri. Dr. Rose called for a vote and majority ruled, so the newest Rose was named Missouri. (The child died two years later during the Runaway Scrape.)

In May 1834 Dr. Rose hired a schoolteacher for the community, a Mr. David Henson who had just arrived via schooner from New Orleans. "He was an Irishman. old ugly and red headed," Dilue writes. The school, she recalled, was a windowless log structure that had been a blacksmith's shop. A month later, she reported that the school was doing well and that the men of the community were preparing a July Fourth celebration.

Her father got home late on a Saturday evening after getting a good price for his cotton at Anahuac. He brought with him supplies from New Orleans—and surprises. "We Children were up early next Morning was so happy over our new shoes couldnt sleep. uncle James and the boys laught at us. Fathe said he had no Idea new shoes would run us crazy. Mother said she was not surprised it had been such along time since we had any new Clothing."

In October, after the harvest, the community celebrated: "I sup-pose I was the hapyes Child in the world that night. all the young men danced with me."

By July 1835, trouble with Mexico was boiling over into full-fledged revolt, and the Roses' friend from Anahuac, young William B. Travis, was busy raising a company of men. "Our school opened agane on the tenth," Dilue reports. "The teacher says the young men and boys dont study they talk war all the time seem to think two or three hundred texans could whip mexico."

The Alamo fell in March, the Mexican army was sweeping eastward and the Rose family, like thousands of other Texians, was desperately preparing to flee. Dilue recalled that she and her sister wept all day about Col. Travis and treasured the little books he had given them. "We were on the move Early next morning," she recalled.

The handsomely restored home in downtown Columbus where Dilue and her husband lived for nearly twenty-five years is open to the public and is worth a visit—as is historic Columbus itself—but it's the untutored words on the page that bring the young Dilue back to vivid life. Clearly, everyday life was hard and dangerous, but as she shares her recollections, you can imagine the sparkling eyes, an impish grin, the exuberance that must have been lifelong. We know the

Texas icons, the men—and they're almost all men—with streets and counties and cities named in their honor. Dilue Rose Harris represents the everyday builders of this state, women and men, mostly anonymous, who not only survived but thrived in the rough country that was early Texas.

Here she is at age eleven, attending an election day party in Houston in the fall of 1836 (on this one, I'll translate): "The young people began dancing at three o'clock and kept it up until next morning.... I had a quarrel with my boy lover, William Dyer. He wanted to dance every set with me.... All the young men would tease me about my baby beau, until I told him I would not dance with him again. He said I was putting on airs since I was dressed in my mother's old dress. Well, I suppose I would have slapped his jaws, but just then Clinton Harris asked me to dance. That was revenge enough for what he said about my dress."

March 28, 2015

★ Runaway mule gave legendary comedians a kick start ★

NACOGDOCHES—The oldest town in Texas has always been a culturally sophisticated place, as best I can tell, anyway.

The locals, after all, built a downtown opera house in 1889. Jere Jackson, a historian at Stephen F. Austin State University and the author of a fine book about early Nacogdoches, says that the two-story structure was built to induce theatrical companies to stop over between engagements in Shreveport and Houston. A ticket office and businesses occupied the ground floor; a wide staircase led to the theater on the second floor. On the front of the building was an open gallery over the sidewalk, where theatergoers would congregate during intermissions.

So, the year is 1907, and you're part of a full house gathered on a Saturday afternoon to hear a New York musical troupe called the Four Nightingales. Your little town by this time is on the southern vaudeville circuit, so you're accustomed to seeing plays, melodrama, magic shows and musical acts. Some folks you know—not you, of course—have even taken in the occasional burlesque show at the opera house.

On this particular afternoon, the curtain opens onto a cramped stage, and four young men wearing sailor suits, white straw hats, clip-on bow ties and paper lapel roses break into a popular song. Accompanying themselves on guitar, mandolin and violin, they offer up a few more numbers in four-part harmony, a dramatic reading or two and then—uh-oh, you find yourself stifling a yawn. The boys are fine. You've heard better, but in Nacogdoches you've heard worse, as well.

What you may not know as you listen is that three of the young men are brothers, and they're a long way from home. Sons of impoverished German Jewish immigrants in a family of five kids, they've grown up in the Yorkville section of Manhattan. Their mom, Minnie Marx, is their

manager. Their names are Julius (soon to be known to the world as Groucho), Milton (Gummo) and Adolph (Harpo), along with their friend Lon Levy.

They're doing well on the circuit, much better than when young Julius had to drop out of school at fourteen and find work to help support the large family. Still, Minnie is pinching pennies as they travel around the country. Here's how Groucho recalled her parsimony years later in a biography: "Because we were a kid act, we traveled at half-fare, despite the fact that we were all around twenty. Minnie insisted we were thirteen. 'That kid of yours is in the dining car smoking a cigar,' the conductor told her. 'And another one is in the washroom shaving.' Minnie shook her head sadly. 'They grow so fast.'"

Whether Minnie was on hand in Nacogdoches that long-ago afternoon is lost to history, but her boys were hard at work making music when a man rushed up the stairs and burst through the theater doors. "Mule's loose!" he shouted, or words to that effect. Members of the audience leaped from their seats and hurried to the second-floor gallery, where they pushed and shoved and craned their necks to see what was causing the commotion on the street below. Others spilled down the staircase and out the front doors as if the building were on fire.

Maybe it was one mule that kicked a cart to pieces and was dragging it down the street, or maybe it was a team of mules pulling a wagon—no one knows for sure—but there was mayhem on Main Street on a Saturday afternoon, and for the moment the matinee crowd found it more interesting than the musical offerings of the young Marx brothers. On the small stage, the befuddled boys saw their audience disappear midtune. They had been upstaged by a raucous mule. Or mules.

Once the skittish animal regained his stolid mulish composure, audience members, no doubt still buzzing about the excitement, drifted back in and took their seats. The Marx brothers were miffed, particularly Julius. He began scurrying about the stage like a frenzied mule himself, pausing every few steps to pepper the audience with ad-hoc insults. "Nacogdoches is full of roaches!" he shouted. ("Roaches" was all he could think of that rhymed with Nacogdoches.) "The jackass is the finest flower of Tex-ass!"

Milton and Adolph, and presumably the non-Marx member of the group, got caught up in the frenzy of absurd insults and slapstick craziness that possessed young Julius. The jokes and Texas jibes kept coming.

Groucho's son, Arthur, wrote decades later that the boys fully expected to be tarred and feathered and ridden out of town on a rail, but that's not what happened. The audience loved it, and at that moment—or so the story goes—the Marx brothers realized they were much better comedians than they were musicians. A star, indeed a comedic constellation, was born.

The brothers were still in Nacogdoches the next day, staying at the Rutland Hotel across the street from the opera house. Groucho was on the front porch with a group of guys playing a card game called euchre, when the local constabulary showed up and arrested them for playing cards on Sunday. Groucho didn't seem to mind. "The way I played it, they shouldn't have allowed it on Saturday either," he said years later.

Maybe, also, he'd already begun to realize that something big had happened the night before. In the next few days, other Texas theater managers got word of the young upstarts, and when they moved on to Denison, they got a raise to seventy-five dollars a week.

The Nacogdoches Opera House, complete with historical marker, is still on the corner of East Main and Church Streets, although the building is now an art gallery. The little Texas town that changed his life seemed to stick with Groucho too. Now and then on his quiz show, *You Bet Your Life*, something would remind him of Nacogdoches—and roaches.

And then there's *Duck Soup*, with Groucho as Rufus T. Firefly, leader of Freedonia ("Hail, hail Freedonia, land of the brave and free!"). Did Groucho know about the real Fredonia? In 1820 Texans in and around Nacogdoches rebelled against Mexico and for six weeks were citizens of their own free state. They called it the Republic of Fredonia.

I wouldn't bet my life that Groucho got the name from Nacogdoches, but it's a fact that Fredonia Street intersects Main Street. It's just a few blocks from the opera house where he and his brothers found their real show-business calling.

February 21, 2015

★ Maybe a Hollywood ending for worn-out downtown Port Arthur? ★

PORT ARTHUR—Down-at-the-heels downtown was ghostly quiet as usual Tuesday evening, but on the fifth floor of City Hall, city council members were getting a bit loud and testy. In the midst of a mundane discussion about council procedure, council member Willie "Bae" Lewis Jr. felt compelled to commence sniping at Mayor Delores "Bobbie" Prince. The mayor threatened to shut off Lewis's microphone if he didn't hush up. When he didn't, she called a fifteen-minute recess so things could simmer down. Port Arthur police chief Mark Blanton, a slight, sandy-haired man who reminded me of Mayberry's famous deputy, was on hand to restore order, but that wasn't necessary.

Despite the testiness—par for the course, a *Port Arthur News* reporter told me—Mayor Pro Tem Derrick Freeman was smiling. The youthful-looking, shaved-head council member was pleased in part because he wasn't the target of Lewis's invective but, more importantly, because his colleagues came together long enough to voice unanimous support for his proposed ordinance making this hard-hat refinery town a certified "film friendly city." That designation gives Port Arthur an opportunity to entice Hollywood filmmakers with what Freeman considers one of its most valuable assets: dilapidated downtown buildings.

Whatever its other attributes, this city of some 54,000 is burdened with what is arguably the most woebegone downtown in all of Texas. In Freeman's view, the crumbling, abandoned buildings, particularly the once-grand Hotel Sabine, are just waiting for a Michael Bay (*Transformers*) or a John Woo (*Mission: Impossible II*) to come in and blow them up in spectacular fashion.

The thirty-nine-year-old council member grew up here, went off to Liberty University and University of Texas at El Paso to play football and then moved to Los Angeles, where he worked in advertising and media for ten years. Coming back home when he and his wife began having kids, he was elected to the city council in 2011 and got the idea for blowing up downtown buildings while attending a Texas Film Commission workshop earlier this year. It was on his mind in part because the city had just received federal funds to raze 310 structures, including twenty commercial buildings, many of them hurricane-damaged.

Listening to movie location scouts discuss what they look for, Freeman raised his hand with a question: "Hey, listen, have you heard anything about somebody wanting to blow anything up? If you hear of anything, just let us know."

I mentioned to Freeman that I had been in Los Angeles a few days earlier visiting my daughter, whose boyfriend is a Hollywood visual effects artist. For the hit CW series *The Flash*, Stefan creates deadly tornadoes, gruesome car crashes and, yes, exploding buildings. (His tour de force is an eight-foot-tall, super-intelligent, super-evil gorilla named Grodd.) As Stefan reminded me, visual effects are becoming so realistic, production companies don't have to stage real car crashes or blow up real buildings—or audition angry gorillas. Computer-generated imagery (CGI) is much more affordable and, of course, a lot less dangerous.

Freeman knows this, although he said he's fielded several inquiries from interested parties. Mainly, he wants to attract attention to a years-long problem. "We don't want to blow everything up and tear everything down,

so we don't have anything to restore," he said, "but if we can get some help on some of these larger buildings that are very expensive to knock down, then we'd be happy to partner with somebody."

From his downtown office a couple of blocks from City Hall, Port Arthur native Sam Monroe, president of the superb Museum of the Gulf Coast, recalls a livelier, more prosperous downtown. On a driving tour of the city Wednesday morning, he recalled bustling streets lined with locally owned shops and businesses, several department stores, drugstores, restaurants, a busy railway depot and a handsome Hotel Sabine.

Fueled by oil money, the hostelry was built in 1929 in the Beaux Arts style and for decades was both a destination point for travelers and a social and business hub for locals. Since it shut down in the mid-1980s, the city has considered a number of proposals—an assisted-living home for the elderly and a minimum-security prison, among them—but nothing short of razing downtown's most prominent eyesore has seemed feasible. Renovating the ten-story, asbestos-laden building would cost an estimated $40 million.

Monroe, seventy-two, has been a downtown denizen his whole professional life and an eyewitness to its decline. Until his retirement last August as president of Lamar State College in Port Arthur, located downtown, he was the state's longest-serving president of a higher education institution. He took over as president in 1974 from his father, who had served the previous sixteen years. He maintains that an urban core doesn't necessarily have to be a commercial center to be viable.

"Downtown has moved," he noted as we drove past sprawling shopping malls, strip centers, the full

complement of chain motels, a hospital and housing developments in the newer Mid-County area. "With the museum, the college, the port and City Hall, with parks and landscaping and lighting, it doesn't have to be retail," he said.

He may be right, and yet the derelict downtown is a tangible symbol of the problems that have afflicted this blue-collar town for years. Beginning in the 1960s, white flight to nearby suburbs emptied out the central city, and business followed the flight. Population has declined by about 20,000 during the past three decades.

Surrounded by one of the world's largest oil refinery and petrochemical complexes, Port Arthur rides the waves of the energy industry, and although the industry has prospered in recent years, unemployment hovers at about 16 percent. More than a quarter of the people who live in this minority-majority community are below the poverty level, and environmental justice is a nagging issue. The city also suffered significant damage from Hurricane Rita in 2005 and Hurricane Ike in 2008.

Freeman acknowledges his hometown's problems, but, he said, "Port Arthur is a tenacious city."

Driving back to Houston on Wednesday afternoon, I was thinking about the confidence he has in his community, and about Police Chief Blanton. "He's a small fellow," Monroe said of his good friend and next-door neighbor, "but, man, he's tough. I've seen him take down a man twice his size. I've seen it more than once."

Maybe, I was thinking, the chief reflects the small city. Maybe one of these days a revived downtown will reflect Port Arthur's toughness and tenacity. And, who knows, maybe someday the city council will learn to get along.

May 2, 2015

★ Dowling wasn't the only hero at Sabine Pass ★

SABINE PASS—If you were standing at the mouth of the Sabine River on the morning of September 8, 1863, and you were looking out toward the Gulf, you would have seen the Civil War come to Texas.

Arrayed before you would be twenty-two Union warships riding at anchor just offshore, including four gunboats mounting twenty-six guns and transports carrying five thousand soldiers. Their intention was to mess with Texas and the Confederacy by disrupting rail traffic and cotton shipments.

At about 3:30 on that long-ago afternoon, Gen. William B. Franklin launched his attack on Fort Griffin, a rudimentary fortification guarding Sabine Pass. Before the sun had set, Franklin had suffered one of the most humiliating Union defeats of the Civil War.

The hero of the day was Lt. Richard Dowling, a twenty-five-year-old Irish immigrant and Houston barkeep whose establishment at the corner of Congress and Fannin, the Bank of Bacchus, featured a drink called "Kiss Me Quick and Go." With only forty-two artillerymen defending the fort—most of them stevedores and "dockwollopers" from Houston and Galveston—the ragtag army captured two gunboats and disabled a third. The Davis Guards, as they called themselves,

killed 50 men, wounded many others and captured 150, without losing a man. After Dowling's quick and deadly kiss, Franklin's battered flotilla floated all the way back to New Orleans.

Dowling became an instant hero. The Confederate Congress passed a resolution calling his unlikely victory "one of the most brilliant and heroic achievements in the history of this war." After the war former Confederate president Jefferson Davis proclaimed the Battle of Sabine Pass "without parallel in ancient or modern war." It was, he rhapsodized, "more remarkable than the battle of Thermopylae."

When young Dowling died in a yellow fever epidemic that ravaged Houston in 1867, the *Houston Daily Telegraph* noted that "the far-off echoes of the guns of Fort Griffin have served as funeral salvos for the warmhearted hero—Dick Dowling."

His fame lived on, for a while at least. The first civic monument erected in Houston was of Dowling, in front of the old city hall in 1905. In 1968, at the height of the civil rights movement, the city opened a new middle school that bears Dowling's name. Even though his star has been eclipsed by time and circumstance, local Irish American groups still commemorate his exploits on Saint Patrick's Day.

Houston newspapers have retold his story off and on through the years, but there's a related story that's less well known, says Rice University historian Caleb McDaniel, who, with his students, has compiled the fascinating Dick Dowling Digital Archive.

In the course of his research McDaniel discovered that a number of "contraband" slaves were aboard the Union gunboats. They likely were fleeing plantations and had managed to make their way to Union naval vessels that had been in the Gulf near the Texas and Louisiana coasts for months.

Several black sailors were among the casualties, including men scalded to death when cannon fire ripped into ships' boilers. Others were among those captured and paraded through the streets of Houston.

Among the black sailors onboard one of the Union gunboats that exchanged fire with Dowling's men were George W. Houston and Randall Smith. McDaniel found that both men turned up some months later on muster records for the *Arizona*, one of the gunboats that escaped the withering fire from Fort Griffin. Amid burning ships, dying men and cannon shells roiling the water around them, they apparently splashed and thrashed their way from the disabled boat they were on, the *Sachem*, to the safety of the *Arizona*. Later they enlisted in the navy, thereby securing for themselves both freedom and wages.

Houston and Smith have been lost to history, but as McDaniel points out, their story converges in a symbolic way with Dowling's story in and around a ten-acre plot of land in Houston's Third Ward, long the center of the city's African American community.

Nearly a decade after Abraham Lincoln signed the Emancipation Proclamation and seven years after Texas slaves found out about it, the Rev. Jack Yates and other community leaders led a campaign among African American churches to purchase land where they could hold festivals commemorating June 19 or, as the holiday is called, Juneteenth, the day in 1865 when Gen. Gordon Granger publicly read emancipation orders to the citizens of Galveston. On July 10, 1872, Yates and his group

purchased lot no. 25 in the Third Ward for eight hundred dollars. It eventually took on the name Emancipation Park.

In 1892 city officials renamed East Broadway, the street running along the eastern border of the park. Its new name would be Dowling Street. The street along the northern border would become Tuam Street, after Dowling's birthplace in Galway County, Ireland.

"Whether it was a backhanded slap at Emancipation Park is difficult to say," McDaniel told me the other day, "but it does seem a little too coincidental to be a coincidence."

Four years after the name change, as McDaniel points out, the U.S. Supreme Court in *Plessy v. Ferguson* ruled public segregation constitutional. When the city acquired Emancipation Park in 1918, it became the only municipal park in which black Houstonians could set foot.

Whatever the city's motive in changing the street names, the Confederate hero moved to the city's periphery, literally and figuratively. The thirty-foot-tall statue came down in 1939 and was stored away in a barn for nearly twenty years. Today it stands on the back side of Hermann Park, near the fifth green of the golf course.

Emancipation Park, meanwhile, remains at the heart of the city. The site not only of annual Juneteenth celebrations but also of concerts, movies, parades and demonstrations, the park is undergoing a $33 million upgrade and revitalization, scheduled to be finished in the fall of 2015. The goal is to transform the historic site into a national landmark, the place to celebrate Juneteenth from 2016 onward.

George W. Houston and Randall Smith aren't well enough known to merit statues in the new Emancipation Park—we don't even know what they looked like—but they certainly deserve a spiritual home there. Unlike Dowling, brave and resourceful though he must have been, Houston and Smith weren't fighting to perpetuate the enslavement of millions of men, women and children.

They were waging a truly American fight—a fight for freedom, for themselves and for generations to come.

June 30, 2014

★ Welcome to the only beauty shop / book club—maybe in all the world ★

HAWKINS—In the pine-tree and dogwood shade alongside FM 2690 on the outskirts of this little town north of Tyler is a small prefab-looking building so unremarkable that I drove by twice before I realized it was my destination. A "For Sale" sign near the two front doors only added to my confusion. (I learned later that the sign's been up for sixteen years.)

Suite A is an attorney's office. Suite B is a one-room, one-chair beauty salon whose owner may be second only to Oprah when it comes to one person having an influence over what Americans read these days. Welcome to Beauty and the Book, as far as I know the only combination hair salon / bookstore / book club headquarters in America, maybe in the world.

The font of East Texas energy for this unusual enterprise is Kathy L. Murphy, a fifty-seven-year-old licensed cosmetologist who presides over nearly six hundred book clubs totaling several thousand members and whose monthly book-club choices can propel an author onto the best-seller lists.

Tall, blond and talkative, the Kansas native learned how to do hair at Crum's Beauty College in Manhattan (Manhattan, Kansas, that is). After working in San Diego for a few years, she put away the beautician's smock in 1988 and moved to Jefferson, the historic little hamlet near Marshall. That's where this lifelong reader found her dream job as a book publisher's representative for Texas and nearby states. Not only did the rep job pay well, but she got to read to her heart's content, travel the country and spend time with writers—for a few years, at least. In 1999 the job fell victim to the demise of independent bookstores.

By then, she and her husband and their two daughters had become a part of close-knit Jefferson. She wasn't sure what to do next, until her sister suggested that she combine her two passions, doing hair and talking about books. For Murphy, it made immediate sense.

In early 2000, she opened the combination beauty shop / bookstore in what had been her husband's workshop in the yard of the family home five miles outside of town. (She eventually moved into a historic building downtown.) By March of that year, with the shop thriving, she decided to start a book club for women who like to read and who like to have fun.

Pondering names for the club, she remembered a beauty contest she'd entered as a teenager. She didn't win—"Hey, I can't help it if I don't have a waistline!"—but she salved her hurt feelings by concluding that the survivors of that painful experience were "beauty-within queens." That title, combined with the timber industry around Jefferson, prompted a name for her club: the Pulpwood Queens. Six strangers showed up for the first meeting.

The Pulpwood Queens caught on in other Texas towns, particularly after Bob Phillips of television's *Texas Country Reporter* dropped by for a show and pedicure. They spread nationwide after she appeared live with Diane Sawyer on *Good Morning America* and then with Oprah herself on her cable TV network Oxygen.

"I appeared on the show *Dallas Style* with a new singing group out of Houston called Destiny's Child," Murphy told me. (Beyoncé's group, for anyone not up on pop music.)

It was a Monday, a traditional closed day for barber and beauty shops, so Murphy was sitting in her own chair as we talked; normally she'd be standing behind the chair conditioning, rinsing and blow-drying. "So I started with Beyoncé," she said, laughing, "and she's gotten a little bit further than me."

A tireless promoter, networker and idea person, Murphy has gotten pretty far herself. In 2008 Grand Central Publishing released her book, *The Pulpwood Queens' Tiara-Wearing, Book-Sharing Guide to Life*. It sold well, and she's working on a sequel.

With clubs forming around the country and now in fifteen foreign countries, she began hosting an annual gathering of club members called Girlfriend Weekend. It started out with tents in her front yard but has ballooned into author discussion panels, costume silliness and a huge Saturday-night dance called the Hair Ball,

where the women wear tiaras perched atop Texas-stereotype big hair.

"I'll do anything, as long as it doesn't break a commandment or get me in trouble with my church group," Murphy said.

Big-name writers also show up. Pat Conroy (*Prince of Tides*), Rebecca Wells (*Divine Secrets of the Ya-Ya Sisterhood*), Fannie Flagg (*Fried Green Tomatoes at the Whistle Stop Cafe*) and John Berendt (*Midnight in the Garden of Good and Evil*) all have graced Girlfriend Weekend. And as usual, the Houston area, with five Pulpwood Queens chapters, will be well represented at next January's event in Nacogdoches. "They're the party girls," Murphy said.

"I think she probably reads as much as she talks," said Carol Dawson, an Austin writer who was the first person to go to Jefferson and do a reading for the Pulpwood Queens. Murphy did her hair before the event.

"Many book clubs around the world get together as a hen session," Dawson said, "but in Kathy's case they really read the books and discuss literature. She is passionate about reading, and so are her members."

Murphy does hair during the day, reads publishers' review copies at night and chooses a book each month for her clubs to read. She looks for "a story I haven't heard before, a different take or spin, a book that's discussible."

Every club—the number's now up to 565—organizes some kind of literacy program of its own choosing. Golden, Colorado, for example, has built libraries for South Dakota Indian reservations. Anchorage, Alaska, helped start a chapter in a women's prison.

Last year, in a plot turn worthy of a Rebecca Wells novel, Murphy's husband of twenty-five years asked her out of the blue for a divorce. Devastated, it took her a while to figure out the next chapter of her life, but then, just as when she lost the publisher's rep job years ago, a path forward revealed itself.

After twenty-six years in Jefferson, the former Kathy Patrick and her ex sold their home. She closed her Jefferson shop and moved sixty miles west to Hawkins, a move that made sense for a number of reasons: she could be closer to her grown daughters in Tyler, one a University of Texas at Tyler student; after attending six colleges without ever graduating, she could finish her own degree at UT Tyler; and, while running Beauty and the Book and Pulpwood Queens, she could take a job as youth minister at the First United Methodist Church in Hawkins.

"Life is about change, and you've got to be able to adapt," she said as she pulled warm towels out of the dryer. "What happened in Jefferson was sad for me—I'm still grieving over the loss—but I also realize that that door closed, but this other window is opened, and God's sending me somewhere else."

October 25, 2014

Katy Prairie at sunset, west of Houston, 2013

Lots for sale, Katy Prairie, west of Houston, 2015

Remains of a development after Hurricane Ike, Gilchrist, Bolivar Peninsula, 2009

Chinese kite, Galveston Island, 2013

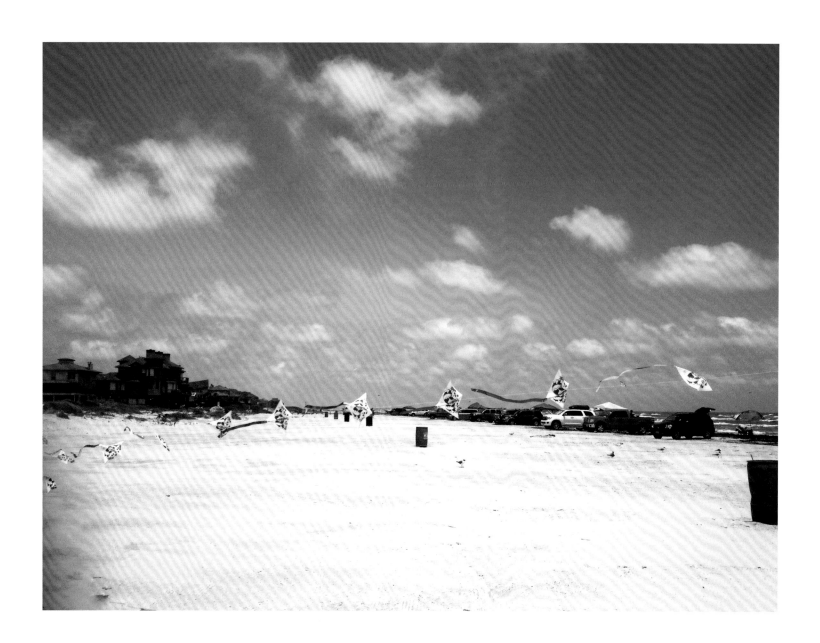

Houston light rail, Pride Parade, Houston, 2015

Fourth of July, Hermann Park, Houston, 2014

Deer stand and feeder in clear-cut, west of Town Bluff, 2015

Happy Mother's Day and other signs, Wallisville, 2015

American flag and construction, Coldspring, 2015

Religious statuary and signs, Dayton, 2012

Inscribed cross, blue house and turkey decoys near Bon Ami, 2012

Repurposed satellite dish, church sign, Shiloh, 2015

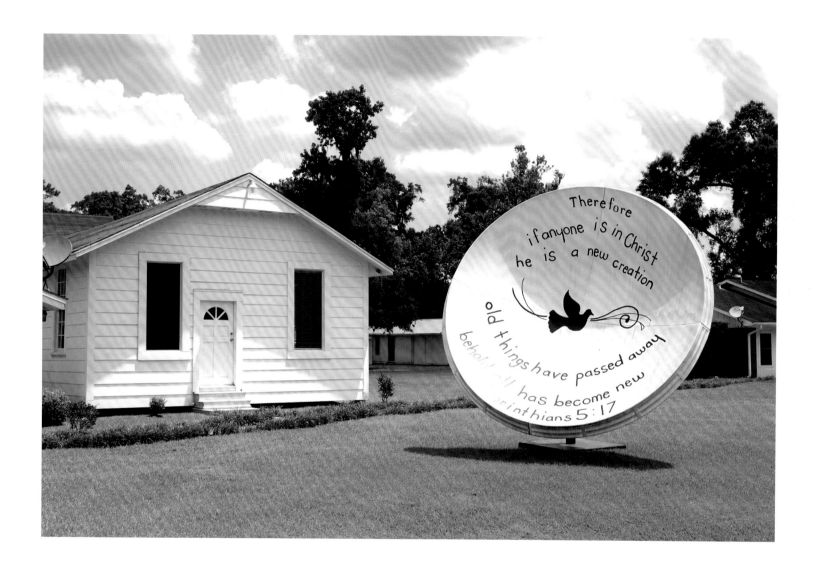

Longhorn Room, Cafe Texan, Huntsville, 2013

Tomatoes for sale and fire, Raywood, 2015

Grave and Confederate flag, Kenefick, 2012

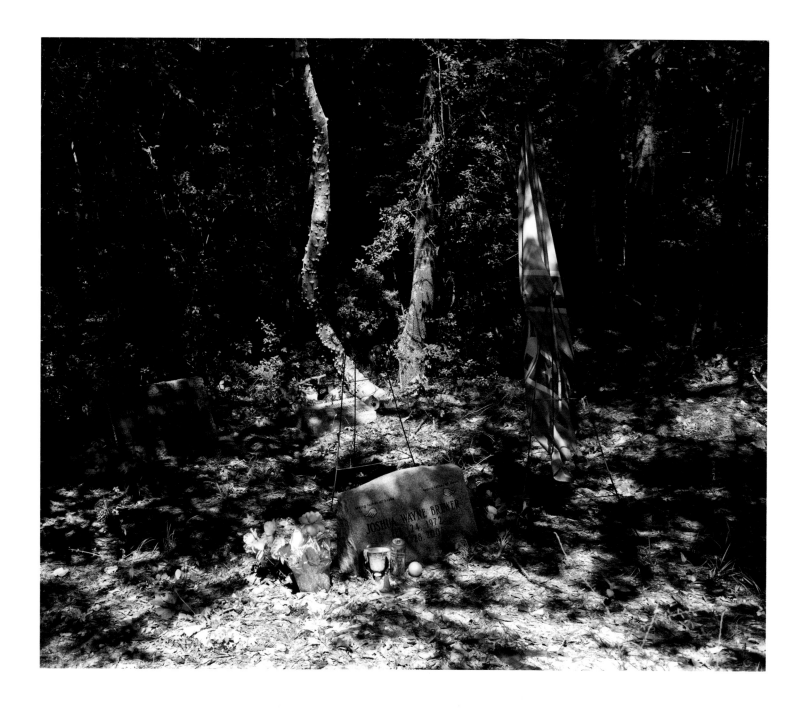

Vines and shadows, Woodville, 2015

Home with flags and picket fence, Woodville, 2015

Alligator, Brazos Bend State Park, 2014

Trinity River flooding and cross near Liberty, 2015

Blackbirds and clouds near Damon, 2012

Acknowledgments

My thanks:

To Rice University, which brought me to Texas in the late 1970s and has kept me around for three decades now.

To Mary McIntire, dean of the Glasscock School at Rice University, and to my wonderful class, a community of inspired and inspirational souls.

To four Texas gallerists who have dealt with my work for many years: Harrison Itz of Harris Gallery Houston; Stephen L. Clark of the Stephen L. Clark Gallery, Austin; and Burt and Missy Finger of PDNB Dallas.

To my friend and collaborator the late Kent Haruf who, along with Joe Holley, I felt riding shotgun with me on many of these trips.

To the Houston Center for Photography, FotoFest, the Museum of Fine Arts Houston, the Contemporary Arts Museum and the other local organizations that have passionately supported photography and have made Houston an international center for the medium.

To Joe Holley, whose writing I love and whose work has informed me and opened my eyes to new things. His roving curiosity, good spirits and deep knowledge unfailingly describe a changing Texas.

To the Fryar, Thornton, Engdahl, Jackson and Fettinger clans. Thank you for taking me in many years ago and teaching me so much about this huge, diverse, beautiful and sometimes confounding state. Special thanks to Marcus Fettinger and Clay and Kasey Engdahl, who make appearances in this book. And to Mackie, our wise and photogenic cairn terrier, who makes a couple of appearances as well.

And finally to Jill and Caitlin, two women with remarkable eyes, minds and souls. They make life an ongoing adventure.

– *Peter Brown*

Thanks to Steve Proctor, the former *Houston Chronicle* editor who suggested that I write "Native Texan," to *Chronicle* executive editor Nancy Barnes for allowing it to continue and to managing editor Vernon Loeb, a frequent source of support and encouragement. Thanks to "Native Texan" readers who generously offered tips and suggestions for topics around the state. The discerning eye of Peter Brown, my *Hometown Texas* partner, also helped me see more clearly as I traveled around Texas. Thanks, Peter.

I also want to acknowledge my dad, H. M. Holley, who long ago shared with me his infectious enthusiasm about Texas people and places and its colorful past. I wish he were here to read the columns because, without his influence, they might never have existed. I miss him to this day.

—Joe Holley

* * * *

Trinity University Press gratefully acknowledges the generous support of these donors

Frost Bank

Alston and Holly Beinhorn

Antonia Castañeda and Arturo Madrid

Hugh and Sarah Fitzsimons

Helen K. Groves

Laura McAllister Johnson

Juliana Seeligson

Susan N. Smith

Anonymous

* * * *

PETER BROWN has photographed landscapes and small towns for twenty-five years. He is the author of *Seasons of Light, On the Plains* and *West of Last Chance*, a collaboration with novelist Kent Haruf and winner of the Dorothea Lange–Paul Taylor Prize. Another book is *Habiter L'Ouest*, a collaboration with John Brinckerhoff Jackson (Wildproject Press, Marseille, France). Trinity University Press will publish an English-language edition in 2018. Brown is the recipient of a National Endowment for the Arts individual artist fellowship, the Imogen Cunningham Award, the Alfred Eisenstaedt Award, and a Graham Foundation fellowship. His work has been collected by the Menil Collection, the Museum of Fine Arts Houston, MoMA New York, the Los Angeles County Museum of Art, the Getty Museum, and the San Francisco Museum of Modern Art. He teaches photography at the Glasscock School at Rice University and lives in Houston.

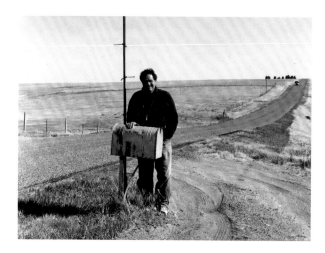

JOE HOLLEY is a former editorial page editor and columnist for newspapers in San Antonio and San Diego and a staff writer for the *Washington Post*. He has been a regular contributor to *Texas Monthly, Columbia Journalism Review*, and other publications and is the author of three books, including a biography of Slingin' Sammy Baugh. In 2009 he joined the *Houston Chronicle*, where his column "Native Texan" appears on Saturdays. He is a 2017 Pulitzer Prize finalist for a series of editorials on guns and gun culture.

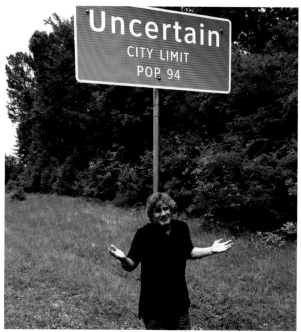

Published by Maverick Books, an imprint of Trinity University Press
San Antonio, Texas 78212

Book design by Kristina Kachele Design, llc

ISBN 978-1-59534-807-4 hardcover
ISBN 978-1-59534-808-1 ebook

Cover front: Ivanhoe State Bank, Lipscomb, 2010
Cover back: Union Pacific freight cars and clouds, Marathon, 2014
Frontispiece: Galveston–Bolivar Ferry, 2014

Printed in China by Four Colour Print Group, Louisville, Kentucky

Trinity University Press strives to produce its books using methods
and materials in an environmentally sensitive manner. We favor
working with manufacturers that practice sustainable management of
all natural resources, produce paper using recycled stock, and manage
forests with the best possible practices for people, biodiversity, and
sustainability. The press is a member of the Green Press Initiative, a
nonprofit program dedicated to supporting publishers in their efforts
to reduce their impacts on endangered forests, climate change, and
forest-dependent communities.

The paper used in this publication meets the minimum requirements
of the American National Standard for Information Sciences—
Permanence of Paper for Printed Library Materials, ANSI 39.48–1992.

CIP data on file at the Library of Congress

21 20 19 18 17 | 5 4 3 2 1